Borrowed From

HOW TO PAINT FIGURES IN PASTEL

HOW TO PAINT FIGURES IN PASTEL

By Joe Singer

WATSON-GUPTILL PUBLICATIONS, NEW YORK

PITMAN PUBLISHING, LONDON

Copyright © 1976 by Watson-Guptill Publications
First published 1976 in the United States and Canada by Watson-Guptill Publications
a division of Billboard Publications, Inc.
One Astor Plaza, New York, N.Y. 10036

Library of Congress Cataloging in Publication Data
Singer, Joe, 1923–
 How to paint figures in pastel.
 Bibliography: p.
 Includes index.
 1. Human figure in art. 2. Pastel drawing.
I. Title.
NC880.S48 741.2'35 75-42410
ISBN 0–8230–2460–1

Published in Great Britain by Sir Isaac Pitman & Sons Ltd.
39 Parker Street, London WC2B 5PB
ISBN 0–273–00123–X

Manufactured in U.S.A.

First Printing, 1976

For Sharon, Brett, Ian, Valerie, and Sam

Contents

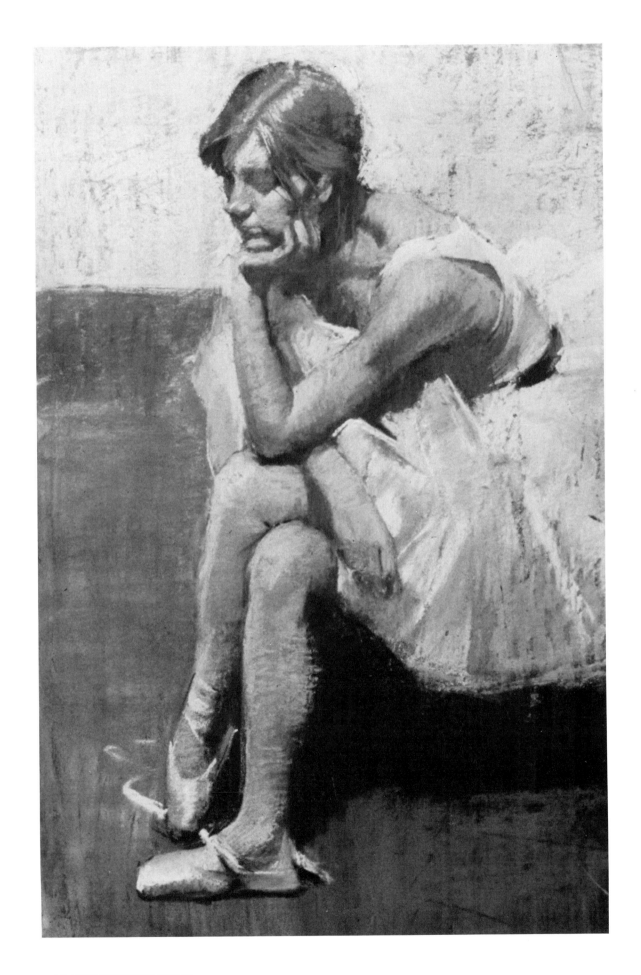

Introduction

Throughout the ages, the figure has remained the favorite subject of painters and sculptors. Portraits and figure studies have preoccupied artists of prehistoric, primitive, and civilized societies and consistently touched the inner core of response in people whether the message was religious, decorative, or literary. Man's abiding love of himself—his self-concept as the absolute jewel of divine creation—has rendered the portrait and figure the most adored and enduring forms of art. What landscape or still life can match the popular appeal of a Mona Lisa, a Venus de Milo, or Michelangelo's David?

A Brief History

Although man has lovingly portrayed himself in every medium from the lumps of earth smeared on cave walls to the glazes on Greek vases, our concern here is with figure painting in pastel—which is of comparatively recent vintage. Artists have used pastel in some form since the sixteenth century—take for example the white, black, and red chalk figure studies of Leonardo da Vinci and his contemporaries—but the pastel medium as we know it today only dates back to the Impressionists. Renoir, Millet, Chase, Whistler, and others experimented with pastel figure painting, but it was Edgar Degas who gave this genre its thrust, consequence, and glory.

Degas was the absolute master of pastel figure painting and no one has emerged as even a close second. He probed every nuance of the human figure, tapping uncharted areas of perception in portraying mood, attitude, and emotion, and producing a body of art that has enriched mankind. Who could fail to respond to the deep humanity of Degas' ballerinas, shopgirls, laundresses, milliners, and housewives burdened by poverty? They are a monument to the unvanquishable human spirit.

Dancer at Rest by Burt Silverman, pastel on canvas, 16" × 10". Burt wasn't afraid—as some lesser talent might be—to take on a subject so closely identified with the master pastelist himself. Burt's dancer is evidently just that; even in repose she instinctively strikes a dancer's pointed-toe pose. This can be called a high-key painting, since the overall tonality of values is definitely on the lighter side. Observe the calculated effect of reflected light on the woman's upper left arm. It serves to lend roundness to the form and to bring it somewhat forward. The folds of the tutu are simply, but skillfully, recorded and its texture seems properly stiff and crisp. Note the effective addition of the blue sash—how much weaker the painting would have been without it!

After Degas, little happened to elevate figure painting in pastel. Toulouse-Lautrec and Bonnard made some tentative stabs at it, as did a few others, but these were isolated excursions and not a concentrated, progressive effort. The one who came closest to the old curmudgeon himself was our own Mary Cassatt, who produced a series of skilled if somewhat sentimental pastel studies of mothers and children. Thus the history of figure painting in pastel is really the history of an individual who bore the weight of an entire art movement on his own shoulders. If not for Degas, there would be little to say about pastel in general and nothing at all about pastel figure painting.

Why Paint Figures in Pastel?

In light of our previous discussion one might ask, why paint figures in pastel? Why get involved in a movement that began and ended with one individual? And my answer is—this is *precisely* the reason! If you dare explore an area already so competently mined and probe it for facets you might establish as your own, then this is the medium and the subject matter for you.

Pastel lends itself to figure painting even more than it does to other subjects. Figure painting in any medium must express fluidity, action, and animation. Otherwise you'll end up with the classic nude whose proportions are perfect but who exudes about as much life as a refrigerator. Degas' nudes pulsate with life—especially his late ones where form is subjugated to color, value, and movement. You can fairly sense the molecules dancing with excitement and the passion of life.

Pastel tends to free you from the restrictions imposed by the more elaborate oils. There's less of a tendency to need to *finish* a painting. With pastel, you're more apt to noodle around, to alter, to leave areas blank, to omit contour lines, to blur—in other words, to take the figure off the pedestal and plant it firmly on the ground where it belongs.

As a medium that combines painting and drawing, pastel is ideal for figure studies in that it allows you to depict the human body *in motion*. You're not locked into a prearranged composition as you might be in oil painting; you're freer to move the figure about and test it in various postures, to play around with changes of light, to

add or subtract elements. I know from my own experience that once I commence a painting in oil I usually stick with my original concept, but when working in pastel I tend to be looser, freer, and more susceptible to change.

Advantages and Disadvantages

Pastel's many advantages bear looking into by those interested in painting the figure. Its speed of execution—it requires no drying time, no underpainting, no stretching of paper, no squeezing of colors onto a palette, no additional mediums or tools such as brushes or knives—is particularly helpful when working with a model who is assuming a difficult pose. Having previously picked out all the pastel sticks for the painting, you can leap right in and flail away without concern for the paraphernalia employed in other media. Your tools are your crayons and your fingers, both of which can be kept reasonably handy.

Reworking in pastel can be accomplished at any time because the previous coat accepts fresh color at every stage of the painting. It's never too wet or too dry; never sticky, gummy, gooey, or gluey. The colors don't sink in, don't darken or lighten, and you needn't worry if you're painting lean over fat or vice versa. Nor is there any question as to whether you're using too much or too little painting medium, since there "ain't no such beast" in pastel painting.

Since pastel is both a drawing and a painting medium, you can make either a line or a tone study, something rather prohibitive in oil, watercolor, or acrylic, which are essentially tonal mediums. This is especially advantageous in figure work when the opportunity to draw a rather intriguing pose often supersedes the urge to paint the model. With pastel and sufficient inspiration, you can execute an essentially *drawn* study with some spots of color thrown in—in the manner of the magnificent chalk figure studies of Leonardo, Michelangelo, Watteau, and Tiepolo.

For correcting a line or for sheer spontaneity of expression, nothing beats pastel. The human body with its actions and very viability cries out for a medium that's casual yet strong, and able to capture the most fleeting effect and convey mass and form with a few strokes.

I could go on enumerating the advantages of pastel in figure work, however in today's spirit of

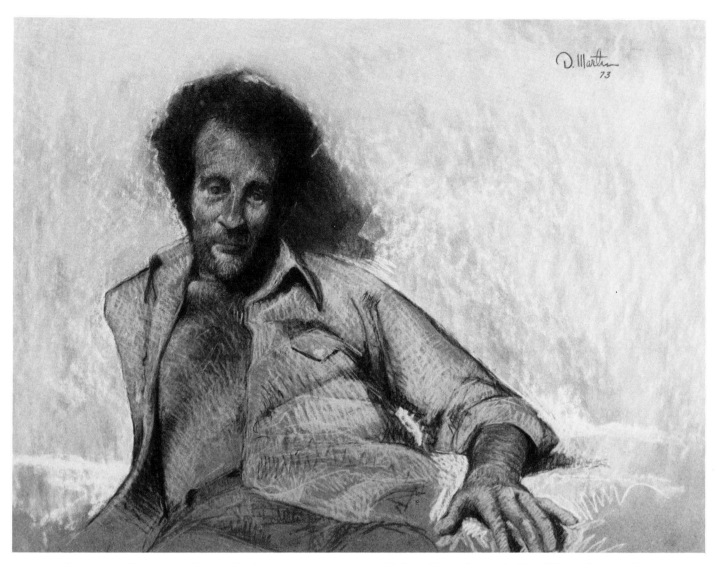

equal time to all points of view, let's examine some reasons against. Those who expect from pastel what they're used to in oil, watercolor, or acrylic are in for a disappointment. You can lay on a beautiful wash in watercolor, you can glaze over a dull passage in acrylic, you can build up an impasto in oil that will lift the painting by its nose —but you can't pull any of these stunts in pastel.

Moreover, pastel smears, blows, and breaks at the most inopportune moments; disappears just when you need it most; stains your fingers; suddenly grows fractious and refuses to go on; changes into a messy puddle after you fix it heavily; and makes you sneeze.

Also, the paper surface is susceptible to tearing and the finished pastel must be framed under glass if it's to remain inviolate. Furthermore, galleries, museums, art associations, art critics, and collectors tend to turn up their noses at pastel.

Richard Segalman *by David Martin, pastel on board, 14" × 21". This painting is entirely pointillistic in technique. Notice how the broken strokes, for all the apparent change of direction, follow the form of the wrist and each finger.*

Old prejudices are hard to break down and pastel has long suffered a stepchild status. There are occasions when shows even refuse to admit pastels due to an alleged puzzlement as to just which category they belong in.

However, in light of what has just been presented to you, and if you conceive the human body as something fluid and mercurial rather than as a magnificent structure whose every angle and curve is sacrosanct, do try figure painting in pastel. You'll find it, as I have—a richly rewarding experience.

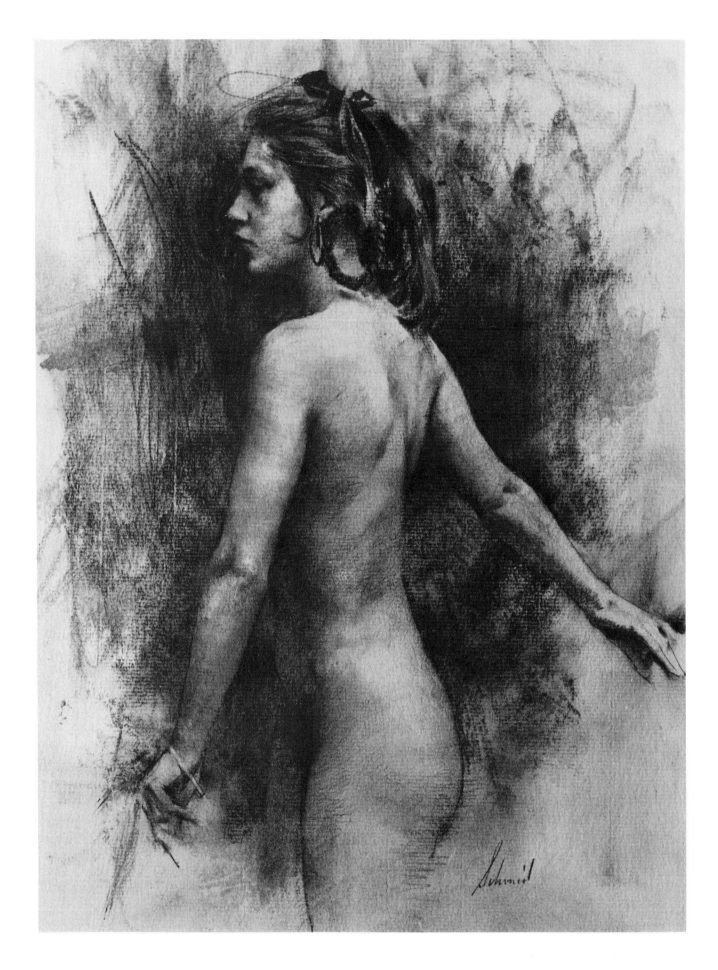

Pastel: Its Composition and Varieties

Pastel is a delightful medium whose qualities and physical properties are yet to be fully explored and appreciated by artists. In this chapter we'll examine the composition of pastel and its varying degrees of hardness—soft, semihard, hard, and pastel pencils—as well as the compatibility of pastel with other media.

What is Pastel?

Pastel is dry pigment (color) mixed with a binder just strong enough to hold the particles of raw color together and form a crayon with which to apply strokes to a surface. Over the years this binder has included such exotic items as plaster of Paris, glue, oatmeal, honey, starch, milk, whey, beer, sugar candy, gum arabic, gum tragacanth, and most recently, methylcellulose. To this pigment and binder mixture, a white substance is added to create lighter versions of the pure color. These substances have included lead white (which due to its poisonous nature is never used in modern pastel manufacture), precipitated chalk, whiting, tobacco pipe clay (also known as China clay, or its modern equivalent, kaolin), plaster of Paris (used also as a lightener), talc, and betonite. Some of these substances also improve the working qualities of the pastel crayon. Black pigment is added to create the darker tones.

Pastels are made in various degrees of hardness, with the proportion of binder used determining this factor. Since modern pastel manufacturers provide a full range of good, permanent colors, few artists these days bother to make their own, although this is a relatively simple process. For those interested in making their own pastels I recommend:

The Artist's Handbook of Materials and Techniques, by Ralph Mayer (Viking, 1970)

Standing Figure *by Richard Schmid, mixed media on paper, 12½" × 9½" (©Richard Schmid. Private Collection). Almost in the classical tradition, the pose shows the twist of the trunk to the left of the pelvis and that of the shoulders, to the right. How much more effective this is than to merely pose the figure straight on, tediously doing nothing! The most apparent aspect here is Schmid's obvious knowledge of anatomy. This is realistic painting at its best, perfectly executed as to line, tone, mass, and proportion. Note (by squinting) how the shadow areas are drifted into the background so that the figure seems proper and natural in its setting.*

The Craft of Old-Master Drawings, by James Watrous (The University of Wisconsin Press, 1957)

Formulas for Painters, by Robert Massey (Watson-Guptill Publications, 1967)

The Materials of the Artist and Their Use in Painting with Notes on the Techniques of the Old Masters, by Max Doerner (Harcourt Brace Jovanovich, 1949)

The Painter's Craft, by Ralph Mayer (Van Nostrand Reinhold, 1966)

All these excellent books give specific instructions on how to roll your own sticks.

Soft Pastels

The bulk of the work in most pastel painting is executed with soft pastels that are made with a minimum of binder and are thus rendered easily friable (crumbly), permitting the splattered, painterly effect so desirable in this medium. Many pastelists use soft pastels exclusively; others use them for most of their work, reserving half-hard or hard pastels for the preliminary and concluding steps and accents only.

Soft pastels differ in their degree of softness and hue from brand to brand. There are perhaps a dozen American and foreign brands, and each manufacturer has his own formula. The best way to learn about the different kinds of pastels is to buy a small set of every available brand and to test similar colors in each. This may prove a somewhat complicated process for a beginner, but to one who has dedicated his or her life to pastel painting, it's an enormously fascinating project. I constantly research developments in the field and buy every new book, color, medium, surface, or gadget that will teach me something new about pastel.

Some popular American brands of soft pastels are Grumbacher and Alphacolor; foreign brands include Rembrandt, Conté, Lefranc-Girault, Schmincke, Rowney, Winsor & Newton, and Reeves.

Soft pastel sells in sets ranging from 12 colors to over 300. They're also sold in open stock so that you can fill in those colors you use up most quickly or assemble a selection of your own choosing. Later we'll discuss the colors I recommend for figure painting.

Semihard Pastels

Pastels prepared with less pigment and more binder become semihard or semisoft—both appellations are used in the trade. These sticks are of a firmer consistency than soft pastels but are not as firm as hard pastels. They're used by some artists for sharp, distinctive accents or for bold, hard-edged strokes. Talens Van Gogh offers them in assortments of up to 45 crayons; Pastellos, another brand of semisoft pastels, come in sets of 24. Conté also makes a set of 24 semihard Contelor pastels.

Hard Pastels

Hard pastels are usually made up in long, thin sticks that produce a sharp, linear stroke exceeded in hardness only by pastel pencils. They come in sets of up to 96 shades and in a brilliant array of colors, many of which I suspect are fugitive, or impermanent, and to be used with caution. Some of the better known brands are: Nupastel, Prismapastel, Grumbacher Golden Palette, and Carb-Othello.

Pastel Pencils

For the finest, thinnest, hardest stroke in pastel painting there are pencils that can be sharpened to a needlelike point. These pencils are best used sparingly lest you end up with a fussy, picky painting. The pigments used in their formulation are of doubtful permanence, too, and care must be taken to use them selectively. Conté, Multi-Pastel, and Carb-Othello are some of the popular brands.

Russian Dancer *by Edgar Degas, pastel, 24⅜" × 18" (Courtesy The Metropolitan Museum of Art, H.O. Havemeyer Collection). Pastel is just right for this kind of essentially* drawn *action pose. By merely turning the stick from* point *to* side *you can draw and paint at the same time and with the same crayon! Degas uses the artist's prerogative here to emphasize the dancer's feet and to minimize her head. Seen by itself, the right foot and leg seem hopelessly out of place. But in context with the entire pose, they fit just fine. If you doubt this, cover the left leg and see how it destroys the model's balance. In figure painting, all the elements of the body are vitally dependent upon one another.*

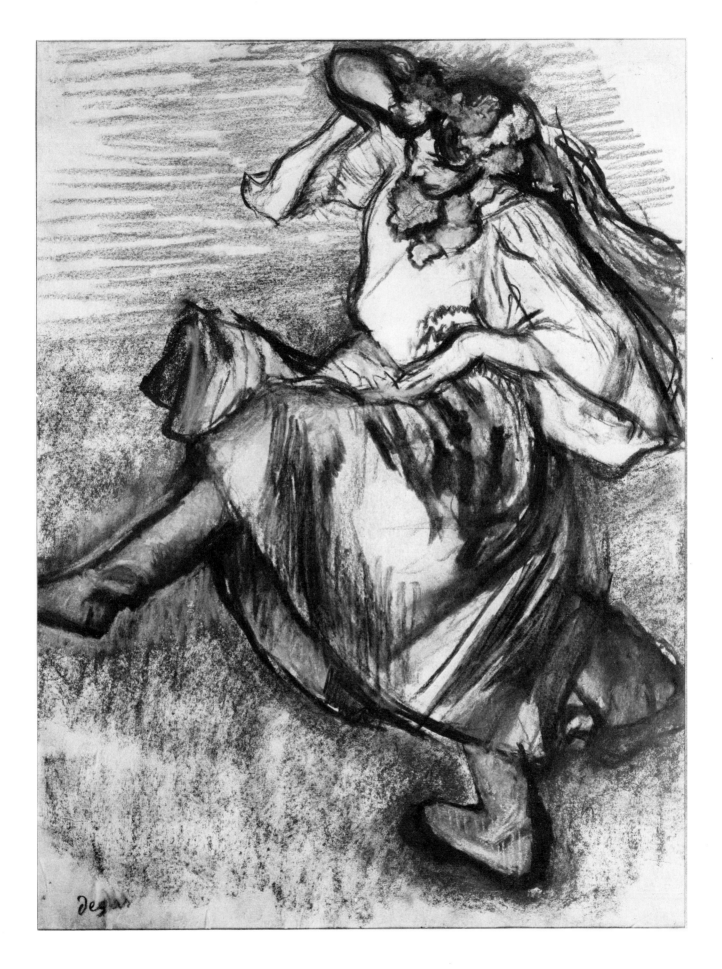

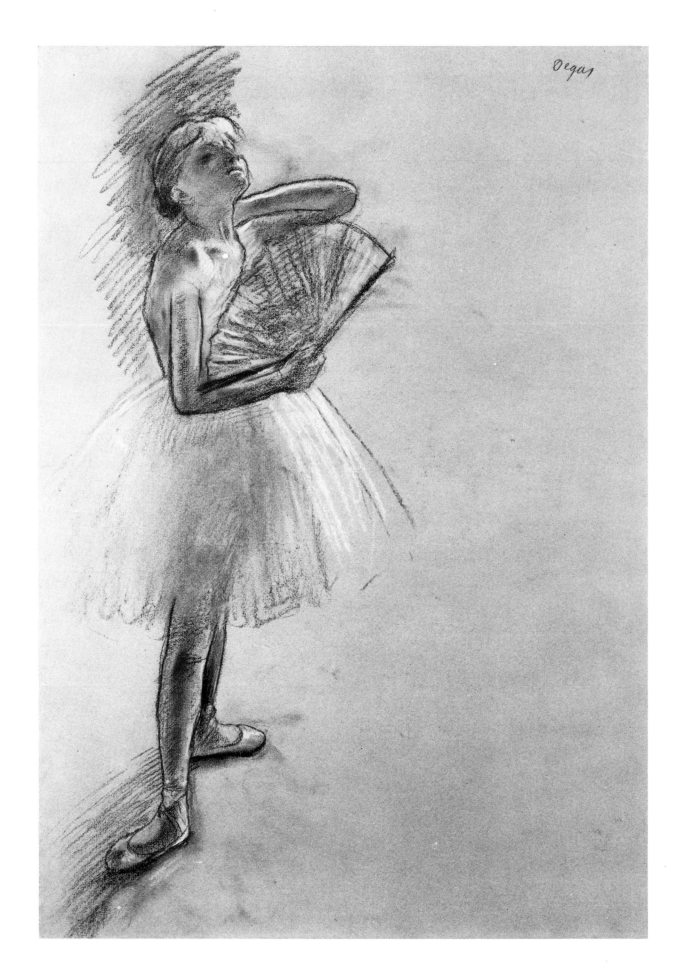

Pastel in Combination with Other Media

An important benefit of pastel is its compatibility with other media. However, it can't be used with media that contain fatty binders, such as oils, oil pastels, wax crayons, and oil tempera, whose greasy surfaces repel the pastel. Several things must be kept in mind when working in mixed media:

1. Except for charcoal, pastel should be the medium used last, or in the topmost layers. Painting with gouache, watercolor, casein, acrylic, or egg tempera *over* pastel is counterproductive since it negates the effects of the underlying pastel.

2. Unless some specifically different effect is desired, the pastel should not be applied to a wet surface.

3. If the underlying surface is painted so thickly or smoothly as to completely fill in the tooth, you'll have a heck of a time trying to apply pastel over it.

Incidentally, *toning* a surface is not the same as working in mixed media (more on that later). Although I believe in working in one medium at a time there are no technical reasons against working in mixed media.

Dancer with Fan *by Edgar Degas, pastel on paper, 24" × 16½"(Courtesy The Metropolitan Museum of Art, H.O. Havemeyer Collection). If there's any question of Degas being the greatest figure painter in history, this daring, remarkable study should put it to rest. Who else would draw a dancer in so awkward yet so human a pose? The face is a mere blob of dots and dashes but what dots . . . what dashes! Look at the skinny, seemingly shapeless right upper arm. If not for the back humping so unattractively behind it, it would look like a stick. The woman is obviously trying to work out a crick in her aching neck after posing for the old tyrant, but we are all enriched for the small price of her temporary discomfort.*

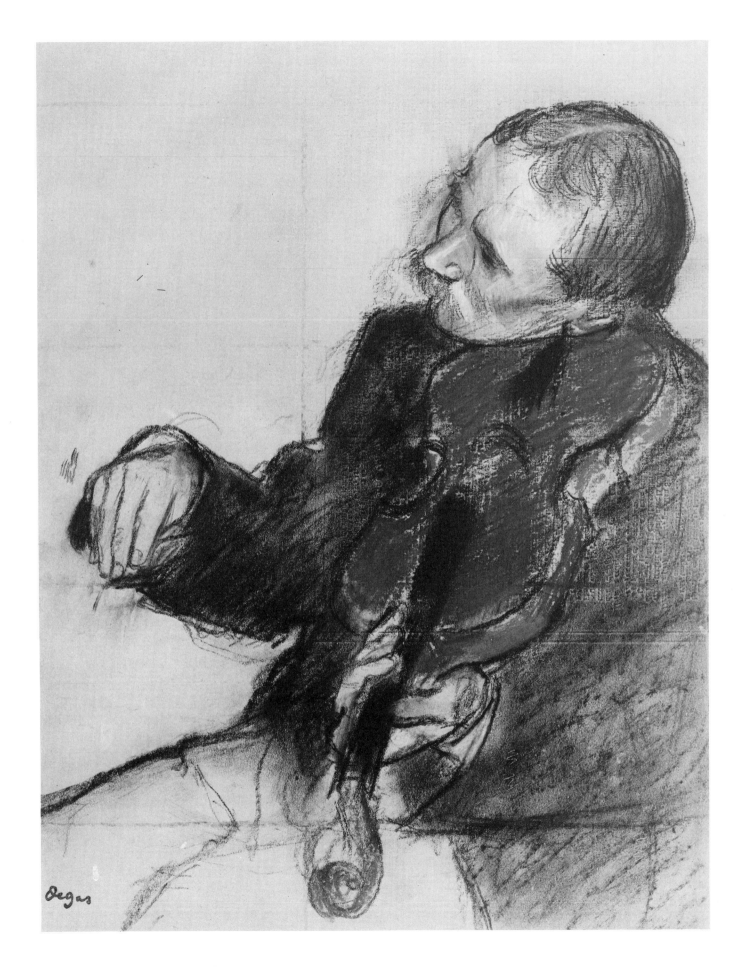

The Surface

What one paints on is certainly as important as what one paints with. Let's consider some of the options in pastel painting. The most popular and traditional surface for pastel is paper. Paper comes in two basic types: unmounted in sheet or roll form, and mounted to a rigid backing. For purposes of simplification I'll refer to unmounted paper simply as paper and to mounted paper as boards.

Fibrous Paper

The best kind of paper has 100% rag content, which is absolutely permanent in every respect. The type designated for pastel usually comes in dozens of tones and colors, and in sheets, pads, and rolls. This paper is heavy enough to take a preliminary tone of acrylic or watercolor without excessive buckling and is adaptable to all pastel techniques and manipulations. The best-known brand of this kind of paper is the Canson Mi-Teintes line that can be used on either side. It comes in two sizes, and in pads and rolls. Another good fibrous pastel paper is the English-made Herga brand.

Other papers used for pastel include those designed for charcoal drawing. They also are perfectly acceptable for pastel painting and many pastelists are quite satisfied with them, although I find them too thin and fragile for the kind of vigorous manipulation I prefer. There is also an annoying pattern on them that interferes with my concentration. Some well-known charcoal papers are Ingres, Strathmore, and Fabriano.

Granular Paper

Granular paper has a rough tooth composed of tiny particles of an abrasive substance that has been permanently attached to the surface. The two substances most commonly used are sand

Seated Violinist: Study for a Painting of Ballet Girls *by Edgar Degas, mixed media on paper, 15-1/6" × 11-3/6" (Courtesy The Metropolitan Museum of Art, Rogers Fund, 1918) When Degas wanted to solve a problem, he seized upon whatever was handy to work out the solution. Here, he combined charcoal, crayon, and pastel and later squared out the sketch to use in an oil painting. Pastel combines with many other media and is a most dutiful and unobtrusive tool in the hands of the artist. Incidentally, isn't this a marvelous sketch? No camera manufactured could capture the essence of a man playing a violin as does this apparently rapid and rough sketch.*

and marbledust, however pumice, silica, or even finely ground glass can be used. This kind of ground acts to shave the granules of pastel and to affix them firmly to the surface. It allows a heavier application of color than the fibrous ground and is preferred by those who like to use their pastels rather thickly. Grumbacher and Morilla offer good sanded papers for pastels.

Velour Papers

Velour paper is an abomination that, happily, is growing rare in the field. I've never seen a serious painting executed on this kind of surface and I hope I never will. It reminds me of the paintings on velvet that certain unfortunates peddle on New York City streetcorners. For those daring enough to rise above my prejudices, Morilla, Talens, and Grumbacher offer this product.

Other Papers

Technically, pastel can be applied to any paper possessing sufficient tooth, and there's no reason the inquisitive pastelist shouldn't try them all. Once a method of working is established, he or she will undoubtedly settle for one or two preferred surfaces. But until then the pastelist can happily investigate the wide spectrum of grounds available.

Thus, you can pastel away on drawing paper, watercolor paper, Japanese rice paper, vellum, parchment, tracing paper, clay-coated paper, Manila paper, butcher paper, etc. After you've finished experimenting, you'll probably go back to pastel paper, but there's no harm in testing your wings a bit first.

Boards

The grounds here are essentially the same as those of the papers, the only difference being the stiff backing they're mounted to. This rigid surface produces a totally different response to the pastel crayon than the yielding paper does. It's very much like the difference between painting on a stretched canvas or on a panel in oil—the former gives, the latter resists.

When to use paper or when to use board is the pastelist's prerogative. I can't recommend one over the other since both offer equally satisfactory results. However, you should be aware of certain qualifications before choosing between a yielding or a rigid ground:

1. Paper is somewhat more fragile and is less suited for vigorous manipulation.

2. Board will accept many more coats of an aqueous medium for toning or underpainting with less danger of buckling.

3. It's easier to correct mistakes on a board.

4. Paper is less expensive.

5. Board generally has a rougher texture.

6. Paper may be bought in rolls and cut to any size, while the size of board is pretty much prescribed (unless you make your own).

7. Paper comes in many tones and colors—board usually doesn't.

8. Paper comes in a greater variety of grounds.

Here's some information on obtaining boards: Fiberboard suitable for pastel is offered in many colors by the Crescent Cardboard Company. Grumbacher makes sandpaper board in a rough and smooth finish, and also makes velour board. Morilla distributes sanded board also, as does Hurlock. Other board that can be used for pastel are illustration board, watercolor board, and if permanence isn't a requisite—matboards and posterboards.

I may point out the enormous difficulty I've encountered in hunting down many of these products. It's frustrating enough for one living in or close to a city such as New York—I can just imagine what it must be like for someone far removed from a metropolitan center.

Study of Nude Female Figure by *Edgar Degas, charcoal and pastel on paper, 12-5/16" × 9-3/4" (Courtesy The Metropolitan Museum of Art, Rogers Fund, 1918). Degas left thousands of such quick studies which he executed by the dozens almost every day of his adult life. What better tool than pastel could capture the fleeting pose of a moving figure? By constantly drawing, Degas turned himself into one of the great draftsmen in history. How does this jibe with his modern equivalent who devotes and hour a day to painting and the other sixteen to preening, club meetings, political demonstrations, parties, sessions with the analyst, coffee klatches, and holding court for admirers?*

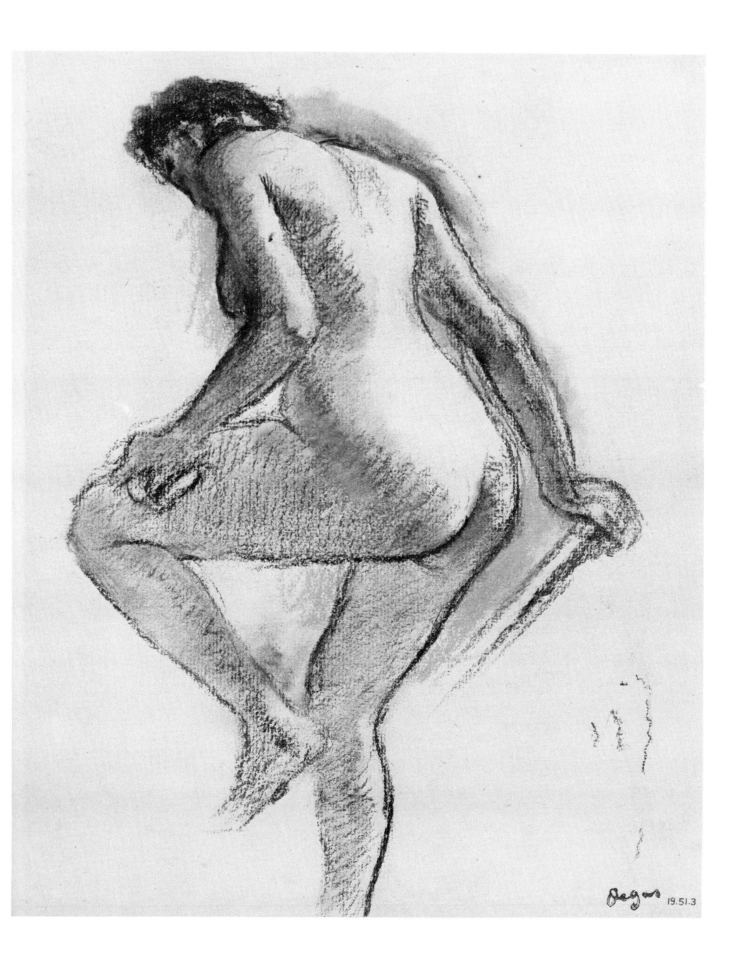

Canvas

A traditional surface for pastel painting is canvas manufactured specifically for this purpose. The way the canvas is cut and stretched is similar to the process in oil painting. Primed canvas can be worked on with no additional coating or priming, although some artists prefer to use unprimed canvas. While I myself never use pastel on canvas, I accept it as a perfectly legitimate practice.

Grumbacher and Fredrix are some of the pastel canvas manufacturers. The finest canvas for pastel painting is made of linen; cotton and other fibers are not considered as permanent.

Other Surfaces

Besides canvas and special pastel boards and papers, artists have employed a variety of supports and grounds for pastel painting, including linen, silk, muslin, taffeta, Masonite and plywood panels, aluminum, etc. To reiterate — use whatever type of surface you choose, providing it meets the requisites of permanence you should demand for your important work.

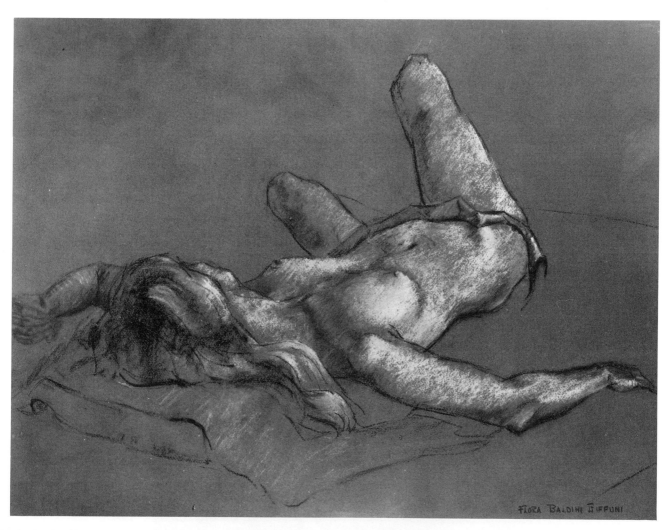

Nude (Left) by Marcos Blahove, pastel on illustration board, 10" × 16". In this rapid study, the artist first made a quick sketch with a hard pastel and indicated the larger dark areas. He then dipped a bristle brush in Lefranc pastel fixative and toned the board over the sketch to create a kind of wash effect. Then he crushed a chunk of the same pastel into powder, mixed it with the fixative, and dripped it onto areas of the drawing with a dab of cotton.

Reclining Nude (Above) by Flora Baldini Giffuni, pastel on paper, 18" × 24" (Collection Joe Picone). In the tradition of the old-master chalk studies, Giffuni spotted color in selected areas to lend roundness and dimension to the form. Note how effectively the softness of the flattened breast tissue is handled. The effect of receding planes is heightened by such devices as keeping the most distant left thigh darker than the closer right. This is a most difficult pose to attempt.

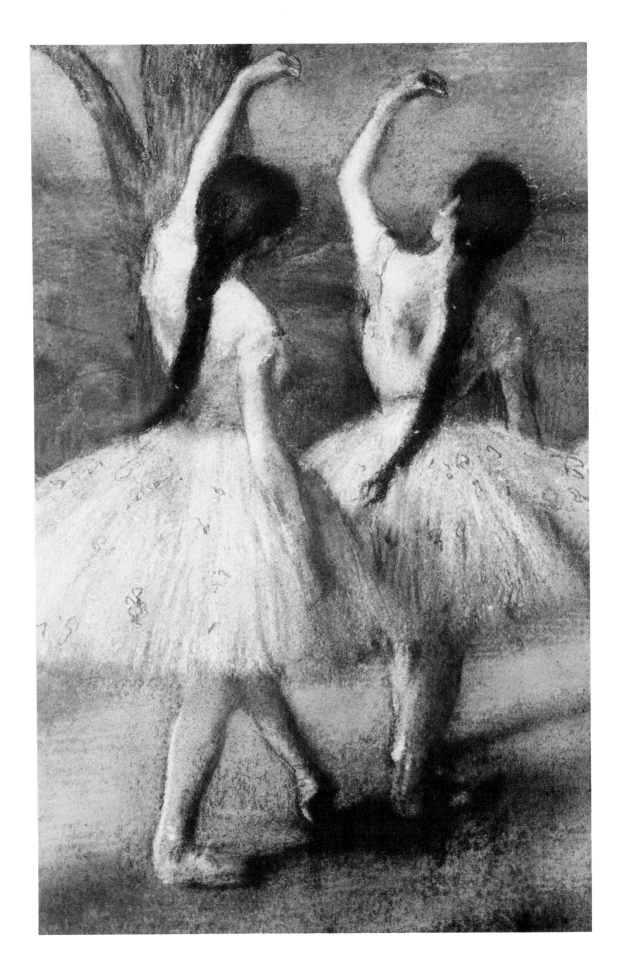

Preparing Your Own Surface

One of the exciting things connected with pastel painting is the fun of preparing your own grounds. The ability to control the value, color, texture, and rigidity of your surface is a definite plus.

Toning

To tone means to achieve the desired value and/or color of a surface. This can be done separately or simultaneously. That is to say, you can lower or raise the value of a surface without changing its color, or change its color and value with the same layer of paint. Toning can be applied to a surface that already has a tooth and a tone (in other words, storebought pastel paper or board) or to an untextured white surface that you create yourself—tooth and all—from illustration board, watercolor paper, drawing paper, etc.

Toning can be done with watercolor, acrylic, casein, or gouache. The tone can be painted on, sprayed on, sponged on, or rolled on. It can be dark or light, thin or thick, even or splattered. Toning for hue is a matter of personal choice and taste. It's not customary to tone a surface a brilliant color such as cadmium red, cadmium yellow, emerald green, or peacock blue, but there's no *technical* reason against it. It's simply that painting on such a garish background will overwhelm any color you use over it.

Then again, painting in pastel on a pure white surface is a most frustrating experience since somehow the value relationships fall out of kilter and there's no end of trouble in achieving a proper color key. Most experts agree that you should paint on a surface that's lower in *value* than white but not necessarily of a specific hue. Most artists find it useful to tone a surface a neutral hue that provides a quiet, subdued area upon which to develop the painting.

Dancers in Pink by *Edgar Degas, pastel on cardboard, 31-3/4" × 18-3/4" (Courtesy Cleveland Museum of Art, Leonard C. Hanna, Jr., Collection). In this fully realized painting Degas exploited the whole gamut of pastel The strokes are heavily applied to the cardboard surface which he previously toned and otherwise prepared to receive the pastel layers. Degas painted in pastel on everything he could think of —paper, cardboard, canvas, monotypes—no potential surface escaped his curious, searching, experimental mind. He also used a brush freely to move the colors about, blew steam into them, soaked them with turpentine, and drowned them in fixative, but somehow they survived and continue to enjoy excellent health.*

Obtaining the Desired Tooth

The tooth of the pastel surface is even more important than its tone since it must seize and hold the pastel granules with a grip firmer than love. The degree of roughness of the tooth is a matter of preference, but its total absence is out of the question because the pastel would simply slide off and disappear.

As I've already mentioned, the degree of roughness of the tooth will strongly affect not only the appearance of the finished painting, but the method in which it is executed. The rougher the tooth, the more granules it will shave off the crayon and the more pastel will be required to cover the area. Since pastel painting can be more or less divided into three techniques—pointillist, painterly, and rubbing-in—the artist should find a ground that best suits his or her particular technique. Generally speaking, the pointillist method is best achieved on a rougher surface, the painterly on a medium surface, the rubbing-in on a fine surface.

There are several ways of creating your own texture, but the first step is always to begin with a 100% rag board or paper if permanence is uppermost in your mind. Having selected and cut the surface to the desired size, lay it flat, face up, and apply the ground to it in one of the following ways:

1. Sprinkle the granules of sand, pumice, silica, marbledust, etc., into a solution of casein or acrylic gesso (which can be bought readymade) and spray, sponge, or brush it onto the surface. The amount of granules you sprinkle on depends on the roughness of tooth desired.

2. Mix the granules into a tone of aqueous medium (acrylic, watercolor, etc.) and spray, sponge, or brush it onto the surface. In this method you can achieve tone, hue, and tooth in a single application.

3. Apply a solution of gesso to the surface, and while it's still wet, sprinkle the granules into it.

4. Sprinkle the granules into a wet tone of medium.

5. Spray the surface with fixative and sprinkle the granules into the wet coat.

6. Sprinkle on the granules first, *then* spray on fixative to adhere them to the surface.

7. If you want to, substitute emulsions of gum tragacanth, gum arabic, gelatin, or other glue or starch paste for the gesso or medium mixture. Then add granules to the wet area in the same manner. Recipes for these various gums, glues, and emulsions are provided in some of the books listed in Chapter 1.

Granular Material

The granular substances used for achieving texture in surfaces can range from the traditional sand, marbledust, pumice, and silica to such experimental materials as crushed glass, gravel, rock salt, sugar, or any material that won't deteriorate, fall away from the surface, or let go of the pastel. The pastelist will find that there's plenty of room for experimentation. In order to find the more exotic substances you'll have to use your imagination and perseverance.

Mounting

Some artists go to the trouble of mounting a paper they like onto a rigid support to form a homemade pastel board. If this is done before the picture is painted, it is a comparatively simple process. If it's attempted afterwards, the task is trickier due to the problems of handling the finished pastel without smearing, tearing, or otherwise injuring it.

Mounting a paper to a firm support can be done in one of several ways, so experiment and choose the way that's best for you:

1. Using a good adhesive of the kind called bookbinder's, or library, paste (rubber cement is not advisable), completely cover the back of the paper—which can first be moistened with a sponge so that it will stretch—with the paste. When the water (not the paste!) is dry, either lay the support onto the paper or vice versa and rub the surface smooth until the sheet lies perfectly flat. If there are any creases or bubbles you can usually smooth them away with a roller.

2. Repeat the same process but apply the paste to the support only.

3. Repeat the same process but apply the adhesive to both the paper and the support.

4. Apply the paste to only the *edges* of the paper and glue down.

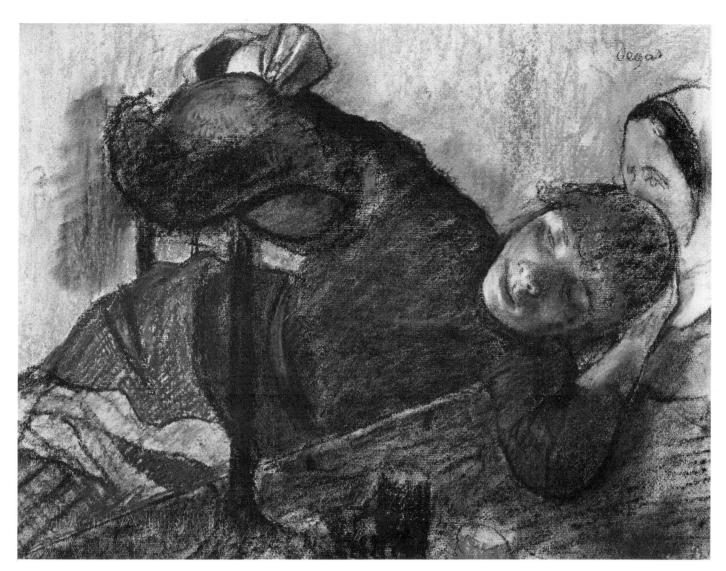

The Milliner *by Edgar Degas, pastel on cardboard,
18-3/4" × 24-1/2" (Courtesy The Metropolitan
Museum of Art, Gift of Kikran Khan Kélékian, 1922).
No one so fully exploited a medium and surface as did
our friend Degas. Look at the rough treatment of the
hair as compared to the smudged areas in the face.
Again in the hat, the crown is smooth, the brim,
scratchy. Degas knew hww to treat different parts of the
same ground differently to achieve these varied tex-
tures. He would deliberately roughen an area with a
knife or other instrument and press crushed pastel into
it to produce a broken, powdery effect.*

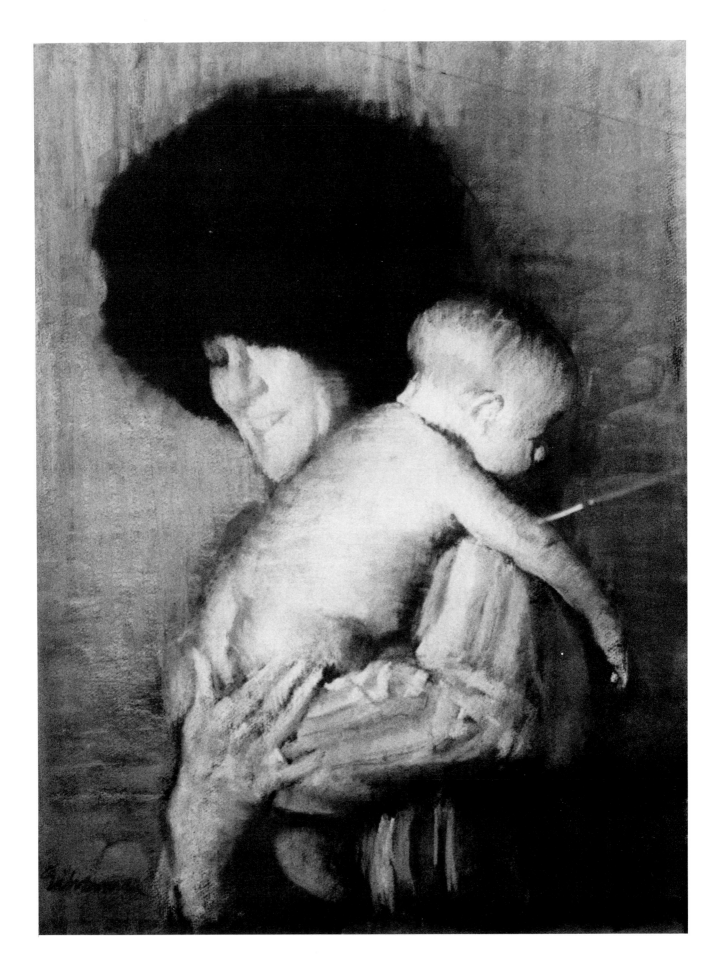

5. Dry mounting—a system in which heat is used to adhere the materials—requires a mounting press, which is a large initial investment. The subsequent operating expenses, however, are quite minimal.

In all the above instances you must be sure to:

1. Protect the surface of the paper that you'll ultimately paint on by covering it with tracing or other paper during all the mounting steps.

2. See to it that the paper is smoothly mounted so that no bumps, bubbles, air pockets, or creases are formed. Extreme care during mounting, judicious use of the palm and the roller, and practice in the procedure will help prevent this.

3. To prevent bumps or hills from forming after the paper and support have been joined, make sure dirt or other foreign material doesn't settle on the mount or paper.

4. Always place an evenly distributed weight, such as a heavy drawing board or a Masonite board weighted down with books, over the entire surface of the paper, which should be protected by tissue. The paper will then dry flat without curling, wrinkling, or sagging.

You can either buy the paste readymade or mix up a batch for yourself following recipes offered in all of the books listed in Chapter 1.

First-Born *by Burt Silverman, pastel on paper, 24" × 19". In this classic mother-and-child pose, handled in an original fashion, the big mass of the woman's hair serves to set off the soft, pliable flesh of the newborn infant. The powerful shadows here serve to strengthen what could otherwise have been a banal, sentimental scene. Also refreshing is the lack of solemnity that usually accompanies this subject. The soft treatment of edges throughout lends particular verve to the painting. Note how the baby's face drifts into heavy shadow under the rather harsh light.*

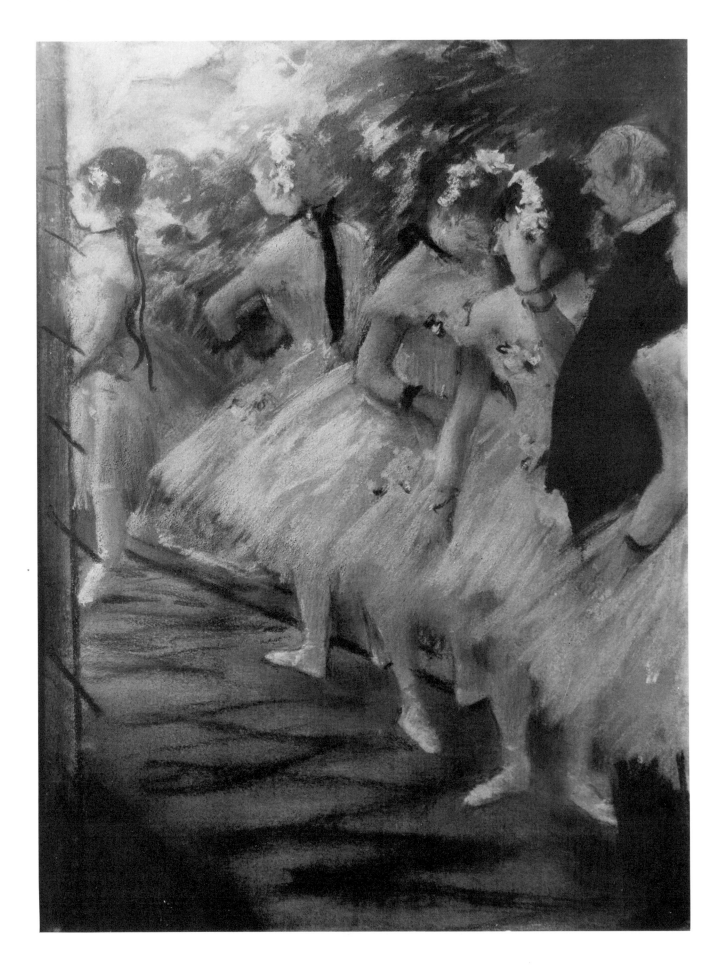

The Uses of Fixative

The Ballet, *by Edgar Degas, pastel (Courtesy The Corcoran Gallery of Art, W.A. Clark Collection). Here is the master, again scoring with this evocative scene of ballet activity. It presumes to show a number of ballerinas either practicing or about to step out on stage. As usual, everything seems to lack apparent rhyme or reason. (Degas never felt the need to explain any of his pictures.) What is the man doing in the center of all this activity? Is it a real mirror we're looking into at the left, or a mirror of life? No matter—the composition is, as usual, striking, the view daring, the relationship of the participants cohesive and firmly meshed. This is how to paint a group figure picture!*

Fixative is the mixture of various ingredients that is used to break up and bind the granules of pastel together and keep them from falling or blowing away from the surface. Because this process tends to rob the painting of some of its freshness and natural appearance, fixative has been used after the completion of the painting, although this procedure has been hotly debated. However, fixative can also be effectively employed during the process of painting and is, therefore, a valuable tool in pastel painting.

Degas was one of the first to use pastel fixative imaginatively. He managed to inveigle an Italian named Chialiva to concoct a special blend for him, and Degas guarded this so zealously that it died with him. Since then artists and chemists have proposed various formulas, each of which lacks some quality that makes it ideal.

Nevertheless, any artist who considers pastel must sooner or later decide how he or she will use fixative both in the final and in the intermediary stages of the painting. To help you in this decision, I'll offer all the pros and cons that I know and leave the final determination to your own good judgment.

Bottled, Aerosol, or Homemade?

Pastel fixative comes in three forms—bottled for you to blow through an atomizer, in an aerosol can to spray (which I don't recommend), and of your own manufacture—which can be applied in a variety of ways.

Which is best? No contest; the last wins by a mile. The aerosol fixative can be most damaging to your painting—as well as the environment—and in most instances, is much too powerful for the job. The delicate pastel particles are literally bombed into submission by the blast of aerosol spray. The only possible advantage of aerosol is

that it's easy to use, which in light of other far-reaching effects is easily outweighed. The bottled fixative, whose force of discharge you control with your own breath, is much less damaging both to you and your painting. It's suited for pastel, both in the intermediary and in the final stages. However, when matching the bottled, manufactured fixative against the homemade, the homemade still wins easily. The reason is that even the bottled, readymade fixative is much stronger than the weak solution you can concoct on your own.

The next question—which formula is best? The choice is large since each expert has a formula of his own preference. I've found that when I'm unsure of my ground, the wisest course is to turn to a reliable expert. Ralph Mayer, Max Doerner, Robert Massey, and Hilaire Hiler (see Bibliography) have demonstrated their expertise in the chemistry of art. Although I don't feel I can put my seal of approval on any particular fixative, I suggest you try their formulas. I use one of their concoctions myself with about as satisfactory results as one might expect from a product which, I reiterate, is at best far from perfect. But if you use a fixative in your pastel painting, by all means use one of homemade formulation.

Preparing Your Own Grounds

When preparing your own grounds, one of the means of affixing granular materials to the surface is with fixative. Under these circumstances an aerosol fixative will do just as well as the others since its adhesive power is the only factor that's important. It can be sprayed on as heavily as one chooses, depending upon the amount and the size of the granular substance used.

The Intermediary Stages

Fixative isolates a coat of pastel and allows the application of subsequent coats, a process that can be continued almost *ad infinitum*. Working in mixed media is facilitated by fixative also, as it allows a different medium to be laid over each coat. When the surface has grown too slick or is unsympathetic to further application, fixative provides a fresh surface. Fixative can also selectively darken an area or be used to obtain an exceptionally dark, light, or bright tone by repeated spraying and overpainting until a *depth of* color is achieved. For an unusual effect, it can be sprayed heavily over the surface and worked into the wet areas with the pastel sticks. The color can then be manipulated with a stiff bristle brush.

Dipping the Sticks

Most interesting results can be obtained by dipping a pastel crayon in fixative and painting almost as if it were a liquid medium. This results in a painterly effect similar to washes laid in watercolor. The plasticity of the strokes is quite unlike the traditional chalky, dry look one expects of pastel and is closer to the effects obtained from oil pastels, wax crayons, or the greasy crayons associated with such masters as Fragonard, Greuze, Ingres, and Lautrec. Degas used this as one means of expanding the use of pastel. It's certainly a process worth trying.

Correcting

Fixative can be used to restore the surface after one has erased or scraped away an offensive area. Although I will discuss the actual methods of erasure later, I do want to mention that fibrous surface that has been erased is usually too slick to be reworked and can be brought up to par with a generous dose of fixative. On a granular surface, after the error has been scraped away with a razor (you can't erase a granular ground) fixative can be used to build a new surface by spraying it, then sprinkling in the granular substance and repeating the process until a fresh surface is obtained.

Final Fixing

Here's where I stop making recommendations and toss the ball to you so that the final decision becomes your province entirely. Whether or not

Male Figure *by John Foote, pastel on paper, 10½" × 8½" (Collection Dr. Leland A. Croghan). For all its apparent sweep, this is a very small painting that fools the eye due to the precision of its proportions and the care paid to anatomical veracity. To obtain the light textural effect on the buttock, Foote used sugar-substitute granules (instead of the conventional sand, marbledust, or pumice) for their small structure and transparency, which lends the area a special brilliance and luminosity. It's this kind of potential for innovation that lends pastel its special aspect and individuality, unmatched by other more constrained and conventional media.*

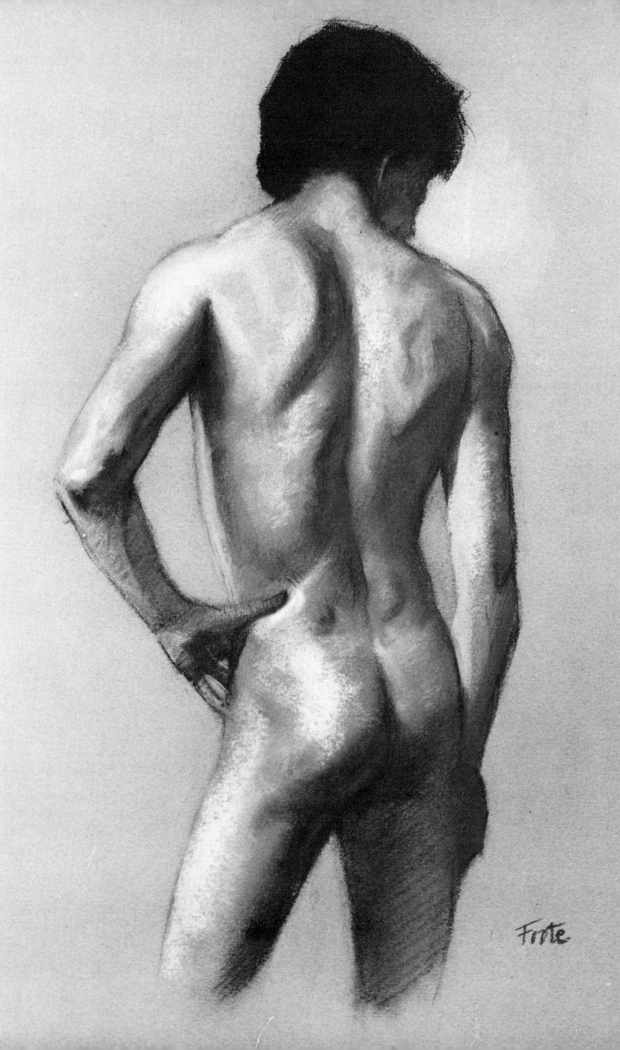

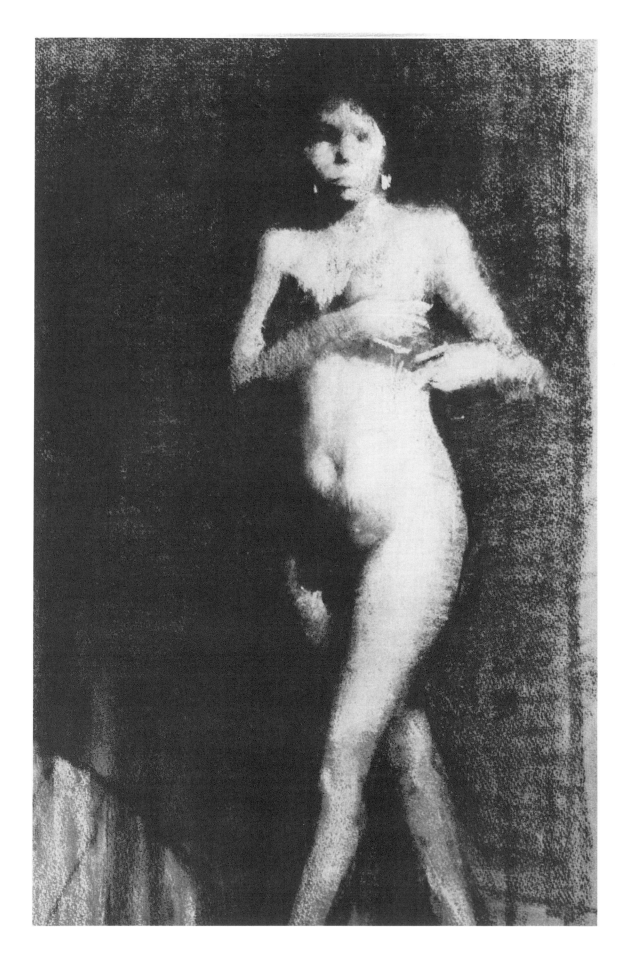

to fix a pastel painting upon its completion is a subject of such controversy that I've elected to play the coward and duck it altogether. The arguments pro and con have been postulated so often that anyone who has ever picked up a stick of pastel cannot help but have heard them all. You'll be damned if you do and damned if you don't, so my advice is to weigh all the consequences and decide for yourself.

However, to sum up very briefly, here are the most basic considerations to help guide your decision: *not fixing* may cause the pastel to fall from the surface and to smudge if handled carelessly; *fixing* may alter the appearance of the painting and spoil all the effort you've put into it. Fixing may cause the painting to become darker, cause the pastel to swim together and lose the chalky effect. So if you do decide to fix, for heaven's sake do so sparingly! Too much fixative on the finished pastel is a deathblow—sure to kill every trace of life and spirit in it.

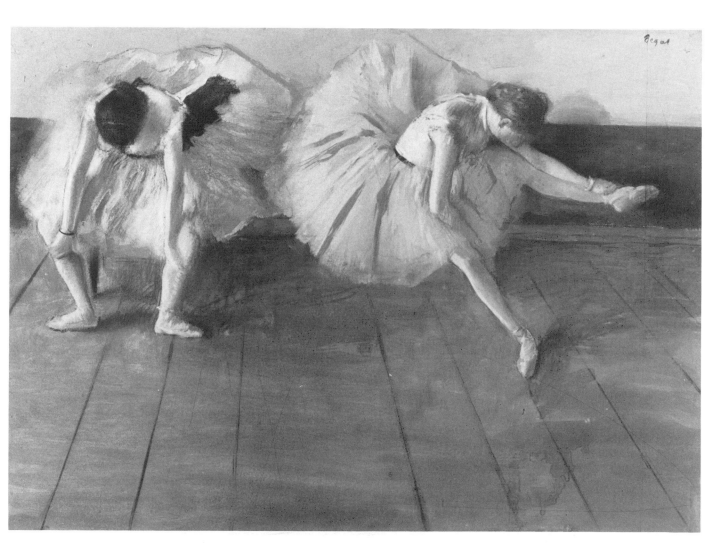

Stripper (*Left*) *by Burt Silverman, pastel on paper, 22" × 16". The contrast of lights and darks caused by a strong stage spotlight is vitiated by the extremely soft handling of edges throughout. Think how garish this picture would look if the edges were hard and the detail explicit. Silverman understands how to wed elements in a painting for best total effect. Losing the shadows of the figure into the background lends an element of brilliant reality to the sleazy atmosphere.*

Two Ballet Girls (*Above*) *by Edgar Degas, pastel, 18-1/8" × 26-1/4" (Courtesy Shelburne Museum, Inc.). Like two brilliant butterflies pinned to the page, the exhausted dancers stretch their tortured limbs to gain even more function from organs constrained by physical limitation. Has fatigue ever been better portrayed than in the girl on the left? Bone-weary but resigned, she waits for her energy to flow back so she can resume the endless practice.*

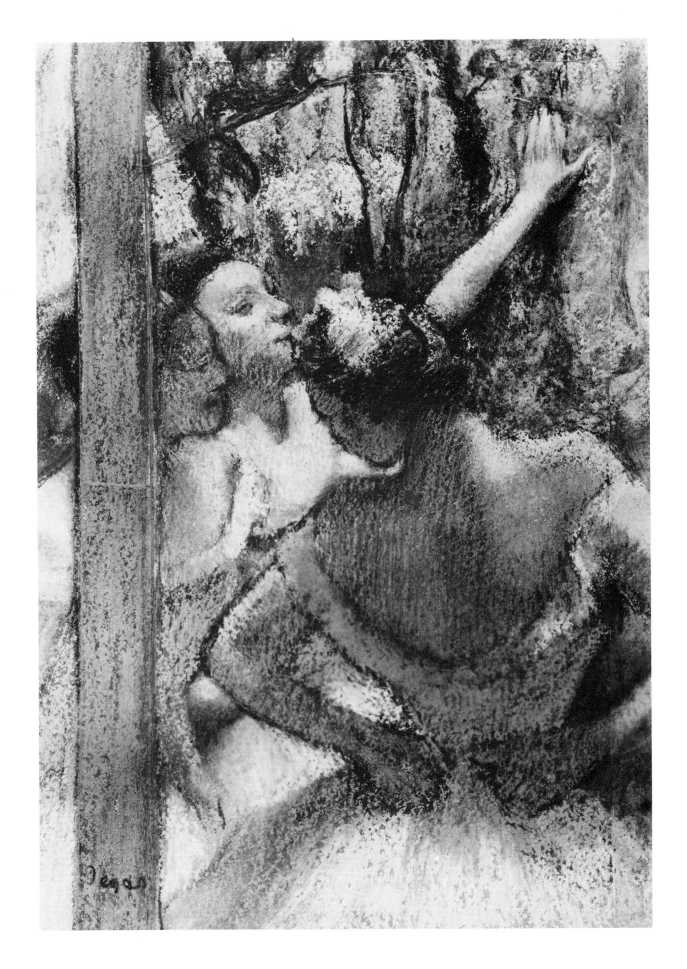

Tools and Equipment

Ballet Girls by Edgar Degas, pastel, 21-3/4" × 16-3/16" (Courtesy Cleveland Museum of Art, Gift of Mr. and Mrs. J. H. Wade, 1916). In order to achieve such depth of pastel layers, Degas fixed, refixed, and fixed again. Although his personal recipe for fixative died with him, he pioneered a bold and imaginative use of the medium. Fixative adds a separate dimension to pastel painting. It allows repeated reworking and opens new areas of applying color and impasto. Although I now favor the alla prima method of working, I've fooled around extensively with fixative and I advise you most vehemently to do the same.

Besides colors, grounds, and fixative, you'll need additional materials for painting the figure such as easels, support boards, aqueous mediums, furniture, and other miscellaneous equipment.

Easels

You'll need an easel to hold your painting surface firmly in place while you're busy creating. Like most items, the best are usually the most expensive, but considering that a good easel may serve you for a lifetime, this is no place to settle for anything less. Look over the advertisements in the catalogs of the leading manufacturers and pick out an easel that best suits your purposes and pocketbook. If it rolls up and down easily, tilts forward and backward, has casters, and seems sturdy—so much the better. You should be forewarned that good easels in today's market can run as high as $300 or more.

You might also consider investing in an additional easel that can be easily transported outdoors or to another locale. The best of these is the so-called French easel that folds into a neat package for easy carrying. This is a rather costly item but well worth the expense since it will perform its function admirably and save you the bother of dragging some unwieldy monstrosity through subway, elevator, or meadow.

Support Boards

A firm support board is a vital factor in pastel painting, particularly if you work on paper. An unmounted sheet of paper needs several allies to lean on, including a solid and rugged support board. Remember that you must never paint on a sheet of paper without cushioning it first with five or six other sheets to provide the necessary give, bounce, and springiness; also to avoid pick-

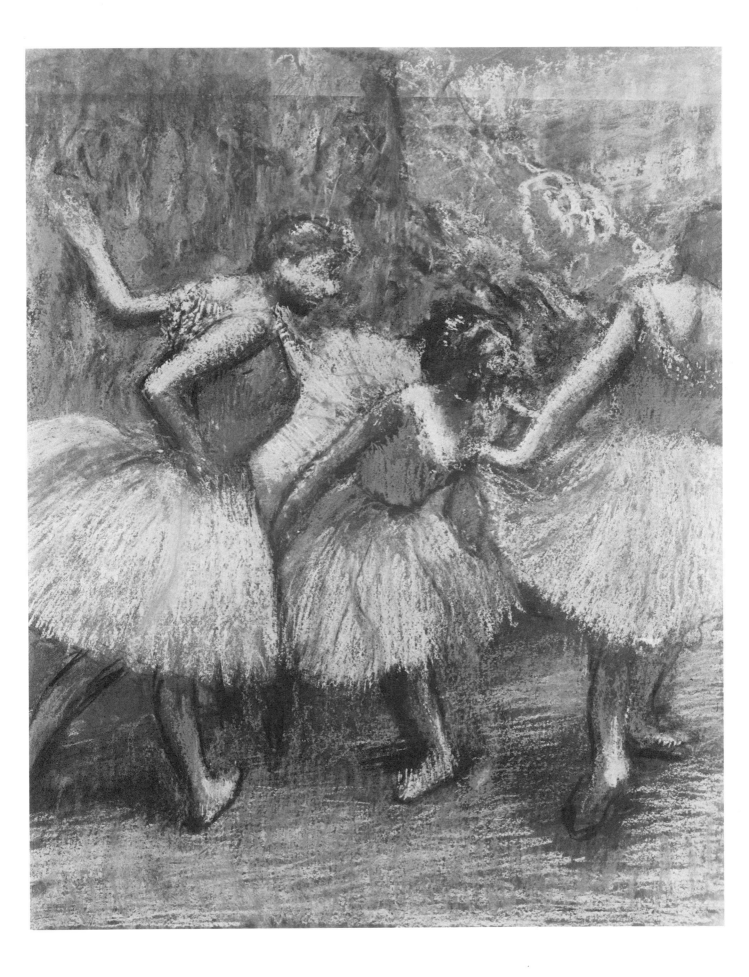

ing up the marks of any texture from underlying surfaces.

Having padded the paper properly with the other sheets, you then attach it with clips or tacks to a rigid backing or the support board. This can be a heavy cardboard, a sheet of plywood, Masonite, plastic, metal, or any of the compressed woods. It should possess strength for the firmness it must provide and smoothness so that it doesn't inject any of its texture into the painting surface. It should also be light enough to handle comfortably. As for its size, it should be large enough to accommodate the biggest sheets you contemplate using. Often times it's more convenient to have support boards of various sizes that will fit whatever size pictures you may paint. I use a support board for added stability even when painting on boards.

Furniture

If you prefer to work sitting down you'll need a stool or chair (preferably without arms) that won't inhibit your movements, that can swivel from side to side, and that adjusts in height. This way, you can find a comfortable compromise level between the box of colors and the painting surface.

If painting from life, you'll also need chairs and stools in different shapes and sizes for your models since you might want to incorporate these into your pictures. The greater your collection, the better your chances to achieve variety in your work. Some painters collect sofas, couches, and divans to accommodate various lying and reclining poses.

Worktables or taborets are needed to hold the trays or boxes of colors and other sundry materials used for painting. Any kind of worktable will

Dancers by Edgar Degas, pastel, 37-1/4" × 31-3/4" (Courtesy Modern Museum of Art, Gift Mr. William S. Paley). Another example of very heavily applied pastel. In these late examples of his work, Degas had already explored every facet of pastel and had bent it to his will to produce any effect he chose. In this exquisite painting he used fixative extensively to build the thick impasto. He may have abetted this by also using steam or brushes to move the colors about and produce oil-like brushstrokes. The result is one of vibrating tension as the colors throb and pulsate one over another. If you're inclined to fuss about detail, study these dancers' faces. . . .

suffice as long as it does the job, however an arrangement that can be raised and lowered is preferable in case you decide to switch from a sitting to a standing position or vice versa and want your tools handy. For this reason, many artists use an adjustable-height drawing table with a large top over it to hold the required items. Additional worktables or cabinets can be used to store spare equipment.

A modeling stand is a flat platform usually set on wheels or casters that brings the model approximately eye-level with the painter. The stand may be built a foot or so high and can be any size. If the artist plans to paint reclining poses, he or she will naturally require a larger model stand. If model stands are sold readymade this is a fact that has escaped my attention. Most artists I know either build them themselves or have them built to their specifications. Model stands also come in handy as general worktables for various studio tasks such as hammering, sawing, etc.

Most artists find a mirror handy in their studios. A mirror has many uses: it allows you to see the subject from another angle; it's vital for self-portraits; it keeps the model from getting bored by allowing him or her to watch the progress of the painting; it doubles the visual distance from artist to object in a small studio; and it permits the artist to bounce reflected light on the subject. Many artists mount the mirror on an easel with casters and roll it to wherever they want it.

Mediums for Toning Grounds

To tone your grounds you'll need an aqueous medium. My preference is casein, but acrylic, gouache, or watercolor will do as well. My advice is that you buy eight tubes or jars of relatively subdued colors such as Indian red, raw sienna, raw ochre, cobalt blue, chromium oxide green, raw umber, black, and white. Then mix up a batch of the color you want to use as your tone from this collection.

The bright, garish colors such as the cadmiums, phthalocyanines, violets, alizarins, ultramarines, lemon yellows, and permanent greens are less advisable for toning since they tend to overpower the painting. However if you intend to work in mixed media, you'll need a full complement of colors in your favorite medium. If you want these colors to remain permanent, buy

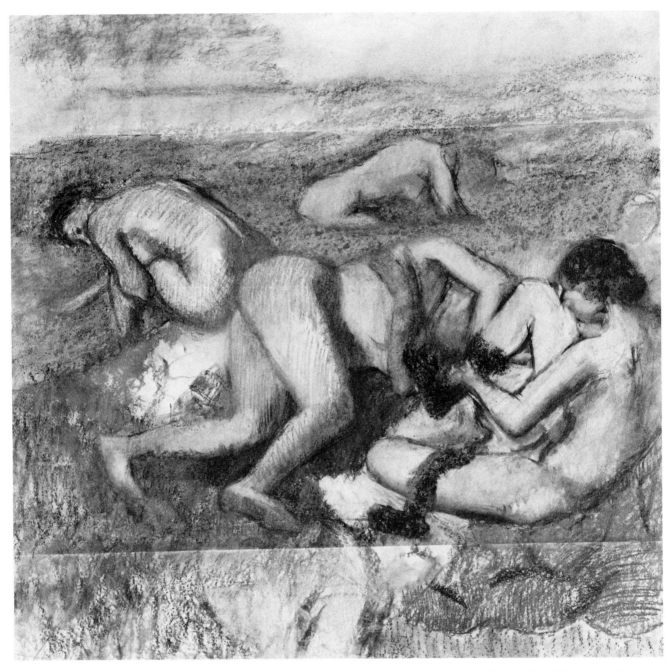

The Bathers (*Above*) *by Edgar Degas, pastel on paper, 44⅝" × 45½" (Courtesy The Art Institute of Chicago, Gift of Mr. Nathan Cummings). Because in his day papers came in smaller sizes only, Degas was forced to glue sheets together on top and on bottom, as he has here, when he wanted to execute a large composition. But nothing daunted the old fellow when he was bent on a task, a quality the young pastelist might well keep in mind. In preparing your own surfaces, let no obstacle stand in your way. Even if it means destroying your mother's wallpaper in the process, consider what takes precedence. Suppose Degas had been too timid and not painted this masterpiece for fear of censure?*

Dancers Coming on Stage (*Right*) *by Edgar Degas, pastel (Courtesy Cincinnati Art Museum, Bequest of Mary Hanna). Here, Degas uses pastel more conventionally, without resorting to his large bag of tricks to build up or otherwise radically alter the character of the medium. He did quite a bit of rubbing-in in the skirts and only employed some clever manipulation in executing the stage flats. By squinting, you get insight into the manner in which the darks are used in calculated fashion to create an abstract design to which the subject matter is strictly subordinate. To Degas, the ballet was merely an excuse to create intriguing patterns. The dance itself was of no interest to him.*

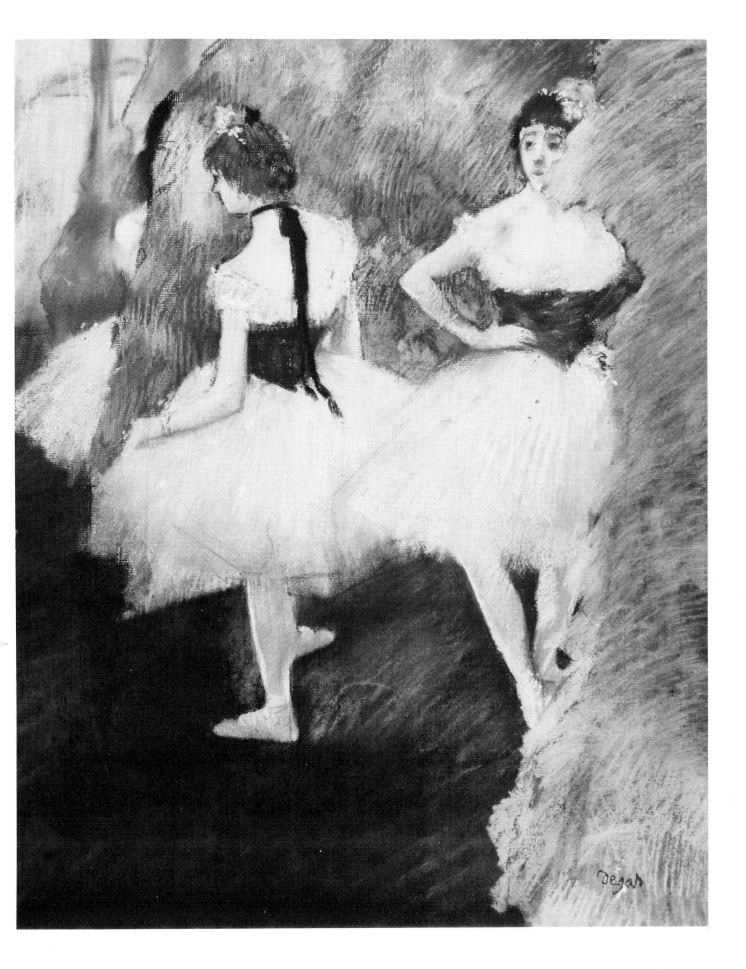

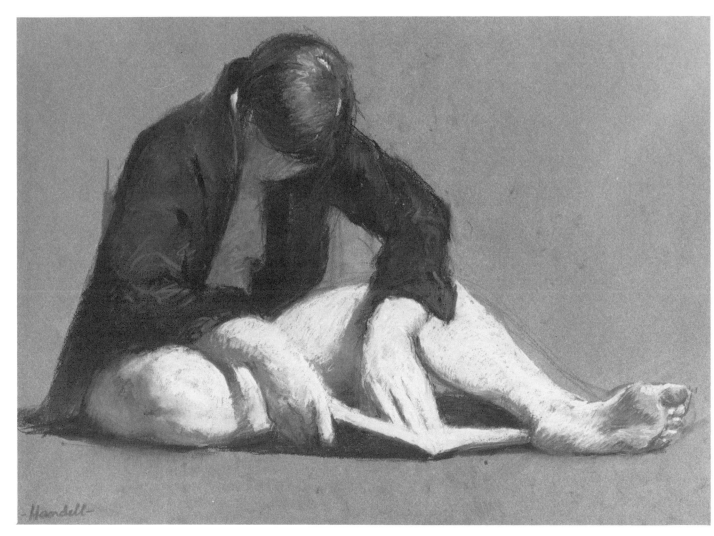

Reading *by Albert Handell, mixed media on sanded board (Private Collection). This is a study in pure light, halftone, and dark. Note the extreme treatment of a face that completely lacks all features. This kind of massing by value and disregard of anatomical detail reduces the figure to an object. It might as well be a vase, a bowl, or a set of blocks—it's merely an effort to show the effect of light striking the form. Yet there's no mistaking the subject nor the action in which it is engaged.*

the professional rather than the so-called student-grade paints.

Miscellaneous Equipment

In addition to the aforementioned materials, you might need the following items:

1. *Materials for Grounds.* For preparing your own surfaces you'll need gesso, casein, and granular material such as sand, silica, pumice, marbledust, glass, etc. You'll also need some kind of adhesive, whether readymade or homemade. The Yellow Pages or the *Product Directory* published by *American Artist* magazine will help in tracking down these items.

2. *Materials for Toning Grounds.* For merely *toning* grounds you'll need a 2" brush. The kind sold to housepainters in hardware stores should be adequate since it's merely a matter of covering an area. However, if you intend to *paint* extensively in the aqueous medium before switching to pastel, you'll need regular artist's brushes designed for whatever medium you intend to pursue. You may also want to consider using sponges to lay in the tones.

3. *Materials for Homemade Pastels.* Although I haven't gone into the aspect of homemade pastels in this book, I refer those interested in this process to Mr. Mayer's books (see Bibliography), where the materials and their sources are covered.

4. *Fixatives.* Solutions for homemade fixatives can be bought in the larger art supply stores, in some drugstores, and in chemical supply houses. Manufactured fixatives in spray or bottle form are available in most art supply stores, as are atomizers and blowers.

5. *Boards and Frames.* Illustration boards for making your own surfaces, naturally, are sold in art supply stores. Masonite, plywood, and other wood fiber and composition boards are sold in lumberyards by the sheet. If you intend to do your own framing, you'll need matboards, frames, rulers, tacks, wires, matcutters or knives, saws, hammers, pliers, sandpaper, and other items such as glass and possibly a glasscutter, cardboard for backing, masking tape, thumbtacks, etc.

6. *Canvas and Stretchers.* If you propose to paint on canvas you'll need a roll of pastel canvas, stretchers, keys, possibly a staple gun, a canvas stretcher, tacks, etc.

Other items you might need are charcoal (soft, hard, compressed, or pencils), razor blades, clips to keep the paper or board firmly fixed to the support board, stumps (tortillons) for blending the pastel, acetate sheets to place between the finished pastel paintings until they're ready for framing, kneaded erasers, tracing paper, and bowls for mixing tones or keeping other solutions in. I'm sure the list can be expanded depending upon an individual's preferences.

I suggest you improvise as much as possible and adapt what you have to suit your needs. This is beneficial both from the financial and the esthetic standpoints since you just might make some revolutionary discoveries concerning pastel simply through monkeying around. After all, that loafer Newton had to be hit on the head with an apple to come up with his startling theory of relativity, and Degas probably backed into a pot of boiling water when he came up with his brilliant concept of mixing live steam with pastel.

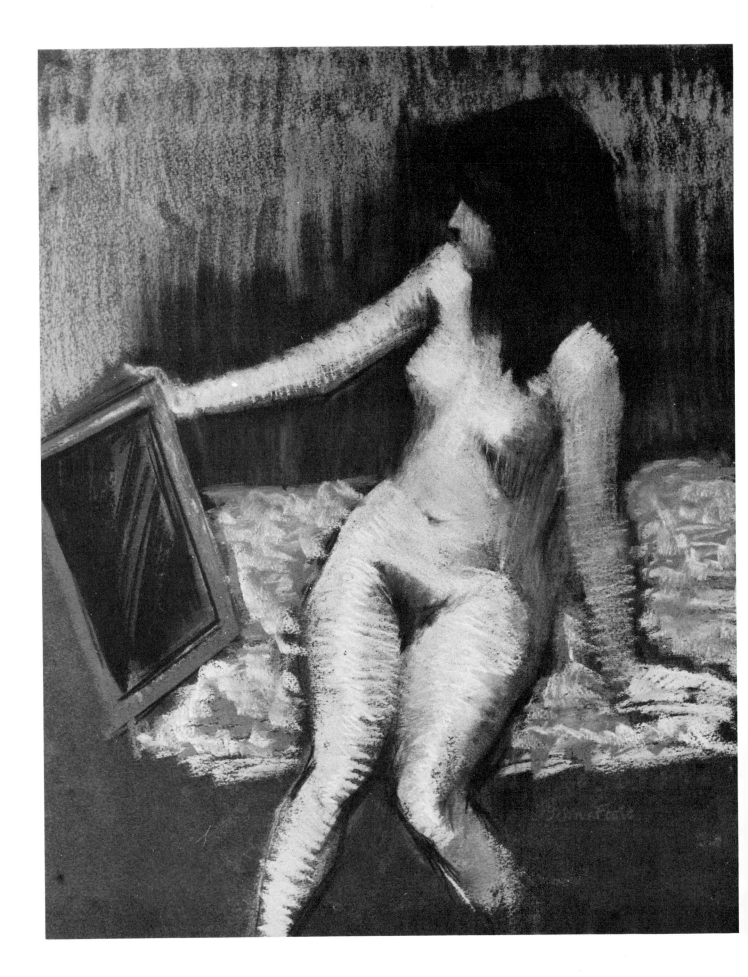

CHAPTER SIX

Your Palette of Colors

One of the most important decisions affecting your painting in any medium is the selection of the colors you choose for your palette—which in this context means the actual total of colors you elect to work with. In pastel, where a stick covers only a small area at a time, the total number of colors is necessarily larger. However, as I grow longer in the tooth I note that actually far fewer pastels are needed than many "experts" seem to think. This realization is based on the fact that the differences between the numerous shades offered by manufacturers are often minute. Instead of gathering the thousands of crayons recommended, there is a better way.

Choosing the Colors

To a beginning pastelist the decision as to which sets or individual sticks to buy can be a most frustrating and unnerving experience. The choice is so vast—there are sets running into 600 or more colors—that the beginner may chuck the whole thing and switch to a medium where twelve colors will do. To add to this confusion, various authorities offer conflicting advice. Most of them dodge the question altogether while others urge the beginner to acquire every color in every set he or she can find. To solve this quandary, I now say: learn to make do with as few sticks as possible.

In my previous book, *How to Paint Portraits in Pastel,* I advised the reader to get along with 128 colors. This decision was arrived at by selecting 18 basic colors and buying each in its full range of light to dark tones (7 for each color), plus white and black—totaling 128. This is a nice, tidy assortment that's hardly extensive, but after some deep contemplation I've come to the conclusion that it can be even further reduced. I must emphasize that this is merely an alternative, and that

Female Model with Mirror *by John Foote, pastel on paper, 16" × 12" (Collection Stephen Feeser). Here is a good example of how a studio prop can come in handy in composing a painting. Note how Foote uses horizontal strokes in the arms, right leg, and left thigh and vertical ones along the model's left side to open up the shadow area and give an indication of reflected light. Varying the strokes this way to make them run with or counter to the form helps lend verve and interest to a painting and avoids the tedious repetition of the purely academic approach. Note, too, the variety of strokes in the body, background, and the seating area—each is distinctly different.*

working with the 128 pastels is still my recommendation. However, if you're the adventurous type I suggest you trim even more fat and cut to the very bone—whether you paint heads or full figures.

My original palette of basic colors included:

Reds—cadmium red light, permanent red, flesh ochre, burnt sienna

Yellows—lemon yellow, cadmium deep, yellow ochre

Blues—cobalt blue, ultramarine blue

Greens—viridian, olive green, moss green

Browns—raw umber, burnt umber, caput mortuum

Grays—blue violet, mouse gray, gray blue

Black and *White*

This system is based on selecting only permanent colors (further on in this chapter we'll discuss permanence) and those lying on the cool and warm spectrum of each hue. My *alternative* suggestion is that instead of buying all 7 shades of each of these basic 18 colors, get the pure color tint and its lightest and darkest shades only—but no other in-between shades. This comes to 54 sticks plus black and white for a total of 56—a compact assortment and one that will do very nicely indeed. Why this drastic revision? Because I've since found it more challenging and rewarding to work with this limited palette, and I hope to pass my findings along to you in case you, too, wish to experiment.

Why Fewer Colors?

The two biggest pastel manufacturers—Grumbacher and Rembrandt—grade pastels in a similar way. In most instances, each makes a basic color in 7 nuances, running from lightest to darkest by adding more white or black pigment to the full-strength pigment (or combination of pigments). Thus, a full-strength color in the Rembrandt line is marked (using cadmium red light, for example) 303,5. The last numeral—5—stands for pure tint. This color has two darker shades marked 303,4 and 303,3. The 303,4 is the blend with 20% less pure tint and 20% more black substituted, while 303,3 is 40% less pure tint and 40% more black tint, making it the darkest cad-

mium red light available in the Rembrandt line. Going the other (lighter) way, Rembrandt produces 303,6 (20% white added and 20% pure tint removed), 303,7 (40% white), 303,8 (60% white), and 303,9 (80% white)—which is the lightest (but not the brightest, since 5 would be the *purest* and therefore the *brightest*) cadmium red light offered by Rembrandt.

Grumbacher offers a similar system. It, too, offers each color in its pure tint, designated—in the case of cadmium red light—17D. The two darker versions are 17C and 17A, respectively. The lighter versions are marked 17F, 17H, 17K, respectively, with 17M the lightest red cadmium light in the line.

Now, since lightening and darkening the pure tint is accomplished by simply adding white or black, why bother to have the manufacturer do this grading for you when you can do it yourself? You can do it yourself by putting down a stroke of, let's say, *pure* cadmium red light. You want it lighter? Run some white or other light color over it. You want it darker? Run some black or other dark over it. In other words, do the grading yourself right on the painting surface!

This sounds extraordinarily simple, and it is! In other words in addition to the pure color tint, I now suggest you buy only 2 additional shades of the color—one lighter and one darker—instead of a complement of 6. So, using cadmium red light as an example, I suggest that you get the pure tint—303,5—in the Rembrandt line and augment it with 303,3 (the darkest shade) and 303,9 (the lightest shade). In the Grumbacher line, this would mean 17D, plus 17A (the darkest) and 17M (the lightest). Possibly in a few years I'll be advising students to paint only in pure tints with no in-between shades at all!

With these 56 colors there's no reason you can't paint masterpieces in pastel. However, as I'll reiterate throughout this narrative, both my recommended palettes constitute a *suggested* list. If you feel more comfortable with 100, 500, or even 1,000 pastels—rush out and get them! My concern is to try and help you paint a decent figure, not to prescribe how to arrive at this goal.

My rather lengthy investigation into Degas' methods leads me to believe that in many of his figure studies he used no more than a dozen sticks of pastel. This merely confirms my tendency to keep scaling down the size of my palette. However, I may be completely wrong in

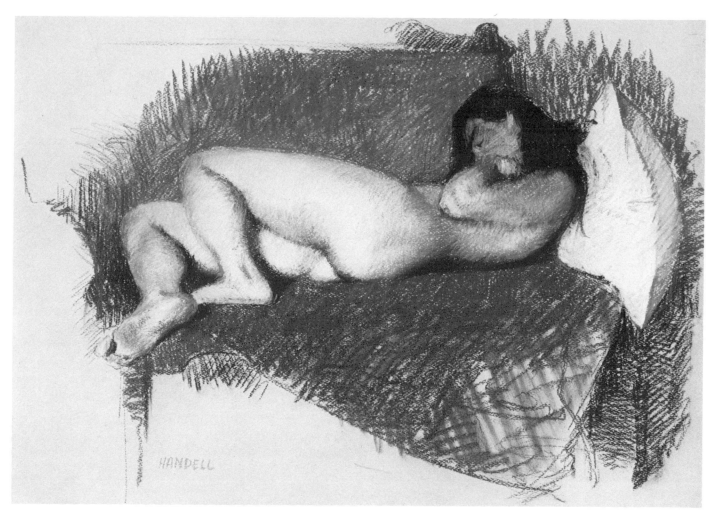

Asleep *by Albert Handell, pastel on board (Private Collection). The light on the thighs quickly draws our attention to that area. Arranging a figure so certain parts receive more light than others is an instant attention-getting device. The reason for its use here is that the upper body is comparatively stable and the artist sought to focus his (and your) interest on the bend of the legs at the knees. Note the simple, almost indifferent treatment of the face—actually, it's deliberately done so. But the effect of the sleeping pose is absolutely correct. Note, too, the extreme foreshortening of the arm. You have to know your anatomy well to attempt this.*

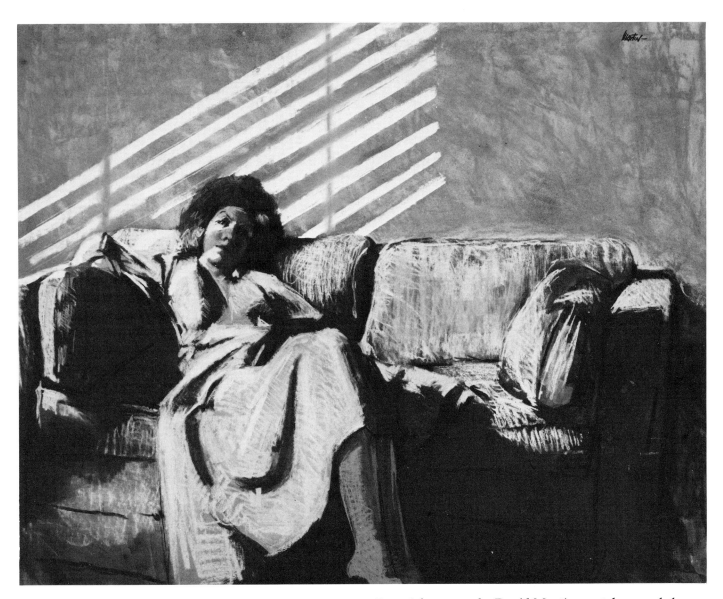

Late Afternoon *by David Martin, pastel on sanded paper, 21" × 27" (Courtesy Desmond/Weiss Galleries). This is a daring attempt to capture the effect of light from an open blind as it sweeps across the figure. Martin tried to show not only the physical but also the emotional aspects of late afternoon when the spirit usually begins to flag as the day (symbolically, life itself) begins to draw to a close. In purely practical terms, it was handy to have the couch on which to pose the model. A chair wouldn't have served the composition as well. Do try to acquire as many such props as possible in order to broaden future painting possibilities.*

my estimation and I don't want to impose my admittedly biased restrictions upon you. I strongly advise, however, that you make do with as few pastels as you need—which in itself can run from 6 sticks to 600.

Permanence of Soft and Hard Pastels

Since the bulk of pastel painting is traditionally performed with soft pastels, the palette of colors recommended before refers only to this grade. Rembrandt and Grumbacher list the permanence of their soft pastels; however the makers of hard pastels fail to do so and the artist is left to his own devices.

Hard pastels (this includes semihard as well) are another kettle of fish. They're used by some pastelists merely for final accents, by others in the beginning stages of the painting only, and by still others as the major components of the painting. Each of these three practices is acceptable as long as the crayons are selected from among permanent colors. The only safe course is to buy only those pastels that carry the name of some acceptable, permanent pigment and to skip those with such exotic labels as Orchid this or Pistachio that. Consult the lists put out by the major pastel manufacturers, such as Grumbacher, for specific information on permanence.

My advice is to buy semihard and hard pastels individually rather than in sets (when this is possible) and to select a couple dozen of the seemingly permanent kind. Hard pastels don't come in tints and are made in futl-strength color only.

Permanence of Your Finished Pastel Painting

How permanent is pastel? If the colors, grounds, and methods of framing are properly prepared and executed, pastel is one of the most permanent mediums. Samples from the sixteenth century are as fresh today as the day they were painted. However, these were done from materials prepared by the artists themselves. Today, the artist must place his trust in others to assure the permanence of his work. The major manufacturers swear on stacks of catalogs that they produce art products of unimpeachable quality, and one can choose either to believe or disbelieve. Be that as it may, one can only select those pastels and surfaces marked "absolutely, positively perma-

nent" and hope that one's grandchildren won't be left with blank sheets of paper that had once held masterpieces.

Keeping and Laying Out Your Pastels

Painting in pastel requires a measure of organization or the colors will lie helter-skelter on your table. What you must do is establish a system—any system will do—that will allow you to concentrate on painting rather than searching for colors.

Now, there are as many ways of keeping pastels as there are pastelists. Being somewhat lax about my own artistic housekeeping, I was relieved to find one distinguished painter with a tabletop of colors lying in wild confusion. This confirmed my suspicions that many artists have little concern for neatness—they reserve their discipline for where it counts—the picture itself. Still, for one just beginning it's eminently better to keep things in order until the mantle of genius settles around one's shoulders. So, do devote time to laying out your pastels in some kind of sequence or gradation. There are several ways of doing this. Here are a few:

1. Keep every stick in its own slot in the tray.

2. Separate the colors by hue—reds in one box, blues in another, etc.

3. Separate the colors by temperature—cool colors on one side, warm on the other.

4. Separate the colors by hue *and* temperature—cool blues, cool reds, cool yellows on one side; warm blues, warm reds, etc., on the other.

5. Separate the colors by value—dark colors here, middletone there, light yonder.

6. Separate the colors by hue, temperature, and value.

7. Separate colors by their hardness and softness.

As you can see, there are many ways to tackle this problem, so devise a system to meet your particular needs. If you adopt the limited palette I recommend, this should be an easy task; but if you go into an extensive assortment, you'll have to exercise care to see that every color is easy to locate. An arbitrary hunt-and-peck method will slow you down and cause no end of frustration.

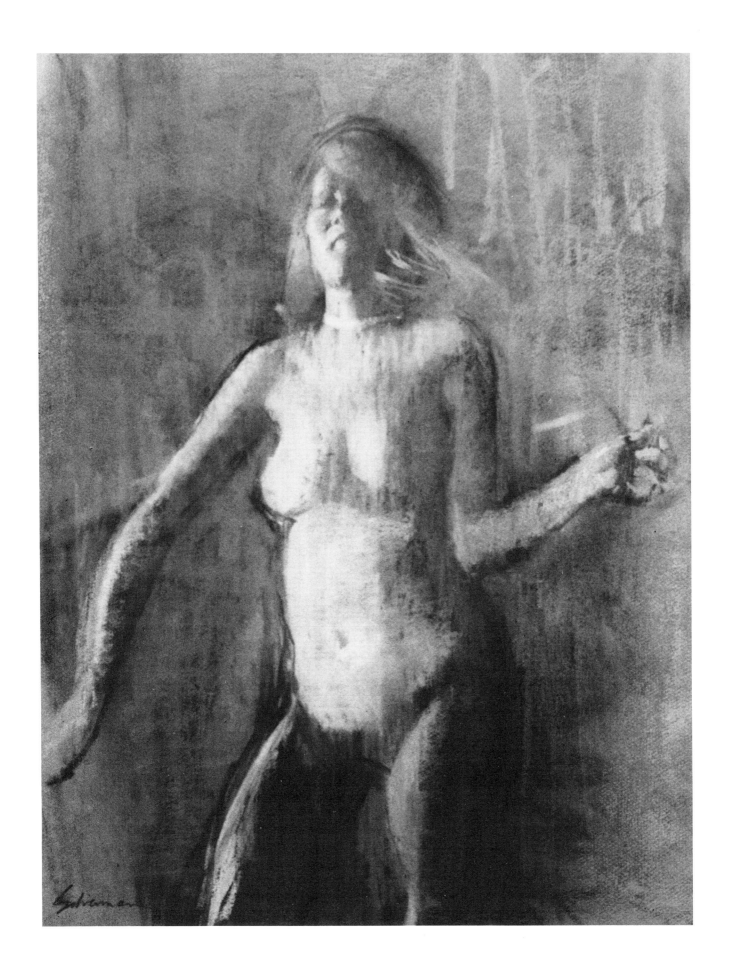

Incidentally, cigar boxes are an excellent way to keep your pastels separated into appropriate categories.

Avoiding Waste

Pastels, particularly the soft kind, break and crumble (and usually at the most inopportune time). This should cause the pastelist little concern since painting with pastel can be done with the tip, the edge (with a square-shaped stick), and the side of the crayon, and so a broken stick constitutes no tragedy—it can be manipulated until it goes up into a mist. But even if a stick crumbles into little pieces it can still serve a useful purpose. Some artists use these crumbs for backgrounds and other flat areas. Others squeeze the crumbs together regardless of color and form a kind of neutral stick for gray areas. If pressure alone won't coagulate the mass, several drops of water, fixative, or binder might get it to stick long enough to transfer the mass to the surface.

Replenishing Your Stock

Never, never wait till the last moment to replenish your stock of colors. Always keep in reserve at least two dozen of each color you use, since there's nothing more frustrating than running out of a color in the midst of a painting session, especially when working from a model. If anything will tighten you up and render your work timid, fussy, and vapid it's the horrible knowledge that you're quickly abrading your last piece of raw umber while the model is hanging from a trapeze by one toe at $4.50 an hour.

In time, you'll see in which areas the gaps are forming fastest and you'll compensate for these shortages by purchasing more of the most frequently used colors. Certainly you'll want to stock up heavily on white, which will probably be used the most. Once you've established your palette, go out and buy as many of each color as you can afford then put them aside. Pastels don't spoil on the shelf and remain usable practically forever.

Topless Dancer *by Burt Silverman, pastel on paper, 22" × 16". It's curious to note how much can be accomplished with merely a few strokes of pastel. Observe the young woman's expression as she performs her gyrations. Isn't it just the right one to arouse her audience? Try covering her face and see how much of the impact is lost. For all that, the work is very loose and sketchy, though cleverly executed. See how the artist produced the effect of flying hair with just a few well-placed lines. The total effect is absolutely perfect and more admirable for its extreme simplicity and economy of effort.*

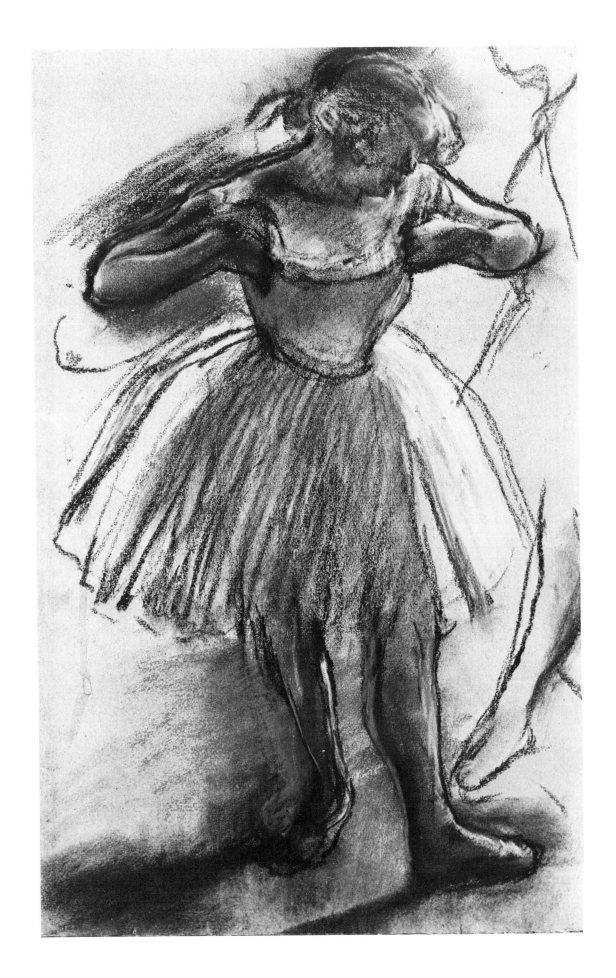

Color in Figure Painting

When contemplating color in figure painting, one automatically thinks of skin color since figure painting is generally associated with the nude. However, one must also consider not only the color of the figure itself, but the color of the figure in relation to the colors of the background. So actually, the color of the figure is a product of both its own *local* hue and the colors of surrounding or reflecting objects. One will often hear that a figure must represent a warm, bright area of color set against a darker area of cooler color; however such arbitrary laws should be disposed of. It can easily happen that the figure is darker than the background either in value or in hue—since flesh tones can range from ivory to purplish black with dozens upon dozens of warm and cool hues in-between.

The Figure in Relation to the Background

Color in figure painting can be broken into two categories: the first category represents the figure as a light area against a dark background and the second represents the figure as a dark area against a lighter background. Both categories have as much to do with value as with hue, since they are nearly inseparable in full chromatic painting. Even though the actual background may be *brighter* in hue than the figure itself, we wouldn't be interested in painting it this way, since we want to make the figure the area of prime interest. Therefore, we should see to it that the figure (whether light against dark or vice versa) receives the brightest colors in the painting. This doesn't mean that you couldn't successfully paint a cool figure against a warmer background. It does mean that the background (whether warm or cool) should be more neutral and less bright (rich in color) than the figure.

Standing Dancer *by Edgar Degas, pastel, 18" × 11-1/4" (Courtesy Museum of Art, Rhode Island School of Design). This is a purely drawn pastel in which painting is absent, or nearly so. Hard pastel can be used to good effect in this kind of effort. It's somewhat sturdier than soft pastel and easier to use in such linear fashion. Line is very important here and tone much less so—a few smudges are merely included to indicate the presence of masses. Note the casual overall treatment and the repetition of lines. Degas wasn't afraid to go over a line if the one beneath didn't seem just right. He even had the audacity to leave the incorrect ones in and show he was only human and capable of mistakes.*

Thus, while we can paint a figure light against dark and vice versa and cool against warm and vice versa, we should paint it bright against a dull background. Otherwise, it would essentially be less a figure painting and more an interior or landscape. Chroma, or brightness of color, is one of the four designations of color in painting, the three others being value (degree of lightness or darkness), hue (actual color—yellow, red, blue, etc.), and temperature (warmth or coolness).

I do hope all this is clear. It's an important aspect of figure painting, whether nude or otherwise. It's perfectly all right to paint men in gray suits walking along a garish neon-lit street, but this isn't figure painting in the pure sense of the word. To me, figure painting means a picture in which the figure or figures predominate. Otherwise, it either falls into another category of painting or is unsuccessful figure painting.

Warm and Cool Color

Color, as we have just learned, is bright or dull, light or dark, of a certain hue, and warm or cool. The first three designations are self-explanatory; however the last merits further discussion. Color temperature is not an easily explainable factor. Merely stating that colors such as red, yellow, and orange are warm, and blue, violet, and green are cool, is an oversimplification, since contrast and reflection play vital parts in making this determination. The question I always pose in response to such arbitrary classification is—cool (or warm) next to what? Although there's a general tendency for red, orange, and yellow to generate a warm emotion, this is too broad a statement to include all reds, oranges, and yellows under all circumstances. The sun might well evoke a sensation of warmth not only due to its heat but also because of its yellowish hue, but a moon can be yellow, too, and it certainly seems cool.

Is it the degree of brightness of a color that helps determine its temperature? Partially, yes. A *bright* orange orange (the fruit) does seem warmer than a dull orange orange. But the same dull orange placed next to a green apple will appear somewhat warmer. This means that not only brightness but contrast plays a role in determining the temperature of a color. The same dull orange placed in a bright red box will absorb some of the warm reds and appear warmer. If the red box is dull, however, and casts no reflections,

the orange may appear even cooler by losing its inherent warm qualities in contrast to its even warmer surroundings!

I know all this seems complicated, but I've used these examples merely to point out that colors are not arbitrarily warm or cool but only *generally* so, and that even this generality is strongly tempered by outside influences. I wish I could be more definitive regarding warm and cool colors, but I can only make some general observations regarding the application of color temperature in all painting: (1) colors are not in themselves inherently warm or cool but are subject to conditions affecting them; (2) brightness, contrast, and reflective objects affect the essential temperature of color. Generally speaking, a bright color will tend to be either warmer or cooler while a dull color will be less inclined toward either extreme. However, very strong light sometimes affects the temperature of color. Bear with me. A bright yellow shirt inside the house can seem moderately warm in temperature. Going outside into the light of day *should* throw more light upon it making it brighter and therefore warmer. But if the sun is shining so strongly as to be blinding, the shirt will not seem brighter but duller. How? The sun acts as a flashlight shined into the eyes—its powerful glare will actually render the yellow shirt less yellow and more white.

So we find that there are warm reds and cool reds, warm oranges and cool oranges, warm yellows and cool yellows, cool blues and warm blues, cool violets and warm violets, cool greens and warm greens. Don't automatically paint any object cool or warm, but do so only after deep and incisive contemplation of the particular object in relation to the objects around it. In the final analysis, you must trust your own eye to make this determination.

The Tyranny of Color

Color can overwhelm the immature painter. By eternally striving for more brightness or richness of color the artist can easily destroy the very effect he or she is after. One must understand that when it comes to color, *less* is often *more*—a lesson taught us by the masters but ignored by many artists. Piling on one rich color after another into a single painting offsets the impact of the whole. When a realistic effect is pursued in

representational figure painting, the arbitrary use of garish or gaudy color is totally counter-productive to the goal. Nature endowed us with subtly-colored skin and used bright accents sparingly, such as carrot-colored hair or bright green eyes. Skin, whether pale or dark, is usually of a rather subdued hue. There are some instances of bright, rosy pinks; deep, warm browns; or really bluish blacks, but these are the exceptions. Most of us come in varying shades of subdued ivory, tan, brown, and off-black.

So keep the subtle colors of the human skin in mind and stay away from those alizarin cheeks, fire-engine lips, and all the other lurid, clownlike colors unless you're trying to simulate a movie poster or shampoo ad. Too many pastelists intoxicated by the plethora of colors packed into their sets end up with figures straight out of Barnum and Bailey.

Skin is a lovely, delicate substance, not what we see on our color television sets and in cosmetic ads. At the end of Degas' life, when old age and blindness were closing in, he painted dancers the shade of green apples and rust. When you and I have produced pastels equal to his earlier efforts, we too can afford to take such license. But until then, let's paint figures with taste, restraint, and fidelity to life.

Learning to See Color

In order to paint true color one must learn to *see* true color. As I'm fond of repeating, looking is not seeing. Looking is a purely physical function while seeing entails discrimination, emotion, intellect, and judgment. One learns to see by self-discipline, training, and experience. Color is an intangible element. A crowd of people can be placed in front of a multicolored mosaic and each will see it somewhat differently. Let's consider the nude figure. Nine out of ten people will say that Caucasian skin is pink, but when seen through the eyes of a trained individual, it's anything but that. Most so-called white skins are—in terms of artist's colors—a mixture of white and yellow ochre with touches of blue or green. There may be a tinge of light red here and there, but only a tinge. The fact is that most nudes are painted far too warm, far too red. The tendency is to follow the "flesh" colors formulated by manufacturers, who are not painters and think that "white" skin is indeed pink.

Skin is a thin layer of tissue that's highly reflective and gently absorbs and throws back the hues of everything around it. Learning to see color in the figure means learning to read light and its effect on form. However, first you must rid your mind of all preconceived notions regarding the color of flesh and accept the concept that flesh has no color of its own but is given color by the light falling upon it at that moment. Beginning with this assumption, you'll be conditioned to stop *looking* and begin *seeing*. Start looking at skin tones anew—see the whites, the yellows, the tans, the grays, the browns, the blues, the greens, the violets. Flesh no longer looks quite as pink and rosy as you've always believed, does it?

This is the first step on the long road to artistic perception of color. If you'll gaze at color with an unjaundiced eye from now on, you'll be surprised at how quickly you'll find yourself *seeing* instead of *looking*. However, it's only fair to point out that even when you've learned to *see* color, there's no assurance you'll automatically be able to *paint* color. But without the former, the latter is next to impossible.

The Importance of Grays

Grays in painting are like the sauce that makes bright colors palatable. I cannot emphasize enough the importance of grays in chromatic painting. Without grays in a painting, one raw color competes with another, thus shocking the eye and causing it to seek rest. Since a person experiences visual fatigue when looking at a strident color, the grays of nature provide a rest for the eye. Take a lesson from nature and go in heavily for grays and neutral tones. Paradoxical as it may sound, more grays will make your picture *brighter*, assuming you apportion them around the brighter colors for the most effective results.

Black in Pastel

Black is a color that evokes mixed but strongly partisan emotions. Some pastelists swear by it; others wouldn't be caught dead using it. Those who advocate painting exactly what the eye sees say that if the subject presents a black area, that area should not be painted dark brown, dark blue, or dark red—but black! This sounds reasonable enough, but the countering view-

Nude (*Left*) *by Burt Silverman, pastel on paper, 21" × 15". Beneath this rather sketchy treatment lies the foundation of a deep and secure knowledge of human anatomy. The strokes of soft pastel travel across the form and contour lines are drawn heavily here, lightly there. There's something extremely compelling to me in the loose way Silverman handles pastel. The same rough treatment in oils might affect me in just the opposite fashion. This is one of the charms of pastel — the enormous potential it offers to paint loosely or tightly, thinly or thickly, linearly or tonally. Looking at this painting serves to encourage me to loosen up in my own technique.*

Nude Drying Arm (*Above*) *by Edgar Degas, pastel, 12" × 17-1/2" (Courtesy The Metropolitan Museum of Art, H.O. Havemeyer Collection). If nothing else, much can be learned from the ease and simplicity with which this study is executed. Degas is almost arrogant in his obvious disregard of what the viewer will think. This contrasts sharply with the large body of painters (in Degas' time too) who paint for critics and for potential buyers. Degas, the pure artist, gave not a tinker's damn for anyone else's opinions and worked merely to please himself. It was this very dedication to pure art that lent his paintings their sincerity and enormous truth.*

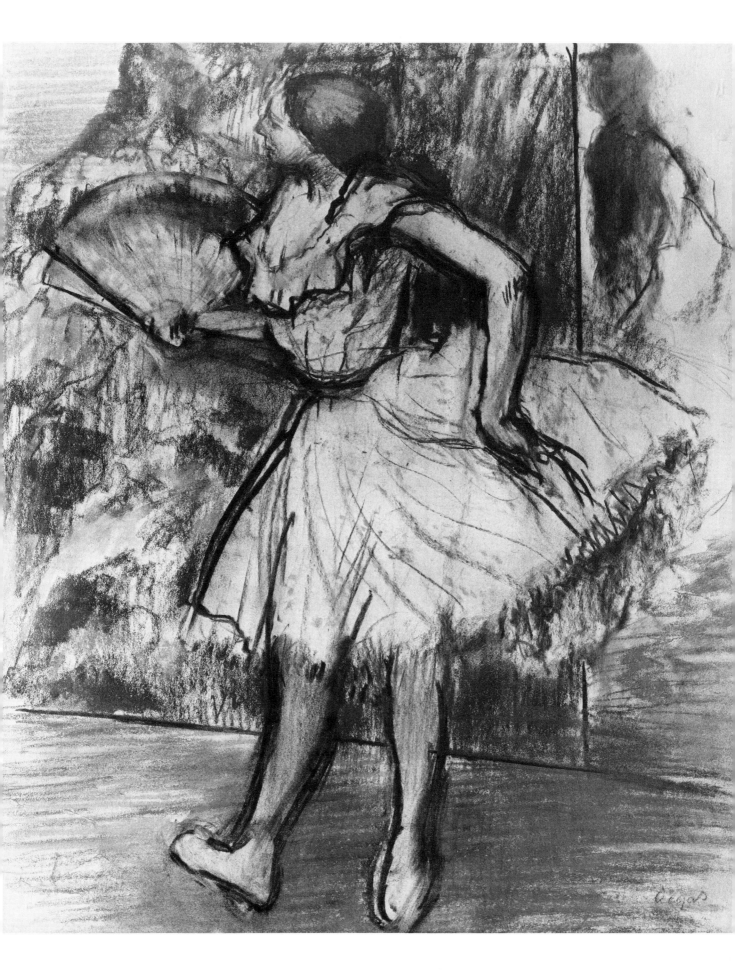

point wants to know what law prescribes the use of black crayon to represent a black area? Why can't it be painted dark enough to simulate black and yet not be black? Pure black, they say, is ugly, strident, and harsh. Isn't a mixture of ultramarine and alizarin or umber a more satisfying substitute? I myself prefer a dark that gives the effect of a deep void. This feeling can't be achieved using pure black, which reflects nothing and presents a flat, dead look.

Black pastel is very hard and won't easily go on a bare surface. However, it will behave better on top of a layer of pastel, so if you plan to use a large mass of black, underpaint it first with some umber, perhaps.

My earlier suggestion (about not assembling a full gradation of tints and darkening those that are too light with black) didn't specify that this darkening process had to be performed with black. On the contrary—any dark color can be used to darken another color with much more interesting results than would be achieved with black alone. If you want to darken a cadmium red light of the full-strength shade, go over it with one of the other darks in your collection. This might well give you a more stimulating version of a darker cadmium red light than would the manufactured version of the color, which merely includes a greater proportion of black and less of red. To darken the lighter-than-pure color shades, you would—naturally—add more of the full strength color itself; in this example, full-color cadmium red light.

A final note: I do use pure black occasionally for accents and for occasional drawing, but I prefer softer charcoal for any elaborate pure black areas since it's easier to manipulate and not quite as abrasive and aggressive as black pastel.

Keeping Color in Its Place

To me, painting—all painting—is not so much the intelligent use of color as the intelligent use of *value*. If the values are right the color cannot help but be right. Color is the spice that adds visual excitement to a painting—and for anyone who knows anything about cooking, what happens when too much spice is used in a dish?

This is not to minimize color, for it's a vital, emotional force in our lives. But dependence upon color alone is the worst and most common mistake that almost every beginner makes. This is the reason that early academic training placed so much importance upon the natural progression of the art student's education from drawing in line from plaster casts, then drawing in tone, and finally using color and painting from life. Although this system had its faults, today's method of completely ignoring line and value and proceeding directly to color, color, and more color, is even more detrimental.

Dancer with Fan *by Edgar Degas, pastel, 21-7/8" × 19-1/4" (Courtesy The Metropolitan Museum of Art, H.O. Havemeyer Collection). Before Degas' eyes started giving out, he outlined his figures heavily. Later, as his vision clouded, color took over. In this rather impulsive sketch, soft pastel takes a back seat to other media. It appears that Degas might have employed charcoal or even a greasy crayon for the extreme darks that surround the figure. Degas never concerned himself with the means. He used whatever tool served him best even if the media were not necessarily sympathetic. Under his sure hand, they gladly merged with one another.*

Demonstrations

The following demonstrations show how six different artists approach pastel figure painting, each in his own highly individual fashion. The demonstrations are designed to provide valuable insight, and to help ease your own problems by showing some of the thinking and technical considerations that go into the total effort. By carefully studying each preliminary step leading to the final painting, you can learn how an experienced pastelist proceeds from the outline right through to the finished painting.

Limitations of space prevent a longer textual explanation, but much more can be learned from a careful visual study of the material. It's interesting to observe the differences of approach to a medium whose versatility is still questioned by those unfamiliar with its rich potential. As I reiterate throughout the book, there is no one prescribed way of working in pastel. Technique is strictly a personal, individualistic factor. Nowhere does this become more apparent than when noting how six skilled, mature artists go about executing a pastel figure study step-by-step.

Study of a Nude, *by Marcos Blahove, pastel on illustration board, 16" × 14". Blahove likes to explore the liquid aspects of pastel. He uses it much as he would watercolor, employing a cotton swab or a brush to float washlike tones over and into the figure. For this reason, he likes the rugged board, which will withstand much more such manipulation than the fragile paper. Since he also likes to experiment, he tests his techniques on various surfaces. In this case, he worked on white illustration board that he toned and roughened himself.*

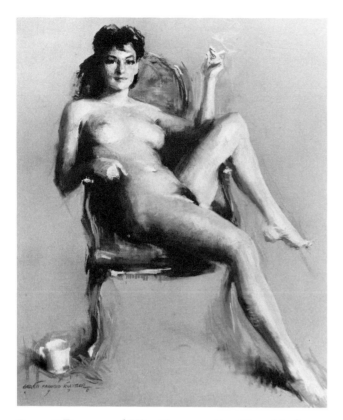

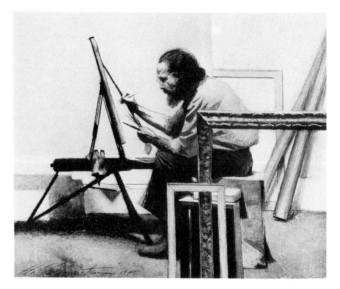

Everett Raymond Kinstler, a native New Yorker, studied at the Art Students League, where he is now an instructor. A protégé of James Montgomery Flagg, Ray himself became a crackerjack illustrator while still in his teens, producing hundreds of magazine and book illustrations and covers.

Now one of America's foremost portrait artists, Kinstler has painted more than 500 portraits, including such prominent personalities as United States Ambassador to England Elliot Richardson, Secretary of Treasury William Simon, astronaut Alan Shepard, former governor John Connally, golfer Byron Nelson, publisher Charles Scribner, Jr., Princeton University president William Bowen, General Richard K. Mellon, Mrs. Irenée duPont, Jr., and many, many others.

Kinstler is an academician of the National Academy of Design, vice-president of the National Arts Club, art chairman of the Players Club, member of the American Watercolor Society and of the Century Club, and, incidentally, one of New York's most impressive conversationalists.

He is the author of *Painting Portraits* (Watson-Guptill, 1971) and recently collaborated with Tennessee Williams on a series of color lithographs.

Harvey Dinnerstein is a native of Brooklyn. He studied at New York's High School of Music and Art, Temple University, and at the Art Students League. A member of the National Academy of Design, he has had nine one-man shows and participated in numerous exhibitions throughout the nation. His paintings are owned by the National Academy, The Pennsylvania Academy of Fine Arts, Syracuse University, Penn State University, Montclair Museum, and the University of Texas. He is a winner of prizes awarded by The Pennsylvania Academy of Fine Arts, the American Academy of Arts and Letters, and of the Louis Comfort Tiffany Foundation Grant. Currently, he is teaching at the National Academy and the School of Visual Arts in New York.

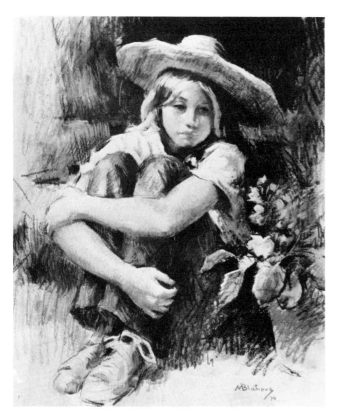

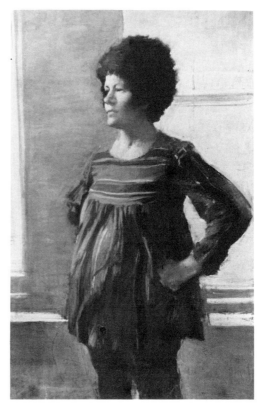

Marcos Blahove immigrated to the United States from his native Ukraine and now lives and works in West Hampton, Long Island. He studied at the Academy of Fine Arts in Buenos Aires and at the National Academy of Design. Primarily a portrait painter, his portrait of composer Aaron Copland hangs in the National Portrait Gallery in Washington, D.C. Blahove is a member of the Salmagundi Club and a winner of many awards for his work, which has been acquired by prominent museums, corporations, and private collectors. He is currently teaching portraiture at Southampton College on Long Island.

Burt Silverman attended New York's High School of Music and Art, Columbia University, and the Art Students League. He works in oil, pastel, and watercolor and is represented in a number of prestigious collections including Brooklyn Museum, Philadelphia Museum of Art, and Cornell University Museum. His awards include the Benjamin Altman, S.J. Wallace Truman, Henry W. Ranger, Thomas Proctor, and Joseph Isidore prizes awarded by the National Academy of Design. He has shown in some 30 solo and group exhibitions and has been written up in *American Artist* and *Art News* magazines.

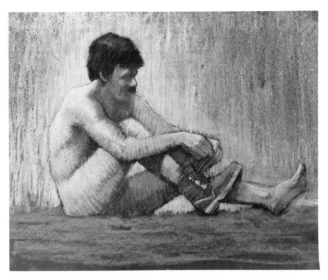

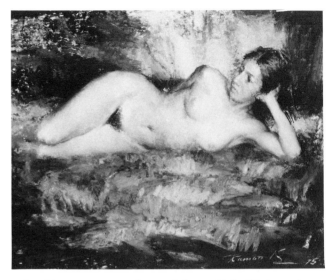

Ramon Kelley has spent most of his life in the Southwest absorbing the rich traditions of its land and people. A member of the American Watercolor Society, the Allied Artists of America, and the Pastel Society of America, Kelley has won a number of prestigious awards for his painting in various media and has exhibited widely throughout the western and southwestern United States. He is particularly known for his studies of Indian and Mexican subjects, an oeuvre that has won him writeups in *American Artist* and other noted American and foreign publications.

John Foote was graduated from Yale University with a Master of Fine Arts degree in 1960. As a leading fashion and portrait photographer, his work appeared in *Cosmopolitan, Glamour,* and *Vogue* magazines.

During his busy career he also attended classes at the Art Students League and in 1970 decided to pursue painting fulltime. He was awarded a scholarship to the National Academy School of Fine Arts and won the Dr. Ralph Waller prize for portraiture.

In 1971 Foote moved to Italy to follow a program of studies suggested by the great Florentine artist Pietro Annigoni. Upon his return from Europe he was commissioned to paint the portrait of Metropolitan Opera star Marilyn Horne by the National Portrait Gallery in Washington, D.C., for their exhibition commemorating the opening of the John F. Kennedy Center.

In 1973 he won the Watson-Guptill Award at the National Arts Club's first pastel exhibition. He maintains a studio in Manhattan and is represented by Portraits Incorporated.

The Coffee Break *by Everett Raymond Kinstler, pastel on board, 40″ × 32″.*

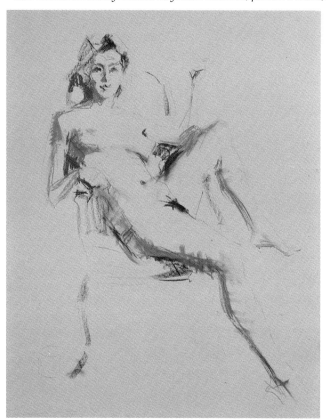

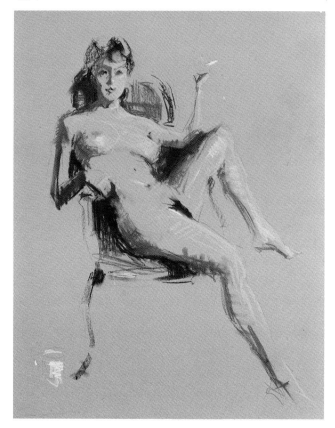

Step 1. *Kinstler is searching for an appropriate pose and finally calls a break. The model relaxes back in her chair and lights a cigaret—and he knows that he's found what he's looking for. The board he selects presents a neutral-hued, middle-shade tone which he presumes would require a small range of pastels, but it turns out otherwise in the later stages of the painting.*

He starts by blocking in all the dark areas in the figure, aiming at the action, placement, movement, and characteristics of the pose. Green and violet pastels are used for this blocking in, with a darker green stick for the darker areas. More attention is paid to the accuracy of the drawing than would be in an oil painting, where correction is that much easier to attain. The model's right nipple, belly, and crotch serve as keynotes from which to gauge proportions, distances, angles.

Step 2. *Kinstler now builds up, strengthens, and reinforces the drawing, working throughout the picture simultaneously, as he does in every stage of the painting. He seeks to strike the correct color values immediately rather than merely suggest them vaguely. Working basically with yellows, he places some warmer pinks at the knees and fingers which are the blood areas of the figure, and introduces red-violet tones into the chair to establish its color relationship with the figure. The cup and cigaret are roughly indicated, and the shadow areas are deepened and extended. He remembers at all times, however, to retain the first impression of the pose, the later stages, merely holding, restating, and sharpening this impression.*

Working with perhaps three tones of lights and two to three darks, Kinstler uses olive greens to fortify the shadows, off-whites to indicate the cup and cigaret, and light yellows and tans to strike some light areas in the flesh. At this stage, the die is cast, so to speak, and Kinstler makes a definite commitment to the pose.

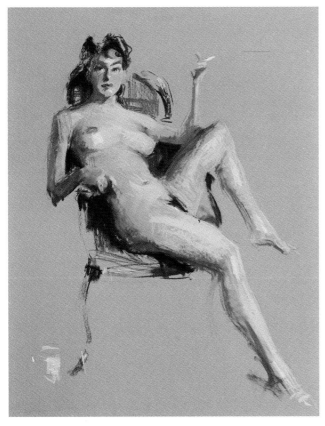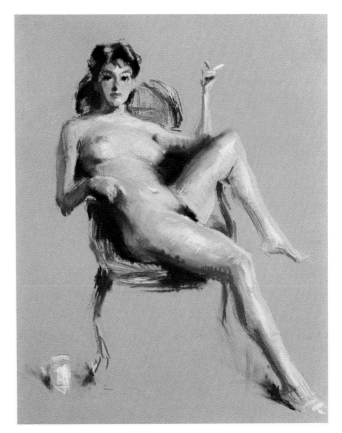

Step 3. *Still working in his usual way in which all parts are developed together, Kinstler uses his finger on the right thigh area to pull planes together and achieve a slight, washlike, transitional effect.*

By now, all areas of the figure are further developed. Kinstler enlarges his range of sticks from six to approximately twelve. Warm orange is used to scumble or wash over the cool greens in the shadows of the arms and the head. The lips, nipples, and shadow side of the right forefinger are all stroked in with a deep rose madder pastel.

Color is enlivened by using two shades where one might do. Some of the red-violet of the chair is introduced into the areas within the figure (such as in the shadow side of the right cheek) in order to unify color relationships.

Light planes on the lower part of the belly are rendered somewhat pinker than those in the upper torso. An effort is made to repeat color areas such as the light on the forehead, the light under the nipple, the light on the right kneecap, and the lights on the calves and ankles.

Step 4. *Now Kinstler enlarges his palette to include some 20 colors. He does this in order to capture the subleties of color he encounters in the flesh.*

Seeking to achieve the effect of roundness in the thighs, Kinstler sharpens an edge here and there, particularly at the top of the right thigh running from the crotch to the knee.

Kinstler rubs some burnt sienna into the shadow side of this thigh to enhance the impression of it turning under and adds some of the same brown to the top of the thigh to further foster the three-dimensional effect. The cool blue grays of the paper are used to indicate the receding planes around the belly and to indicate an area of reflected light in the right side of the buttock.

Kinstler keeps looking for areas where he can repeat colors and run colors from the chair into the figure and back again to achieve a sense of unity and cohesiveness in the color relationships.

The colors in the flesh are further strengthened and enriched and additional modeling is affected in the legs, breasts, arms, and hair. The chair is drawn somewhat more explicitly and the shadows cast by the cup and the foot resting on the floor are stated.

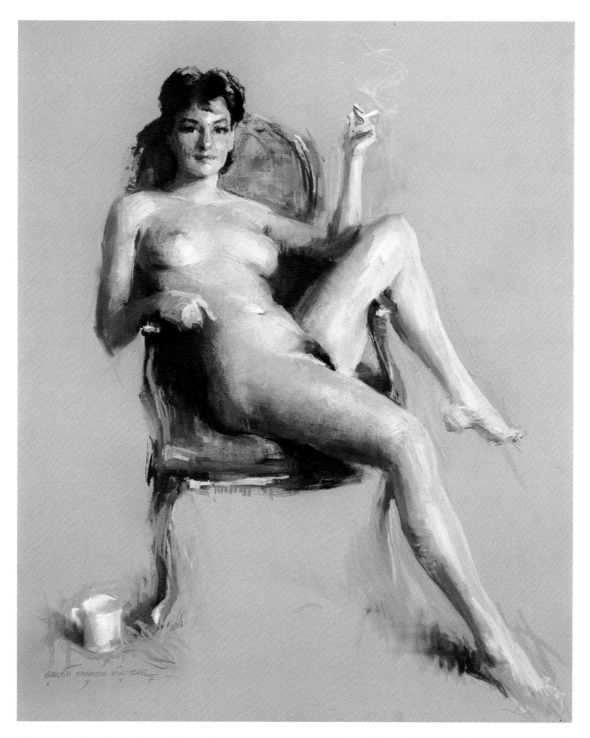

Step 5. *By now, Kinstler enlarges his palette to some 40 colors—particularly in the area of violets that he finds particularly effective for the subtle middletones in the flesh.*

Kinstler finds that fixative, like most things in this world, has certain advantages and disadvantages. It enriches the shadow areas but it also darkens the light areas. He concludes that fixative has to be used selectively, after having sprayed some on the right hip; there it softens some of the planes and promotes the sense of

transition but also works to lose some of the character of the strokes.

Kinstler goes on to develop some of the subtle colors and tones in the head and the right leg and to work out the chair in greater detail where he manages to use the tone of the paper. It's interesting to note that the two apparent white areas—the cup and cigaret—are painted in tones far lower in value than white—an error that many students of pastel fall into.

Self Portrait *by Harvey Dinnerstein, pastel on prepared board, 16-3/4" × 21".*

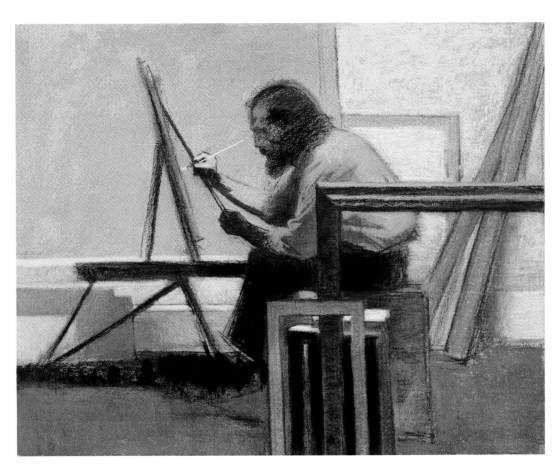

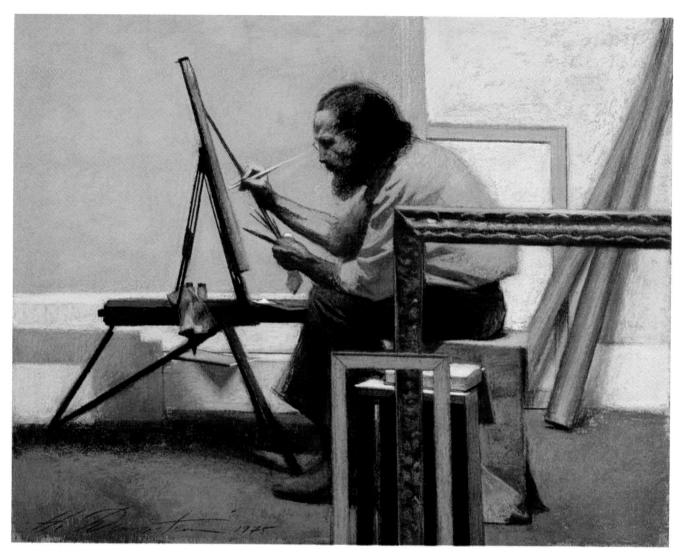

Step 1. *(Top Left) Dinnerstein uses charcoal to block in masses and shadows simply and to establish all the areas and levels of space and all the values. A conscious effort is made to treat the painting as a picture in which all elements are accorded equal significance.*

Step 2. *(Left) Working on all parts of the painting, Dinnerstein now seeks to establish the forms simply in their basic values, colors, and planes within the picture so that the frames lie definitely in the foreground, the figure definitely in the middle, and the canvases, definitely in the background. The platform of the model stand is raised, blue and cool yellow papers behind the easel are moved forward, and an envelope is introduced for its desired yellow color. This also reveals the white ridge of the right floorboard in back of the canvases.*

Dinnerstein uses the light plane of the book lying just in front of himself to make that area appear to come forward, and the dark of the frame and model stand to make that area appear to recede.

Step 3. *(Above) Dinnerstein adds a book on the model stand and other objects such as the rag and bottles, as well as the brushes in his left hand and the back of the book in the foreground. Many of the lines used to define the contours of objects are eliminated and this separation of form is achieved by the conscious use of air, space, and color rather than line. In doing the shadows, he paints them all broadly at first then goes back into them in order to lighten and break up the mass.*

Dinnerstein now adds some cool lights into the book lying on the box and adds appropriate colors to represent the paints on his palette. He picks up glints of gold in the frame and models the rolls of canvas stacked in back, adding warmth into this shadow area. Such accents as the frames of his eyeglasses and the lights in the rag serve to lend the painting reality, but the treatment throughout remains loose, free, and easy. Note how roughly the artist paints his right upper arm.

Daydreaming *by Marcos Blahove, pastel on board, 16" × 12".*

Step 1. *A careful charcoal drawing is executed, indicating all the darks, halftones, and lights and establishing the background, foreground elements, and general form. Unlike the other demonstrations, this initial sketch is carried much further and Blahove solved many of the problems of placement and composition the other artists left for subsequent stages.*

Step 2. *Instead of proceeding immediately to pastel, Blahove now uses transparent watercolor to tone the board somewhat and to establish the color aspects of the painting. This is a good example of how pastel can be combined with other media. Blahove chooses to carry the watercolor stage fairly far, leaving the pastel for finishing accents. Left at this stage with no additional pastel applications, the picture could easily be presented as a pure watercolor painting complete unto itself.*

Step 3. *(Right) Blahove employs pastel to finish the painting. He models the form in all the areas, adds highlights, introduces strokes of broken color, enlivens the background, paints in the flowers, and strengthens the shadows throughout. Although pastel is used merely as an extension of the watercolor in this painting, it adds the verve, the strength, the color vivacity, and the character that the more timid watercolor often lacks. This is an admirable example of how pastel can be used in thin but effective fashion to lend richness to a rather bland underpainting in an aqueous medium.*

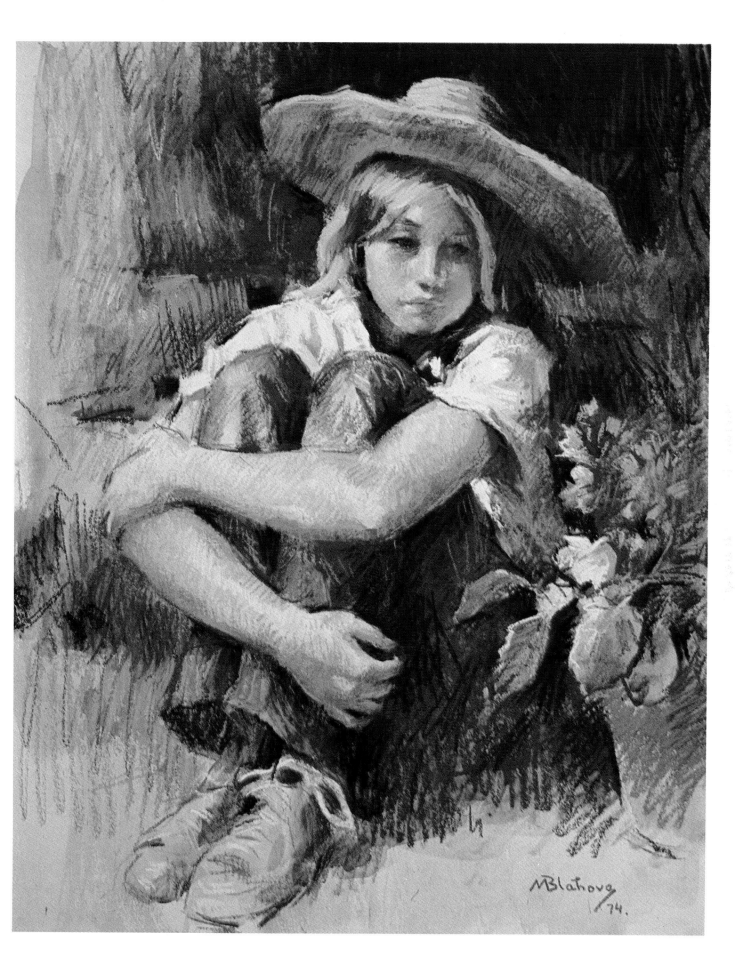

Claire by Burt Silverman, pastel on cotton canvas, 22" × 14".

Step 1. On a special pastel canvas which was tinted a grayish green by spraying on an appropriate tone of acrylic with an atomizer, the artist begins to draw in soft charcoal. He then applies touches of color in the face to establish the thrust of the head in the pose and that sense of withdrawal that seems to accompany pregnancy. Although further work was carried out, the artist felt doubts about continuing the pose since it failed to project the variety of feelings that he wished the figure to convey. So he abandoned the pose and decided on a new one.

Step 2. The beauty of pastel is that it allows such change to be quickly effected. Even the factor of the false start works to Silverman's advantage: his concentration is sharpendd in the process of obliterating what already had been put down and creating a new image that is more intense and striking. In reworking, the danger of building up too much color too quickly is obviated by fixing the surface lightly. This allows you to mass in the new pose using soft pastels only.

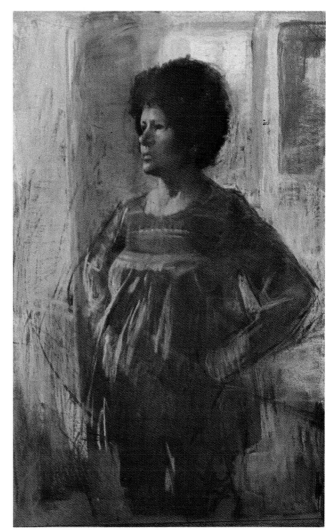

Step 3. *Here, Silverman refines the drawing, adding color to the smock and cool and warm whites to define the walls. He keeps his light areas cool and his dark areas warm, but permits some spillover so that the figure and surrounding areas acquire a natural, cohesive relationship. The painting to the model's left is indicated lightly. (It will later be removed.)*

Step 4. *Now the pastel is applied in thicker, more painterly fashion. The features of the face are more thoroughly rendered, but this creates a too-aggressive expression which clashes with the spirit of the painting. It will be ultimately softened and modified. The colors in the smock are cooled to some extent, but the figure is still left relatively unfinished.*

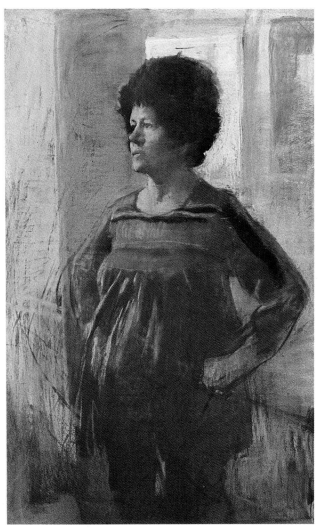 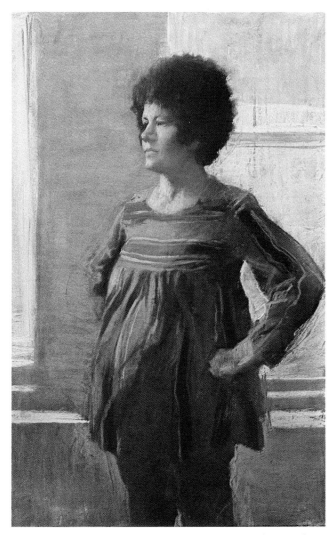

Step 5. *The striped pattern is introduced into the smock and the head is further refined and developed. The model's mood was changed in the course of the painting, and this is reflected in the painted image. Some work is done on the arm and hands, and reds and greens are laid in on the smock. The shape of the hair is more accurately rendered, and a few lighter tones are established in its overall mass.*

Step 6. *At this point, Silverman decides to change the background and make it blank—an open window. This helps provide contrast for the curved forms of the figure. The expression in the face changes again to reflect the mood of the model. The colors and shapes of the pattern in the smock are more specifically articulated, and the contour of the legs are firmly established. Additional work is done on the folds of the smock and in the hand. Appropriate edges were sharpened where indicated, and the pastel is brought to its final stages.*

Step 7. *(Right) The contrasts of lights and darks within the figure are modified throughout to allow flat and round areas to coexist more naturally. The arms, legs, hand, and smock are brought to completion, leaving scattered rough and frizzy passages here and there. The painting is brought to this point then deliberately stopped, since Silverman likes to leave part of a picture unfinished.*

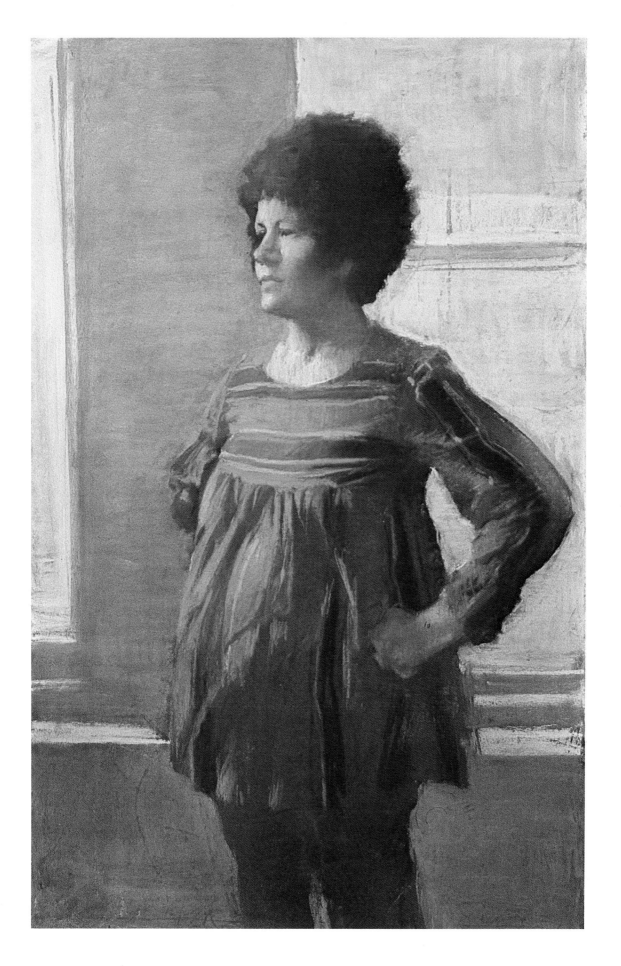

Seated Male Figure *by John Foote, pastel on paper, 14″ × 18″.*

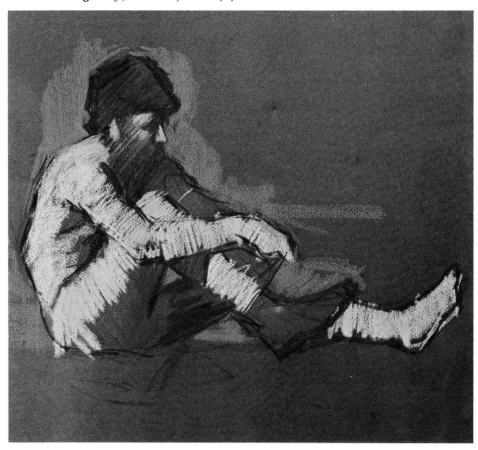

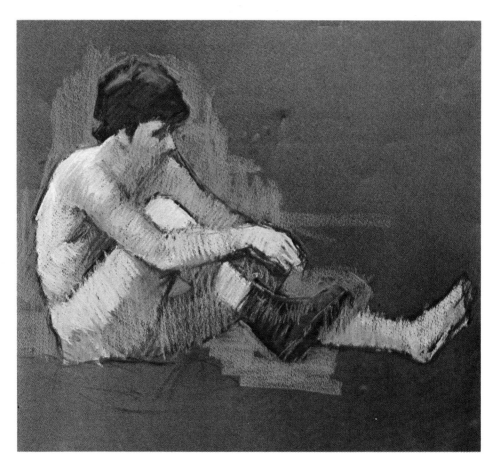

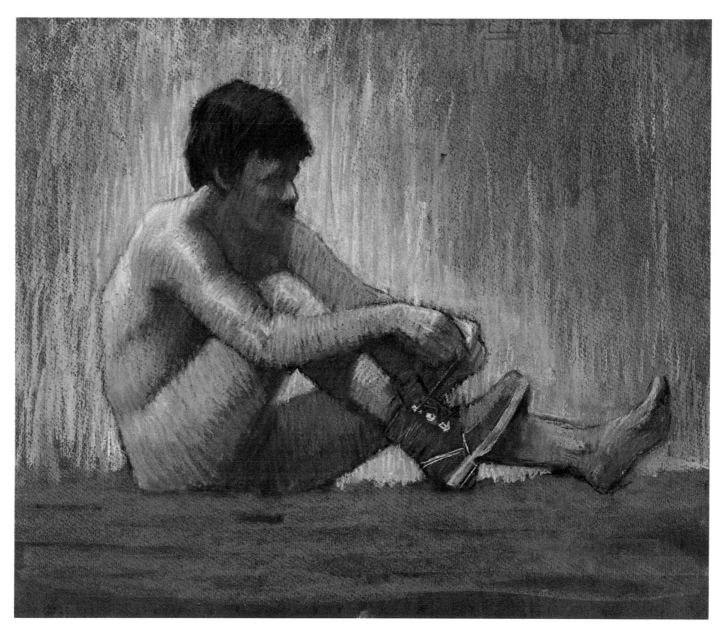

Step 1. *(Top Left) After blocking in the figure lightly in charcoal to indicate the general action of the pose and the placement of the masses, with emphasis on the big swing and sweep of the gesture, the artist sets down two light values—one to separate shadow from light and the other to separate the figure from the background. Although the pastel is applied more heavily in such areas as the shoulders, the back, and the upper thigh, the same value is maintained throughout the figure.*

Step 2. *(Left) Foote now shifts to a full range of pastels to lend the figure a three-dimensional, sculptural quality. The top, side, and bottom planes of the form are established. Key areas are interwoven rather than merely distinguished as separate anatomical entities. The cheek, jaw, shoulder, and arm are rendered as a*

unified mass; the foreground and background are fused with a series of unifying strokes. Foote tries to maintain a balance between the hard, angled lines and the gentler curved ones.

Step 3. *(Above) All the forms are strengthened, employing the full contrast of color from dark to light. The olive green and deep ochre of the background is played against the warm ochres, siennas, and oranges located within the flesh tones of the figure. The entire approach in this study from beginning to end is essentially linear. The background is laid in in a rash of vertical strokes that grow lighter as they approach the figure, particularly around the head and shoulders. This serves to bring these forms into sharper focus without hardening any of the edges. Even the highlights are laid in as a series of closely parallel lines running consistently across the form.*

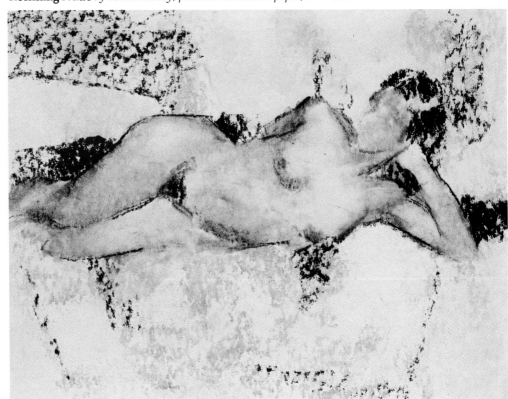

Step 1. *For this painting Kelley selects a medium-texture watercolor paper, a surface he hasn't fully explored for pastel painting, yet one that seems to offer a good potential because of its good tooth and 100% rag content. The figure is lightly sketched in, with accents strategically situated to capture the placement and sweep of the pose. Having decided to set the figure high up on the paper, Kelley rubs umbers and sienna tones into the skin tones and roughly suggests the color of the background.*

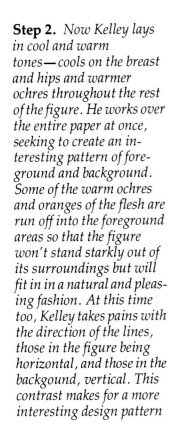
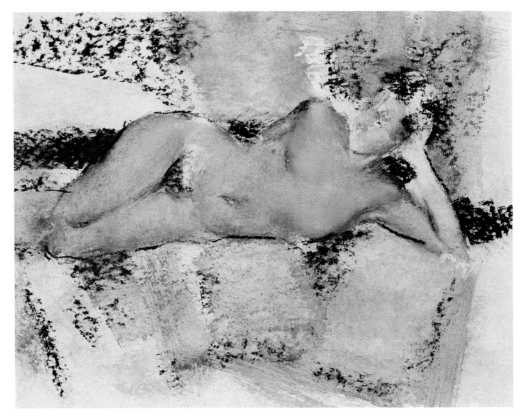

Step 2. *Now Kelley lays in cool and warm tones—cools on the breast and hips and warmer ochres throughout the rest of the figure. He works over the entire paper at once, seeking to create an interesting pattern of foreground and background. Some of the warm ochres and oranges of the flesh are run off into the foreground areas so that the figure won't stand starkly out of its surroundings but will fit in in a natural and pleasing fashion. At this time too, Kelley takes pains with the direction of the lines, those in the figure being horizontal, and those in the backgound, vertical. This contrast makes for a more interesting design pattern*

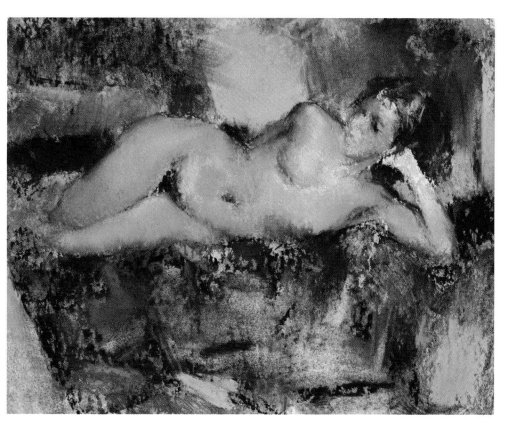

Step 3. *In this stage Kelley focuses his interest on maintaining overall color harmony and on compositional factors throughout the painting. The previous color lay-ins are covered in selected places, making for an interesting effect as some of the underpainted areas show through. Reds, ochres, violets, and blues are used in the foreground and background, and Kelley uses his finger to rub, blend, and occasionally "feather" the lighter tones into the darker areas.*

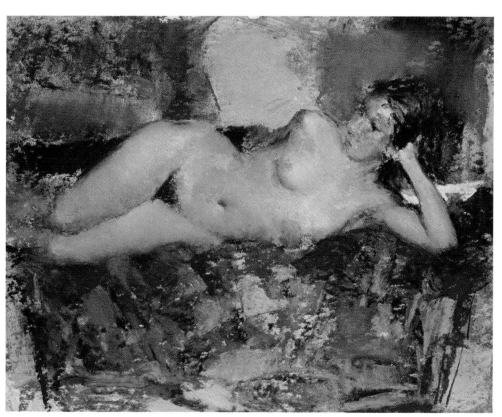

Step 4. *Now Kelley paints more lights into the dark areas of the foreground and background. He begins to define the figure with more precision and model it with color and tone, consciously distinguishing between lights, halftones, and darks. The overall flesh tone is composed of pinks and warm ochres, highlighted by cool blue tones on the forehead, the top of the shoulders, the breasts, and the hip. Hot orange accents are introduced into the shoulders and arm.*

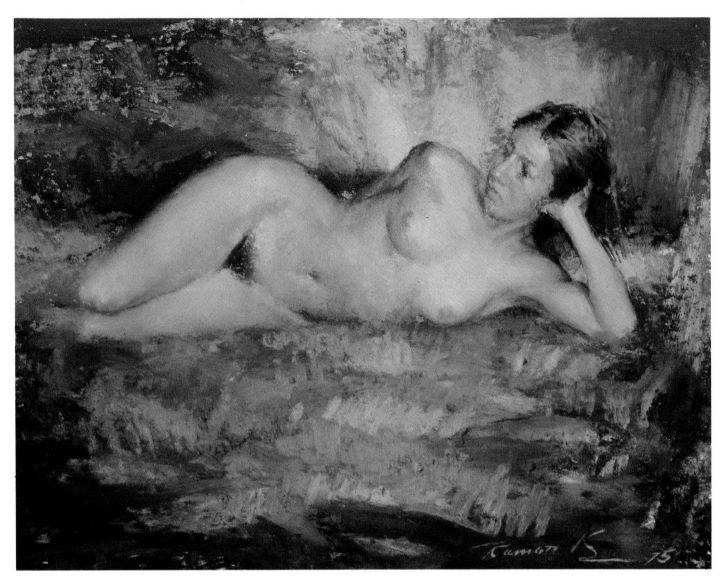

Step 5. *After spraying the painting lightly with fixative, Kelley commences his finishing strokes. He mixes dark blue into the warm brown of the hair and adds some cool blue highlights. Because of the small size of the painting, Kelley keeps the figure predominantly warm to make it stand out against the cool ochres in the foreground and background areas. However, warm flesh tones are woven in and out of the entire picture to lend movement and lively color harmony throughout. A special effort is made to keep the flesh areas smooth in contrast to the roughness of the background. To conclude the painting, Kelley places the highest lights on the forehead, the top of the breast, and the right knee. The painting is left as is, because Kelley, like many pastelists, doesn't believe in final fixing.*

Aspects of Pastel Painting

Pastel is like a growing child. Some children can be guided, goaded, pushed, and prodded into overachieving; others resist every effort to bring out the best in them. Just as in the case of children, it's the one who does the prodding, the prodder, that assures the results—not the prod-ee, if I may coin a word. A wise parent or teacher can get more out of a child by exercising a blend of restraint, logic, judgment, and perseverance. Like the skilled mentor, a clever pastelist must understand the limitations of his charge and proceed accordingly.

How Far Can You Push Pastel?

Pastel *can* be pushed far beyond its assumed limits, but maybe it's not necessary to do so. Maybe the same results can be achieved by rethinking one's concepts and getting to the nub of the matter earlier rather than later. What I'm saying is that instead of painting, fixing, repainting, refixing, and so on, why doesn't the artist aim for what he or she wants from the beginning by painting in a more direct manner? This concept is the result of much soul-searching on my part regarding pastel techniques. While it's true that excellent pastels have been produced by over-working—Degas is a perfect example—I now suspect that he was searching and exploring rather than reworking merely for the sake of achieving a thick impasto. I suspect that after Degas fully explored the possibilities of the medium, he proceeded in subsequent paintings to achieve the same results immediately, without all the preliminary stages.

Pastel, I *now* believe, is a medium for direct painting—for the *alla prima,* or *premier coup,* approach in which the final effect is aimed at from the very first stroke. However, I do not want to tell anyone which technique to adopt; I merely want to discuss all the possible methods.

Traditional and Innovative Methods

Before Degas, pastel was considered a charming, airy, even effete medium to be lightly stroked and blended into somewhat vacuous portraits and still-life studies. Although such masters as Chardin, de la Tour, Liotard, and Perroneau achieved some remarkable results, the medium was treated with the kind of delicacy afforded a sickly child. Few darks were used—the key was consistently high—and the subject matter was generally confined to the frivolous and romantic.

It was left to Degas to seize the medium of pastel and force it to yield treasures the likes of which have not been seen since. He proved that with pastel you can paint thickly, darkly, spaciously, boldly, earthily. The subjects didn't have to be society figures but could be laundresses, shopgirls, and prostitutes. He took this "humble medium," as the *Encyclopaedia Britannica* calls it, and rubbed its nose in the dirt until it emerged lusty, rugged, and thoroughly plebeian. Degas blew steam into his pastels and turned them into a thick soup that he manipulated with stiff brushes. He fixed and refixed them, dipped them in various solutions, and mixed them with every medium under the sun until they cried for mercy. This disturbed the notion that still clings in some quarters regarding the delicacy of pastel. Degas proved once and for all that pastel can indeed be pushed nearly *ad infinitum*, but the question I pose is—even if it can be, *should* it be? To my way of thinking, pastel is hardly a timid, fragile medium. It is inherently an immediate medium rather than a gradual one such as egg tempera, in which each layer plays an integral part in total painting. Pastel, I now believe, can be applied as thinly or as thickly as one pleases, but in either case it should be painted *alla prima*—aiming for the final result from the very first stroke.

One final and most important note. By no means accept my opinions about this (or anything else) as definitive. Weigh, digest, and evaluate all views regarding pastel technique and make up your own mind, for it's incumbent upon every artist to remain flexible and open to all new and revised concepts concerning both the mechanics and the esthetics of his or her work.

Edges—Hard or Soft?

The treatment of edges is a somewhat tricky area in that much of it depends on the panter's individual preferences. I could babble on about the benefits of putting hard edges up front and soft edges in the rear to create the illusion of advancing and receding planes, and about other such "rules" regarding edges, but I consider this pompous and self-defeating. I believe there should be no rules regarding edges in painting, although edges still must be considered.

When, then, is one to paint a hard edge or a soft edge? With my advancing age accompanied by a progression from tight to loose painting, the hard edge has become, to me, an abomination. Therefore, based on my own prejudices, I'd say the fewer hard edges the better. However, if you're a fan of hard-edge painting, again don't let me dissuade you. But please, no rules—don't mechanically place a hard or a soft edge because of law number 3 or 4½! Place a hard or soft edge only because you think you see one there or because it appeals to you. Painting hard or soft edges for the arbitrary reason of establishing distance, contrast, perspective, or anything else is *nonsense*. Trust your eye and your taste. If you think a hard edge will help your painting in some way, stick it in, but don't worry whether it conforms to any rule or principle.

The Sketch Versus the Complete Painting

One of the happy aspects of painting in pastel is that it leaves room for almost any degree of completeness in a picture. Oil is a medium that usually calls for a more-or-less finished effort, but the less inhibited, playful pastel is more easily accepted in all versions from a casual line sketch to a fully realized, edge-to-edge painting. If you doubt this, compare Degas' oils with his pastels. Every inch of his oil canvases is eloquently filled in, while his pastels are either loose and free or carefully worked. With Degas' understanding of

Eskimo by Bettina Steinke, pastel on paper, 16" × 10". This quick study of a young Eskimo boy, although only a sketch, is so deftly executed that the subject is instantly recognizable. Only two colors were used for the lines; full color was reserved for the head alone. Note how sure and confident the artist is in treating the head. Steinke uses pastel with complete assurance. You can almost follow the progress of the sketch as she swiftly follows stroke with telling stroke.

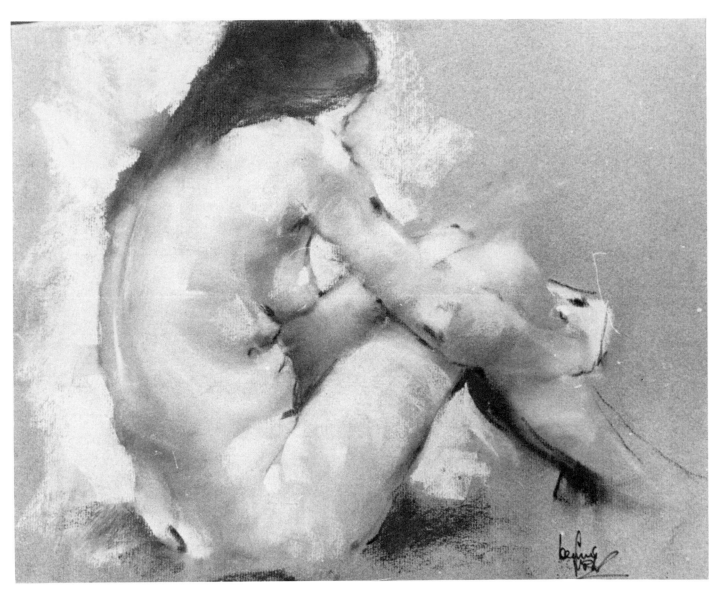

Nude Study by Dennis W. Frost, pastel on paper, 12″
× 14″. Heavily rubbed, this is merely another way in
which pastel can be used to good effect. The lights are
the only areas which show some thickness of pastel.
This kind of method relies heavily on a thorough knowl-
edge of anatomy, since it can easily deteriorate into an
amorphous mass. It's very high in key, with only the
hair and thigh areas somewhat lower in value. The
selective use of contour lines such as in the buttocks, the
breast, the belly, and the underside of the calves must be
carefully controlled or it may overwhelm the interplay
of the subtle planes within the figure itself.

the versatility of pastel for us to follow, we can feel free to draw, fool around, experiment, or diligently finish our pastels. Line drawing, tone study, color sketch, or fully realized painting—each lends itself admirably to pastel.

The Key

Selecting the key, or the overall range of tonality, for your painting is a most important consideration. A high-key painting evokes a different emotion than a low-key one. The choice of key in a painting can depend upon an artist's personality, the subject matter, and the degree of realism in which the painter works.

Pastel has long been associated with high-key painting—its darkest dark being much lighter than a medium dark in a low-key painting—and there may be a valid reason for this. If pastel suffers in any one area, it is in its lack of truly rich, dark shades in many of the colors. To compensate for this gap, pastelists naturally turned to what was readily available and commenced to paint with the lighter shades. However this is no reason *you* should paint in high key. If the manufactured shades aren't dark enough for you, make some that are. Even though I seldom make my own pastels, I have on occasion made a crayon or two when I couldn't find what I wanted at the store. All you need do is increase the amount of black pigment until you obtain the mixture you want, roll it, and wait for it to dry.

But *when* to paint in high, medium, or low key takes some contemplation. No discussion of key can be pursued without the consideration of contrast. A key represents the *total* tonality of a painting. What happens to this concept when you paint a milky white nude in a strong light against a nearly black background? The key now runs from very high to very low because the range of values runs the full gamut. What key does this painting represent? Doesn't this negate the whole concept of *key*? Let me try to explain. Nature always presents an ideal key. But we mortals must determine *beforehand* whether we'll paint in high, medium, or low key. This can be done in two ways: (1) pose the subject in such a way that it falls naturally into one of the keys, or (2) consciously paint the subject in a certain key regardless of what key it really falls into.

After all, there's no law compelling the artist to slavishly copy what is before him. He can serve as his own choreographer and orchestrate the visual elements to suit his own wishes. So if he does choose to paint a pale-skinned figure against a jet black cloth, he can either bring down the value of the skin or bring up the value of the cloth. Of course, if he's a stickler for accuracy he can follow the first course by changing the cloth to a medium gray and then painting what is before him.

Erasing and Correcting

Correcting mistakes in pastel isn't as hard as you might imagine. Since paper is comparatively cheap, it's no tragedy to begin anew in case of a foul-up. However, you *can* correct a mistake on paper, board, or canvas and rework passages that may have gone sour.

To correct a mistake on paper, begin by dusting or scraping off the offending granules with a stiff brush. Then blot (do not rub) with a kneaded eraser until the surface is more or less workable again. Next, scrape the area lightly with the edge of a razor blade held perpendicular and as close as possible to (but not actually into) the paper surface, blot with the eraser, and resume painting. At all times be sure not to dig into the actual paper surface itself, only into the layer of pastel. If the scraped or erased area is unsympathetic to further application of pastel, give it a spray of fixative and rework.

When correcting a mistake on board, which normally has more tooth than paper, you can be more vigorous in your efforts. Granular boards will permit you to actually scrape away the ground itself with a razor blade right down to the support. The area can be then resurfaced with additional granular material by the already noted methods (fixative, layer of tone, glue, etc.). Another method of correcting an area on board, suggested by Elinor Sears in her excellent book *Pastel Painting Step-By-Step*, is to dampen a rag with fixative and continue to pass it over the grainy surface until the area is reasonably clean.

Pastel can be partially removed from canvas by rubbing the canvas gently with a damp cloth of water or fixative. Once dry, the canvas may be *lightly* rubbed with sandpaper to restore a measure of tooth. A final note—avoid scraping and erasing whenever possible, but if you must, treat the surface with the tender loving care you would your own skin.

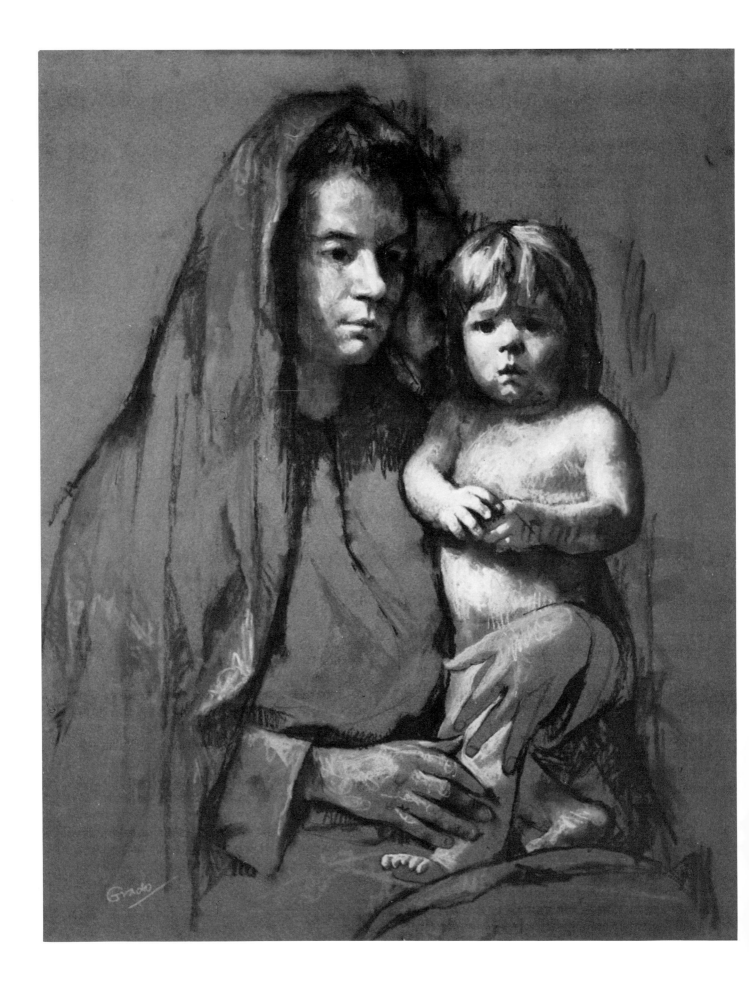

CHAPTER NINE

Planning the Figure Painting

Artists traditionally look at the world through different eyes than the rest of humanity. And similarly, people in other professions have their own way of looking at the world. For instance, a police officer whether on or off duty is ever alert for potential lawbreaking. After a while, this becomes an automatic reaction. A basketball coach sees a potential star in every young man over six feet. A movie talent scout looks for photogenic people with charisma.

The Artist's View

Painters who are serious about their work see with the eyes of an artist. To an artist, appreciation of a figure isn't necessarily based on sexual preferences, but is concentrated on whether a particular figure is artistically stimulating. An artist interested in figure painting must also learn to look at a figure as an entity, not as a mechanism composed of many interlocking parts. No matter how intriguing some of these components may appear, their significance to the artist lies in how they interrelate with the rest of the body. An artist must view the figure as an object of flow, action, and movement that even in repose should express the animation, excitement, and essence of life. You can paint a figure out of proportion, you can paint a figure in every color imaginable, you can even paint a figure in abstract fashion so that anatomy is cast out the window—but you *cannot* and *must not* paint a human figure that's devoid of life.

Rhythms, Forms, and Masses

The body is the most ingenious creation of God, nature, or whatever one may choose to call the force that guides our world. Although the human body is no more remarkable than that of any other animal species, it does differ in the infinite

Mother and Child by *Angelo John Grado, pastel on paper, 24" × 20". Compare this to Silverman's study of essentially the same theme on page 28. See how formally Grado has treated it in comparison to Silverman's more casual approach. The same subject can be handled again and again with the artist's personality the factor that lends it uniqueness and individuality. This is the more traditional approach, with the infant's light skin set off against his mother's dark robe and the background. Probe each subject you contemplate painting for the emotional factors you wish to evoke.*

variety of individual characteristics it presents. Man comes in so-called white, yellow, brown, or black; in giant, medium, and pygmy form; curlyhaired, straighthaired, and bald; and of every contour and symmetry. There are humans who still swing from vines and those who wouldn't walk three feet to keep from starving.

To an artist who works realistically this represents an enormous challenge in that each time he paints the figure he's confronted by a new combination of shapes and proportions. This tends to discourage beginners from attempting this seemingly difficult task and turns them to painting that which presents a more constant subject. One way to conquer this initial fear is to cease worrying about the comparative length or breadth of noses, forearms, and fibulas, and to force oneself to see the figure as a unit.

Think of the figure as an entity composed of several big masses and forms that function in rhythm (although not necessarily in a placid manner) with one another. Everything we do physically is a composite action that's relative to and dependent upon the other parts of the body. Translated into artistic terms this means that you cannot paint the figure without considering the entire body, whether you show it all or not. This is probably the most important concept in this book and I urge you to read and consider it again and again, for once you have grasped it you will understand the basis of figure painting.

In poor figure painting, a man may be pointing a sword ready for battle while the rest of his body is out to lunch, as the saying goes, picking daisies, or taking a nap. In a good painting of a seated figure, not only do the buttocks sit but so do the arms, legs, shoulders, and even the neck. For example, how do your ankles react when your palm has inadvertently come to rest on a hot stove? Can your features remain aloof when you're experiencing grief or sorrow? In other words, a figure can be artistically expressed in a state of extreme inner turmoil, but never in a state of detachment from any of its external components.

Line Versus Tone

Here we pass from the conceptual to the more practical approach to figure painting. The notion of line versus tone (or color) has preoccupied artists from earliest times. To me, there need be no conflict here since pastel allows either approach, or as we shall see, a combination of both. For those who prefer to emphasize line there's no better drawing medium than pastel. For those who like to express themselves in tone, pastel again supplies the ideal method.

Pure line is represented in the chalk figure drawings of the early masters, a medium quite similar to our modern pastel. These chalks usually come in degrees of yellow, brownish and reddish earth colors, white, and black. A talented artist can combine these few shades and simulate the effect of full chromatic paintings. Painting only with tone and without line is a more modern development. The Impressionists were instrumental in this rather revolutionary approach and since then a large part of modern art has been influenced by it.

However, a combination of line and tone is the way most artists choose to express themselves. Again, it becomes the province of each artist as to how much or how little these two factors will be incorporated into his or her work. All that's needed is a thoughtful consideration of the approach that will best suit the artist's statement.

Line versus tone isn't as important as conformity versus individuality. In other words, be yourself! If you feel the urge to outline your contours, do it, but if you don't—don't. By all means try both approaches, but don't lock yourself into either until you've determined which comes most easily and naturally to you.

Light

Realistic painting is actually the act of representing the effect of light striking form—whether this be a cabbage, a railroad locomotive, or a figure. The amount and angle of light falling upon the object determines whether it will be painted in one of the accepted *artistic* degrees of value— light, halftone, shadow, highlight, reflected light, or cast shadow. Naturally the area that faces the light source at the most direct angle will be the lightest. As the other planes of the form begin to turn gradually away from the light source, they become progressively darker halftones until they are turned so far from the light source that they turn into shadow.

Highlights are those small areas that are the highest in value in the painting by virtue of the fact that they are found on shiny surfaces that

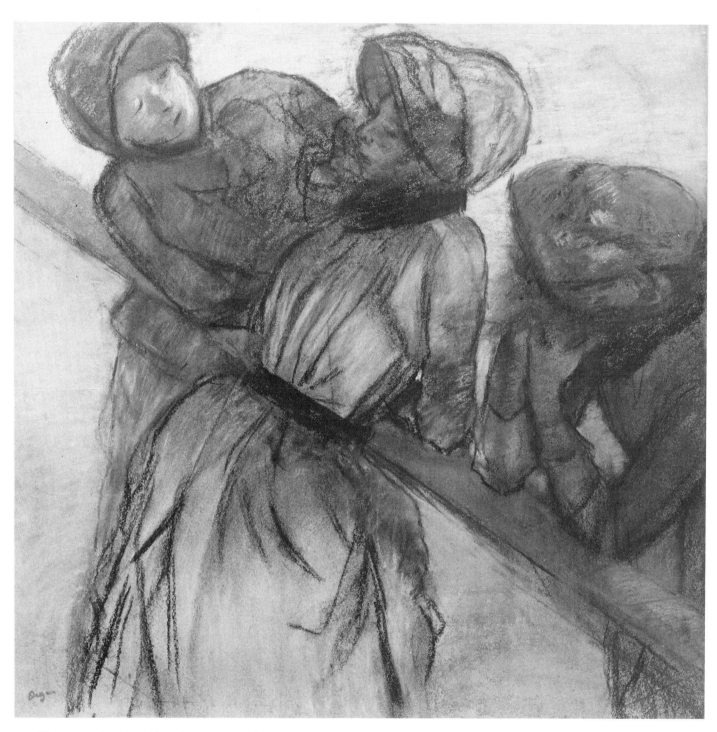

Conversation *by Edgar Degas, pastel on paper,
27-1/2" × 27-9/16" (Courtesy Milwaukee Art Center,
Gift of Mr. and Mrs. Harry Lynne Bradley). This is
purely an abstraction in which design plays a major
role—the contrast of dark shapes against the light
negative forms that surround them. Degas clearly
loved the diagonal composition that he borrowed from
the Japanese masters with whom he grew acquainted at
the height of his career. Note how often he uses the
device of a line running from the lower right corner up
to the upper left.*

reflect the original light source. Reflected lights, on the other hand, are areas—nearly always within the shadow areas—that reflect colors other than the original light source back into form. By the way, this is a very dangerous phenomenon since too many artists become entranced with these seductive reflections and weaken their shadow areas by flooding them with reflected light. Cast shadows are created by some protrusion of the form, such as a nose, which casts shadows by blocking the light.

Light in its various degrees is a topic that can be discussed practically forever; however, I'd like to avoid this and just point out that the artist should learn to *see* in terms of light, halftone, shadow, etc., and be able to relegate areas of the subject into one of these variations in order to facilitate the painting procedure. After becoming aware of this *graded* degree of light, the artist can paint accordingly, trusting his or her eye to assign the areas in the painting to one of these categories. There cannot be laws arbitrarily declaring this or that area to be light, halftone, or shadow, since each situation dictates its own value order. What is light in one pose can quickly change to halftone by the simple process of moving the subject several inches one way or another.

When you've finished posing your subject, take a good look and decide which area of his or her body falls into which category of light. This will help you to paint in a correct *relationship* of values, which is more important than the factual interpretation of these values. As long as they relate harmoniously to one another they will appear correct even if they're not precisely the way they appear in the subject. If there's a natural progression from light to halftone to dark that lends substance and solidity to the form in your painting, and none of these values are so close together or far apart as to appear contrived or artificial, your chances of achieving a good picture are that much advanced.

Loose or Tight Painting?

As I mentioned before, my view is that artistic maturity usually swings the painter toward a looser method of working. This may either be due to deteriorating eyesight or the wisdom that (supposedly) comes with age. Whatever the reason, the condition does exist. Somewhere during his or her career an artist usually adopts a

loose or tight painting approach. I'm convinced that the approach chosen by the artist is firmly tied to his or her personality and to try to counter it is like forcing a left-handed child to write with his or her right hand. So except for a few comments I won't try to tell you which is best.

Tight is all right and so is loose since there are superb exponents of each technique. However, I doubt that you'd be happy with your painting if it's so tight that it looks like a drawing with the colors filled in or if every hair is painstakingly painted in. Conversely, you wouldn't like it to be so loose that the form disappears in a mist of cotton or drifts into the background so that you can't tell a knee from a shoulderblade. Therefore, I advise a middle course. Unless you're planning to paint pop art, *trompe l'oeil,* or abstract expressionism, do try to achieve some kind of balance between loose and tight painting so that the form is retained but you don't end up with a collage of figure cutouts pasted against a background.

Choosing the Size

Some painters like to paint big, some small, some medium, and some in all sizes. There's no rule predetermining the size of a painting except the practical one: considering the size of the average room today, it's easier to sell a small painting than a large one. Outside of this, it's merely a matter of taste and individual preference.

For years pastel has been relegated to a medium reserved for small paintings, but this notion is just another fallacy about pastel. I've seen successful pastels in every size imaginable and there is no reason that it must be limited to certain dimensions. It's true that the manufactured boards and papers usually don't come larger than 32" by 40" or thereabouts, but there's nothing to stop you from preparing your own surface as big as you want it.

However, whether big, small, or medium, you should *plan* the size of the painting before you begin rather than haphazardly yanking a piece of paper from your closet and pasteling away. When choosing the size of the picture, you should think about the following considerations: Will it be edge-to-edge or a vignette? Is it a standing, sitting, or reclining pose? Is it a full figure, a three-quarter figure, or a half figure? Is it a single figure or a group? Will the background be simply a mass tone or will the form of the objects be

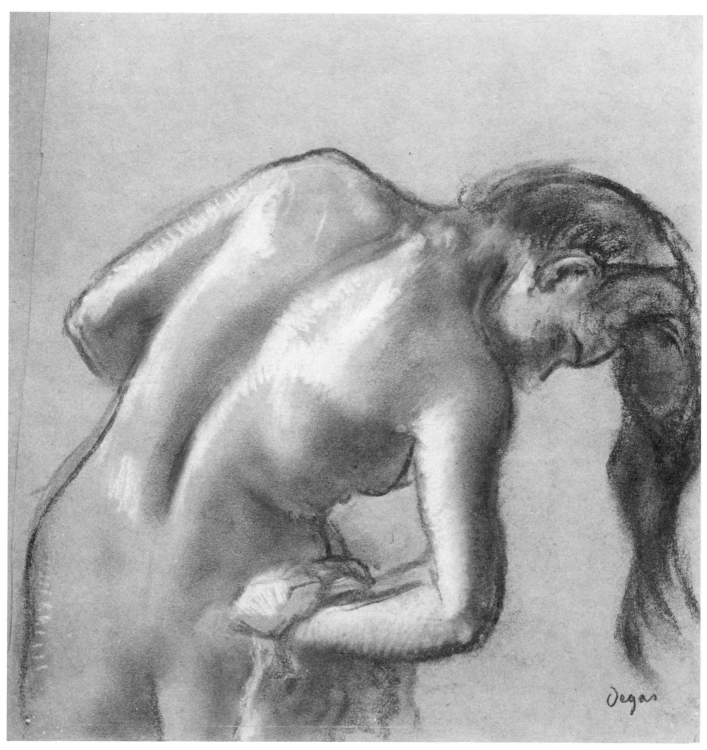

Nude (Study of) by Edgar Degas, pastel on paper, 10-3/8" × 10-3/8" (Courtesy The Metropolitan Museum of Art, Bequest of Stephen C. Clark, 1960). The deep, dark groove in the woman's lower spine and the fold of her flesh at the waist are the two most important touches in the painting. Learning to look for such vital, telling marks is the key to effective figure painting. Place your thumb over these two areas and the whole effect of the painting is lost. The thrust of the trunk is no longer so evident, and the study means very little now. Whenever you paint the figure, look for the two or three angles, curves, or planes that characterize the pose of the model, then stress and dramatize them.

accurately depicted? Would the subject be shown to better advantage in a square, vertical, or horizontal setup? Where will the painting ultimately be displayed—in a living room, an office, a museum, etc.? These factors should affect your decision determining the painting's dimensions and you would be wise to consider them well before you begin. Leaving such decisions to chance is lazy and unprofessional.

The Preliminary Sketch

Few of us are so talented that we can pitch right in and paint the finished figure without some kind of map or outline to guide us. The only question is—how extensive should this outline be?

Some artists make careful drawings, or cartoons, that are ultimately transferred to the surface of the paper or canvas before commencing the actual painting. This method allows them to solve all the problems of drawing and composition in advance of the process of painting itself. It's not a bad method at all, but it requires a kind of patience and discipline that's not found in all artists' personalities. It takes a special cold-bloodedness to dampen one's eagerness to paint when the fires of creative effort blaze up inside. Making countless drawings and preliminary color sketches before commencing the final painting is surely a traditional and acceptable method of working. But if you're anything like I am, you can't wait to get going; and taking the hours or days to compose and draw would be like sitting in a 100° heat watching an icy glass of water on the table without taking a drink. If I don't paint when I get the urge, I feel that much of the excitement of painting will be lost and that this will show up in the final product.

Therefore, I make a compromise between my impulsive side and my logical side and I make an outline of sorts, but only a very rough preliminary map executed right on the painting surface and calculated to keep me from straying too far afield. This outline puts down the rough proportions of the figure in relation to each other, the main thrust of the body as it leans or twists in a certain way, the sweep of the masses and forms, and the approximate breakup of the big lights and shadows. At this time I also indicate to myself how the figure will fit into the space within the four sides of the surface and how much "air" will be left around the subject's outer contours.

And from this rather primitive shorthand note, I jump right into painting and follow through to the bitter end.

Again let me stress that this is not the *best* way, only *my* way. If you are able to curb your impatience and make detailed preparations for the ultimate painting, by all means do so.

What to Watch For

As we have just discussed, the preliminary sketch can range from a few scribbles to a conclusive, fully orchestrated drawing. We have already decided that the degree of finish of this preliminary effort is open to various interpretations. Now we'll examine the factors that should be taken into consideration during its execution:

1. *Anatomy*. If you're not familiar with the anatomy of the human figure, learn it either through reading, art school, or practice. Despite the rebellious movements and political upheavals of the past decades—human beings continue to emerge according to certain prescribed proportions and configurations. Until this, too, changes, consider the anatomy of the figure when executing your preliminary sketch or outline.

2. *Perspective*. The laws of perspective take in such factors as foreshortening and relative size, depending upon the angle from which one is looking. I don't know the rules of perspective (I can't think of anything more tedious) but I do know that perspective can't be ignored either. If you don't naturally *feel* what looks right or wrong relating to the perspective of your subject, read up all you can on the subject and try to resolve the problem intellectually.

3. *Balance*. One of the most obvious mistakes beginners make in figure painting is that their subjects so often lack balance. Make sure in your preliminary sketch that your figure stands, sits, or lies in *balance*. Aside from levitation, Marc Chagall, and astral bodies, none of us has yet learned to float in the air unassisted.

4. *The "Ideal" Proportions*. Although this properly falls under the aegis of anatomy, I must take a moment here to speak of the so-called "ideal" proportions as set down by generations of bores who have had nothing better to do than confuse the impressionable. According to them, the ideal

proportion of the human figure is eight times the length of its head. To this I say stuff and nonsense! There's no such thing as "ideal" proportions and I can only advise you to ignore such talk.

5. *Composition.* Composition has also suffered the attentions of those who insist on attaching to it all kinds of rules and restrictions. To put it as simply as possible, composition means the placement of your subject within the confines of the painting surface. As to rules—if it looks good where you've placed it, it's good composition.

However, this placement must be carefully thought out beforehand so that it *does* look proper and right. What determines this is simply good taste and a good eye.

To sum up—in doing your preliminary sketch think of anatomy, perspective, balance, and composition. If all these factors are right, chances are much better that you'll go on to produce a lively, provocative figure painting. Incidentally, this preliminary sketch can be in charcoal, carbon, or soft or hard pastel (which I prefer).

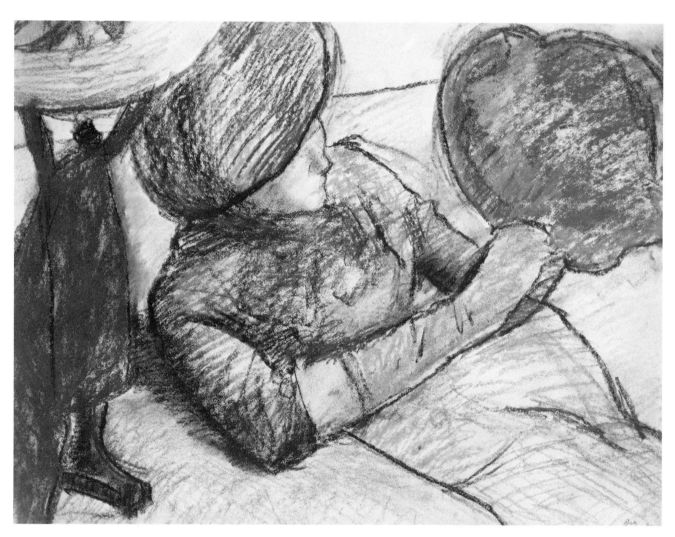

Woman Holding Hat in Hand *by Edgar Degas, pastel, 19-1/4" × 25-1/2" (Courtesy M. Knoedler & Co., Inc.). Showing women absorbed with hats gave Degas an excuse to utilize the broad-brimmed shapes of the hats fashionable during his era. He used millinery scenes extensively to express both color and tonal ele-* *ments. The rough stroking is very evident here, with scant attention paid to detail. Only the major forms are expressed, and as usual the shapes are run out of the picture. Before the Impressionists, artists always made sure to include all of the subject within the confines of the painting.*

Posing and Composing

The human figure is capable of four fundamental actions—standing, reclining, sitting, and moving about. We will consider these, and then discuss formal and informal poses and painting the group. Then we'll examine lighting, backgrounds, and props in figure painting.

The Standing Pose

The standing pose allows you to paint the figure in its truest proportion. This is probably the best pose if you're doing a historical or allegorical painting and wish to express grandeur or heroism, although this genre of art is long dead and buried. The standing pose does allow you, however, to show the body in positive action such as boxing, fencing, or dancing. It also shows the great twisting action of the trunk in relation to the legs by bending it radically at the waist and neck. A favorite pose of artists has been to paint the legs pointing one way, the shoulders in another, and the head back in the first direction. This is a traditional art school pose and it does much to acquaint students with the great sweep of the three major forms of the figure—the legs, the torso, and the head. It's corny but effective. The model can also be posed standing but deeply bent at the waist.

The thing to avoid in a standing pose is the "mug-shot," in which the subject stands as stiff as a convict looking straight into the camera and displays as much animation as a stalk of asparagus. The only thing worse than a stiff standing figure is two stiff standing figures. If you're posing people eyeball-to-eyeball, make sure they're doing something interesting with the rest of their figure—crossing their arms or ankles, leaning against a desk, etc.

If you're really stuck for an interesting standing pose, don't hesitate to borrow one. Artists have

Time Out *by Flora Baldini Giffuni, pastel on paper, 24" × 18". The young woman's right leg is bent naturally backward so that she can help maintain her balance while sitting. Were she to thrust it forward as she does her left leg, this would cause her to slouch and push farther forward from her sitting poistion. Even when we relax, each part of us works in unison with all our other parts to arrange or maintain certain positions. Painting a figure as a series of unrelated parts is contrary to the law of anatomical interdependence. Think of the figure as an entity regardless of what pose it assumes.*

shamelessly stolen poses from one another over the centuries. Surely you've seen scholarly art books comparing the compositions of—let's say—a Manet and a Goya. This is an accepted practice, so don't worry about it. Your only obligation is to execute your painting with such verve and vitality that one day someone will steal *your* pose. One final note—remember the factor of balance in painting the standing pose.

The Reclining Pose

Think of all the nudes you've seen reclining against satin pillows while chubby little cherubim hovered overhead. The reclining pose is traditionally associated with languor, indolence, frivolity, and sex. Consider Lautrec's bordello scenes, Boucher's and Fragonard's courtesans, and Manet's outrageous (at that time) *Olympia*. Few men have ever been shown in reclining poses, so here's your chance to break new ground.

The reclining pose is in direct opposition to the standing in that all the muscles are in a state of relaxation rather than tension. This is an important factor and you won't be faulted if you emphasize this condition. In art, it never hurts to exaggerate certain factors since we are the *interpreters* of nature, not her slavish renderers.

It's interesting to note that Degas, one of the greatest interpreters of the female body, seldom, if ever, painted a reclining pose. His women were always busy doing something and never had the time to lie down and take five.

The Sitting Pose

The sitting pose strikes a fine compromise between the standing and lying poses. Sitting is a state of half-relaxation, half-tension. The more you recline, the more you ease your muscles, but when sitting it is possible to keep your muscles nearly as taut as when standing. This is a factor you must consider when painting a sitting figure, since this relative tension or lack of it shows up in the other parts of the body. The face of a person resting is not like the face of the same person standing. If you doubt this, look down at a reclining person and compare his or her face to the way you're accustomed to seeing it during the day. An artist must be keenly aware of such things—the ability to observe and evaluate these factors

must be operative at all times. Keep in mind that a sitting pose can be terribly bland and uninteresting, so it's up to you to add some spice to it.

The Action Pose

When a person is in motion—walking, running, jumping, or being suspended by outside forces—everything is different from when the feet are planted solidly on the ground. With the advent of photography it has become easier for artists to represent the figure in motion, yet this remains the most confused kind of painting. For example, in the classic crucifixion scene, the figure of Christ is supposed to be nailed to the cross, yet in the majority of such painting this sense of suspension is missing. The same holds true for most other action paintings. The *sense* of movement is usually missing and the effect is more that of frozen action, much like a frame of a motion picture film that has jammed in the projector.

The reason for this is that most artists don't understand the mechanics of motion. Only by close observation will you be able to sharpen your understanding of the human body in action and in repose. A study of Eadweard Muybridge's magnificent photographs of people walking, squatting, running, etc., will teach the artist about the body in motion. The artist will learn not to exaggerate certain motions and to play down others, and see that a person doesn't walk with his legs alone but with his arms, hips, trunk, and whole body.

However, the study of photographs alone isn't enough. If you plan to paint a runner, attend a local track meet and see how the athletes respond to the stresses of intense physical effort. Watch their faces as they cross the finish line. They aren't very much like those of the warriors in seventeenth century battle scenes who look as if they might be thinking about which tie to wear to the victory ball that night.

Painting the Group

One of the most challenging aspects of painting can be depicting two or more figures and relating them to one another. This relationship can be emotional, compositional, tonal, linear, chromatic, or spatial, but if it's not there, you'll simply end up with several figures in one painting that can be cut up and hung individually. A good

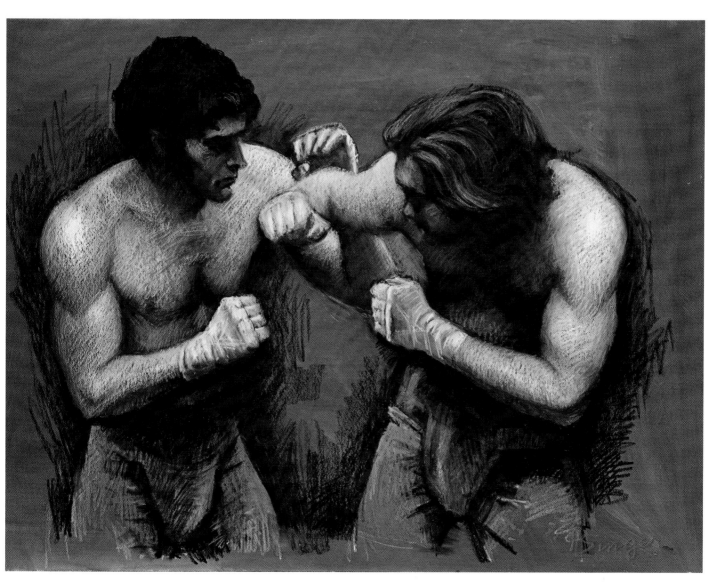

The Boxers *by Joe Singer, pastel on board, 23-1/2" ×
31-1/2" (Collection Mrs. June Singer). My son, Ian
(left), slipping a right cross by his friend John Dunlop,
the Ballymena Brawler. I caught the boys just as they
concluded a heavy workout and were tapering off with
some good-natured sparring. I tried to depict the effect
of gleaming skin and muscles still tense from the
strenuous exercise. Even though their faces aren't dis-
tinctly delineated, I think I've captured the determina-
tion of the experienced boxer who knows to keep his
guard up, even when fooling around.*

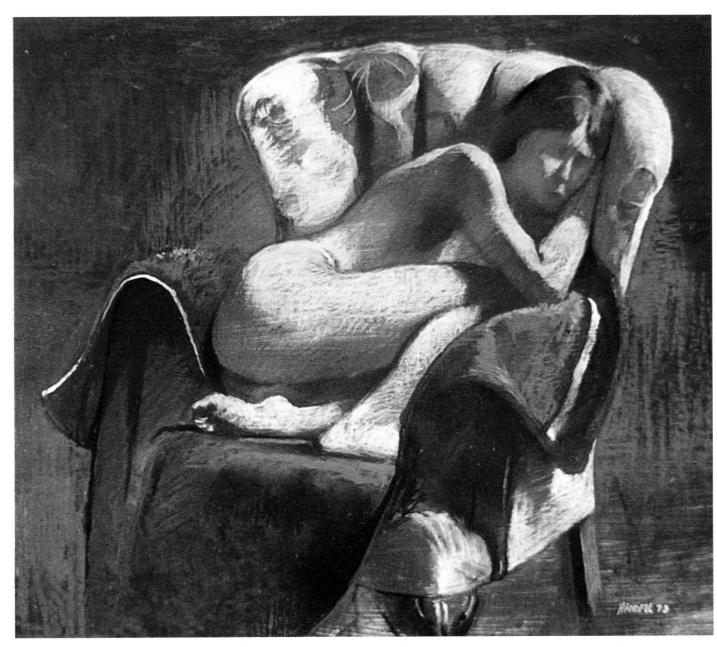

Curled-up *(Above) by Albert Handell, pastel on board (Private Collection). Albert's usual method is to use a sanded pastel board on which he works with inks and watercolors. He tones the board, surprisingly, with water-based wood stains because he finds their transparent tones more sympathetic to paint on. First he composes the picture with charcoal, then uses the inks to lay in the flat color patterns. When the inks are dry, he turns to soft and hard pastels and to pastel pencils. The results, as seen in this study, are most effective. Particularly striking in this particular painting is the quality of cool light that bathes the subject. Doesn't it create an enormously dramatic impression of contrasting high and low values?*

Nude Study *(Right) by Richard L. Seyffert, pastel on paper, 24" × 18". The subtle and almost monochromatic coloration produces a soft, pleasing effect of cool, pearly skin. The pinks are properly placed in the hand and nipple areas, and the yellows, greens, and blues properly placed in the cooler halftones. Note how the higher values are reserved for the normally lighter breasts. The artist has employed the rubbing-in method in selected places to achieve smooth, rounded planes. Highlights are kept to a minimum and shadows are kept open and loose. Again I want to stress that an experienced painter like Seyffert has wisely kept away from the warm reds and pinks in depicting the true color of "white" skin.*

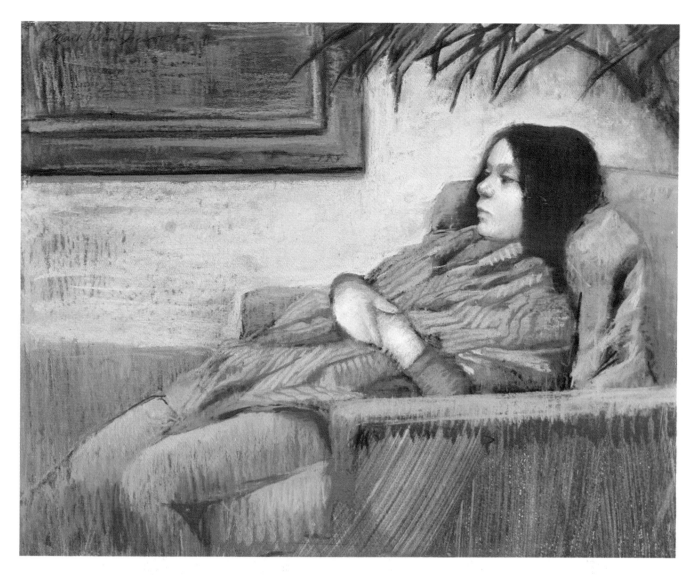

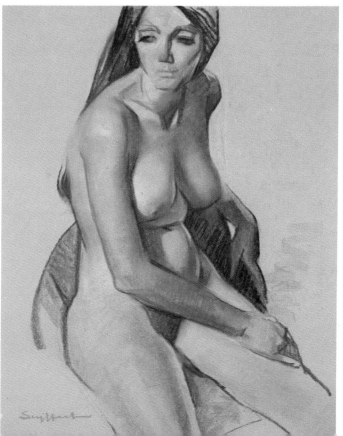

The Striped Shawl *(Above) by Mark Alan Isaacson, pastel on sanded paper, 22" × 24" (Courtesy Baruch College). Isaacson uses his strokes to follow the form. This is an accepted practice in pastel painting and one of its many advantages as both a linear and a tonal medium. Painting the subject against a lighter background is one of the products of Impressionism, prior to which the figure was always portrayed as a light area placed against a darker setting. See how simply—as one mass—the artist has painted the dark hair. The hands are also very simply but effectively treated. The fingers aren't individually outlined, but the impression of one hand gripping the other is achieved.*

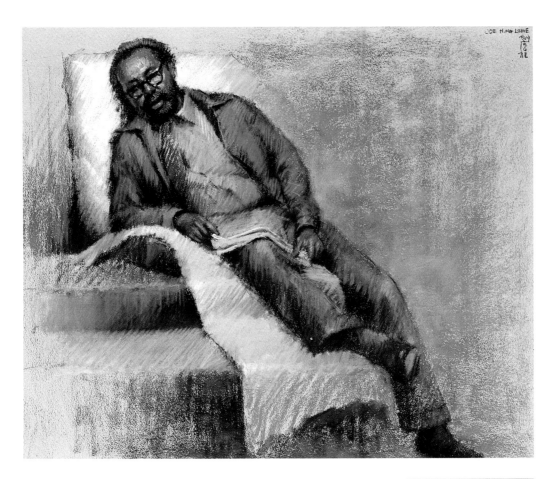

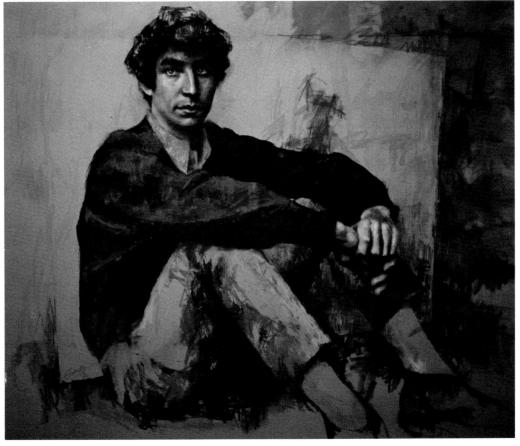

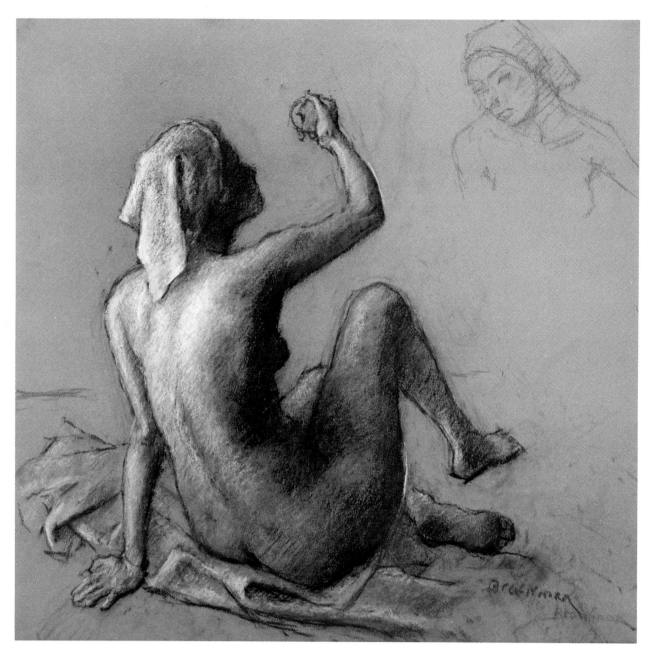

A Short Sleep *(Top Left) by Joe Sing Lowe, pastel, 24" × 20". The artist strokes pastel to indicate the varying shapes in the trousers, shirt, cloth, and steps. Contrasted to this are the rough, smeary sections in the background. The handling of the head reveals a sure, skilled hand—the cool, blue highlights bring areas of the face forward from the warm, brown skin tones surrounding them. Lowe isn't afraid to use bright color—note the strong hues of the jacket and tie. This only works well when grays and neutrals are employed in conjunction with such vivid primaries, as is the case here.*

Dan *(Left) by Angelo John Grado, pastel on paper, 37" × 43". The artist centered all the warmer elements of color in and around the face, surround-ing it with the cools of the sweater, trousers, and background. Because warmer color tends to advance and cooler to recede, this is one way of focusing a viewer's attention on a certain area of the painting.*

Nude *(Above) by Robert Brackman, pastel on paper, 16" × 16" (Collection Charles Pfahl). In this exquisite study by one of the contemporary masters of painting in America, Brackman outlines the fig-ure in dark—a stunt that could easily trip up a less talented artist but which works out perfectly due to the simple but absolutely expert modeling of the form. The use of color is rich yet subdued—tans and ochres predominate with barely a trace of blues or greens. This is the palette favored by the Dutch masters who obtained remarkable flesh tones.*

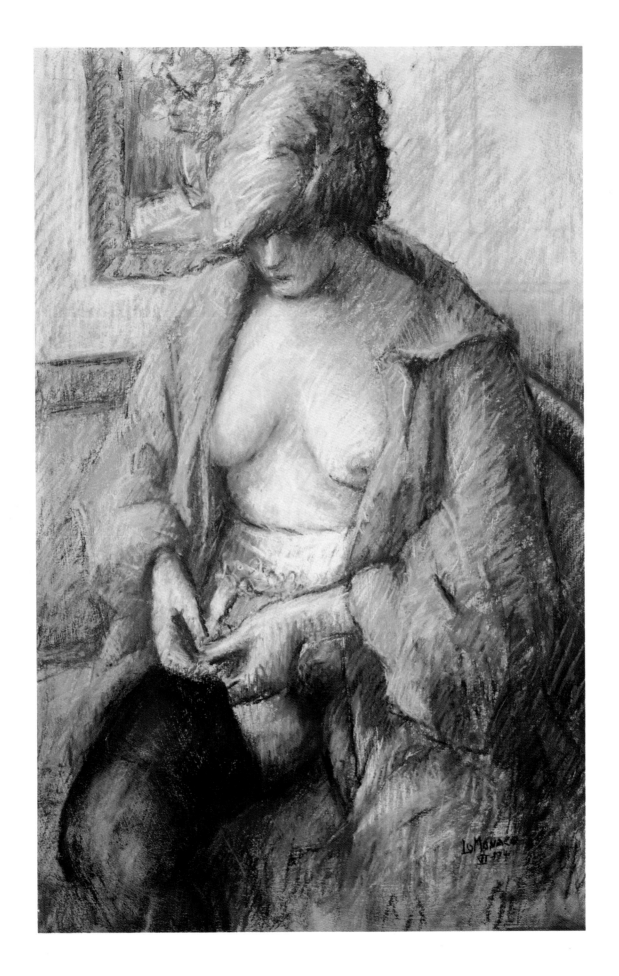

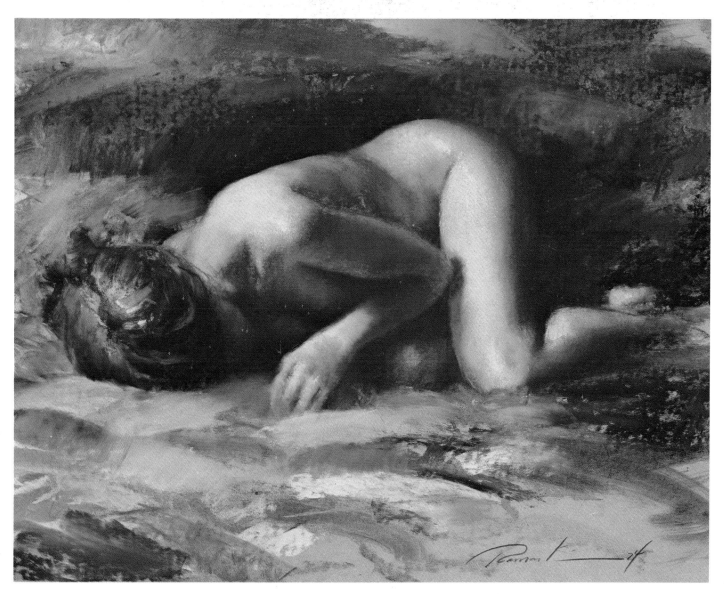

Vannina Dressing *(Left) by Stephen LoMonaco, pastel on paper, 36" × 24". Elements of impressionistic and pointillist influences are at work in this lovely pastel reminiscent of some of Renoir's and Pissarro's lusty, sensual women. LoMonaco uses a broken-stroke technique with effect, especially in such areas as the neck, hands, and robe. Note how the cool blues of the wall are repeated in the neck and the warm tones of the robe in the picture frame. Edges are lost and emphasized in selected areas rather than made studiously consistent, which tends to be boring. Particularly striking is the way the artist handles his shadows—strongly yet not so densely that they don't breathe.*

Nude *(Above) by Ramon Kelley, pastel on cardboard, 16" × 20" (Private Collection). A most skillfully executed study in the true painterly technique. The deftly placed highlights on the hair, hips, knee, and shoulder lend roundness and dimension to the form. Note how loosely Kelley has treated the face—it's a blob of shadow. Yet we ''buy'' it completely since it's so right and natural and fitting. As in Rembrandt's later works, there isn't a hard edge anywhere, yet the form is solid, strong, and stable throughout. The bright colors of the background are in direct opposition to the dictum that these elements should be reserved for the subject—but the whole thing works, doesn't it?*

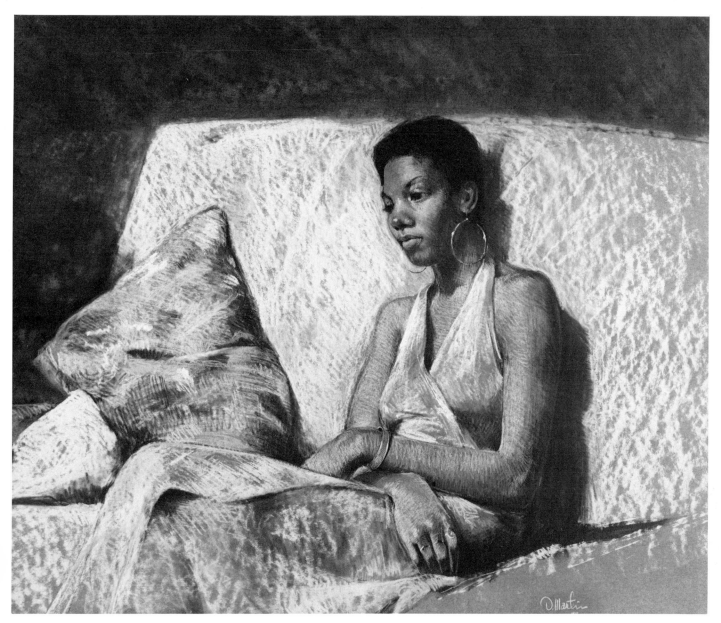

Santa Clara Dancer *(Left) by Bettina Steinke, pastel on charcoal paper, 22" × 14"(Collection Mr. William H. Hughes). This loose, sketchy method of using pastel results in a marvelously alive study which virtually breathes the atmosphere of the arid, dusty, sunbathed Southwest. The head is painted in several basic planes, but it tells all it has to about the solemnity and concentration of the dancer. Note the distinctive cool highlight on his forehead—a phenomenon frequently encountered in dark skin. The skin is painted in halftones and shadows only, with no more than four highlights to round out the form. Steinke made good use of the tone of the paper on the inside areas of the leather robe and on the left moccasin.*

Silver Earrings *(Above) by David Martin, pastel on sanded paper, 22" × 26" (Collection Dr. E.C. Cuadras). The sanded surface provides the rough, pebbly ground for the artist's broken-stroke technique. Martin uses the pastel traditionally to follow the shapes of the form in the forehead, arms, and the halftone area at the edge of the light and shadow in the face. But when he turns to the dress, sofa, and cushion material, he paints in broken pointillistic strokes, scumbling and cross-hatching freely. The style is generally on the tight side, with such details as rings and the bracelet clearly delineated. When properly handled, this can result in a most effective painting.*

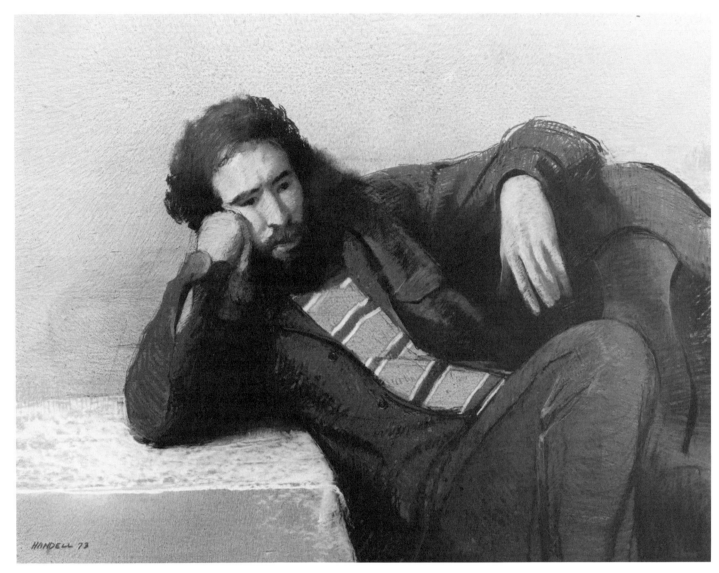

Saul Krotki *by Albert Handell, pastel on board. Props make all the difference here. They provide balance for the composition and let the subject drift naturally into his introspective mood. Note how subtly Handell modeled the right cheek pushed sideways by the fist. It's such little touches that lend credence to figure painting. As an artist you must force yourself to learn to detect and capitalize on such factors so that after a while you see everything with a painter's eye. It's both a curse and a blessing, but its advantages outweigh any discomfort or disillusionments this "X-ray vision" may bring.*

group painting may have figures in an obvious state of alienation toward one another, but even incompatibility expresses a relationship, although a negative one.

A group figure painting grants the artist a marvelous opportunity to make a statement about man in his most natural environment—relating to his fellow creatures—which is the way most of us spend the majority of our hours. You don't have to love humanity to execute a successful group painting. You do, however, have to recognize the deep dependence we all share with and have upon one another whether we like it or not. A group painting also provides the artist the scope to do something grand, eloquent, and complex. Some favorite themes that come to mind are episodes from the Bible, history, and mythology.

The artist who elects to paint a group of figures mustn't necessarily forge an emotional involvement with the subject. He may not care who is doing what to whom—his interest may lie purely in the interplay of muscles, forms, colors, lights, and shadows. The way *not* to paint the group is having them all stare back at you with expressions of blank vacuity in the manner of the family snapshot or some nineteenth century representations of important events. Simply painting a group of people standing around is often an exercise in pure showing off.

If you contemplate a group figure painting, make sure in your own mind what your goal is. Ask yourself a number of tough, searching questions such as: Is it a purely decorative effect I'm after or am I trying to convey a message? Am I prepared to lose some of the figures in the shadow to help the total effect? Am I sure that every figure shown is acting or reacting in accord with the mood of the painting?

The Formal or Informal Pose

The trend today is toward the informal, casual pose as compared to the poses of the heroic figures of the past. Even such a deeply humanistic artist as Rembrandt stuck helmets and armor onto the plump Dutch burghers to lend them a measure of pomp and glory. Goya was among the first to deflate the grandiloquent approach to painting the human figure. The Impressionists once and for all put to rest the concept that all people are tall, muscular, lithe, and supple by showing the average stumpy, lumpy, squat Frenchman and Frenchwoman with brutal but sympathetic candor.

To paint the figure formally these days takes a bit of courage. One invites the scorn of colleagues, teachers, and critics. But to say that it's wrong is fatuous. However, one must differentiate between formal and stiff, formal and pompous, and formal and pretentious.

Lighting the Figure

"Lighting" connotes the artist's ability to control the illumination bathing the subject. There are three basic kinds of lighting situations—natural indoors, natural outdoors, and artificial indoors. Under the first two conditions there are limited means of controlling the lighting. In the third, the artist can light the subject at will. I find that all three lighting setups work in painting the figure.

First, I would like to comment on artificial lighting in figure painting since there has been controversy regarding its use. The basic differences between painting under natural and artificial light is that artificial light tends to falsify (warm or cool excessively) certain color tones. The reason that many realistic painters object to it is that in a portrait, let's say, fidelity of color and attention to detail may be of more pressing concern. However, artificial light doesn't falsify *values* to any appreciable extent, and to me, figure painting is more a matter of value than of color. I like to think of figure painting as an exercise in large forms and masses, a condition encountered in tone drawing where color is vital but not of uppermost consideration.

In the artificial lighting setup, you are the master and can orchestrate at will, moving lights about freely and doing whatever you please. However, if you *are* going to impersonate nature, take a lesson from her and remember that she uses only one sun to do the job. It may be all kinds of fun to place seventeen lights hanging from every sconce and mantle, but you'll end up with something resembling a carnival.

My rule is one light source only with no secondary light sources to throw reflected light into the shadow or auxiliary spotlights to cast interesting glints into the irises. Leave all that to wedding photographers and other poor souls who try to improve on nature. A single light source—whether natural or artificial—

will lend the form its true and proper value tonality in which light is light, halftone is halftone, and shadow is shadow.

In natural indoor lighting you can raise or lower window shades, or if you have a skylight you can control the amount of light in order to achieve the effect you're after. You can also make a light fall from the side, from below, or from above. Much of this adjustment, of course, can be gained by moving not the light but the figure itself. But through the use of screens, mirrors, reflective objects, venetian blinds, window shades (preferably rolling up from the bottom), cloths, etc., you can to some degree control the amount and the direction of light illuminating your subject. In the outdoor setup, you have such options as posing your model in the sun or the shade, under a tree or an umbrella, etc. The amount of control here is negligible.

The type of lighting you decide upon is a most personal choice that depends on the person you're portraying, the place you're working at, and hundreds of other conditions that accompany each painting experience. Some like the spotlight effect, others prefer the scattered effect. Side lighting naturally produces different effects than top, bottom, or back lighting does. So, I would never venture to recommend a particular lighting effect—what's best is what appears most attractive to you.

I do, however, urge you to experiment with different lighting setups so that you become familiar with them all. By all means, shift, move, adjust, maneuver, turn, block, focus, blur, screen, lower and raise your light source and your model so that you've explored all the possibilities. Degas painted some interesting pastels of the figure on stage with the footlights shining up its nose. Borrow the lighting tricks of the masters. Get acquainted with the chiaroscuro of Caravaggio and Georges de la Tour. Books, reproductions, and museums can teach you more about lighting than anything I might discuss in these pages. Since lighting isn't a mechanical process but strictly a matter of taste, I can only advise you to learn, read, inquire, and study, and hope that some of the aura of genius that passes before your eyes will rub off on you.

Two final pieces of advice about lighting—try to see to it that both your easel and your box of pastels are illuminated by essentially the same light that strikes your model. This will keep your painting cohesive and consistent, even if it isn't 100% realistic. Secondly, try to avoid or at least keep down the amount of reflected light in your painting. Nothing makes a picture look more gaudy than globs of reflected lights in the shadows.

About Backgrounds

A knowledge of backgrounds, which is useful in most kinds of painting, first comes with an understanding of their various functions. Backgrounds serve:

1. As contrasts in value to set off the subject.

2. As contrasts in color to set off the subject.

3. To help lose edges.

4. To supply a medium tone that keeps the figure in eye-pleasing tonality. By this I mean that such a background tends to fuse the values within the figure by reducing the variations between extreme light and extreme shadow to a realistic ratio.

5. To provide the three-dimensional effect of receding and advancing planes.

6. To aid the composition by stressing certain areas and directing the viewer's eye to desired points of interest.

7. To depict some sort of action or incident in genre painting.

8. To combine the figure with a cityscape, landscape, seascape, interior, still life, or other kind of subject.

I'm sure there are dozens of other useful things that backgrounds do, and whatever these might be I'm all for them and I'm firmly dedicated to their importance in painting. Since I have always been fascinated by backgrounds and tend to go on about them, I'll spare you and just say that slapping a few indiscriminate strokes here and there does not a background make. It must be articulated just as carefully as any other part of the painting, and this includes both planning and execution. It's true that some painters are able to complete the figure first then dab a few splashes into the background, but I have to keep everything going at once. To me, the background is just as important as the arms, legs, and torso.

Naturally, each kind of painting calls for a dif-

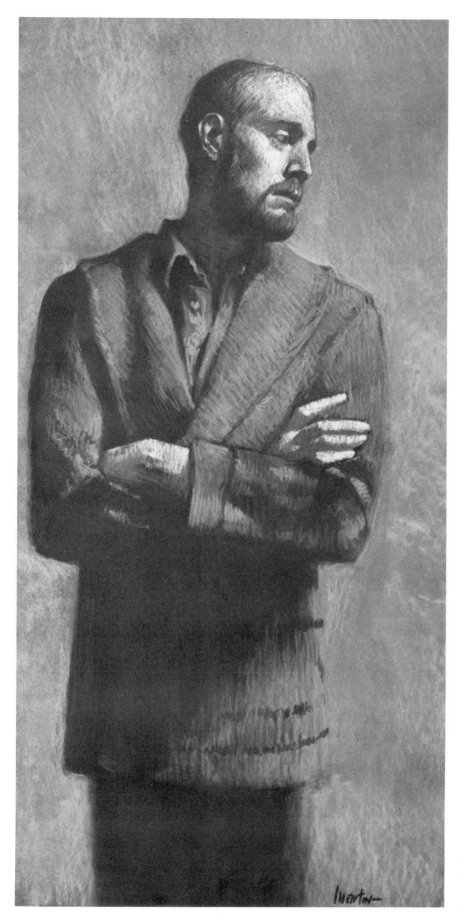

Russell in Red by David Martin, pastel on sanded paper, 21-1/2" × 11-1/2" (Courtesy Desmond/Weiss Galleries). Had the subject been facing us straight-on, this might have emerged a static painting. Turning his head to the side obviates such a possibility and lends a measure of intrigue to the picture. This device too was rarely practiced prior to the Impressionists. The Academy would have rejected such a departure from its hard and fast rules. Observe the standing poses from the eighteenth century and earlier. Even as the subject is fleeing a lion about to devour him, he turns his face squarely toward us to let us fully savor his fear and deep distress. Happily, such "rules" have been swept under the rug.

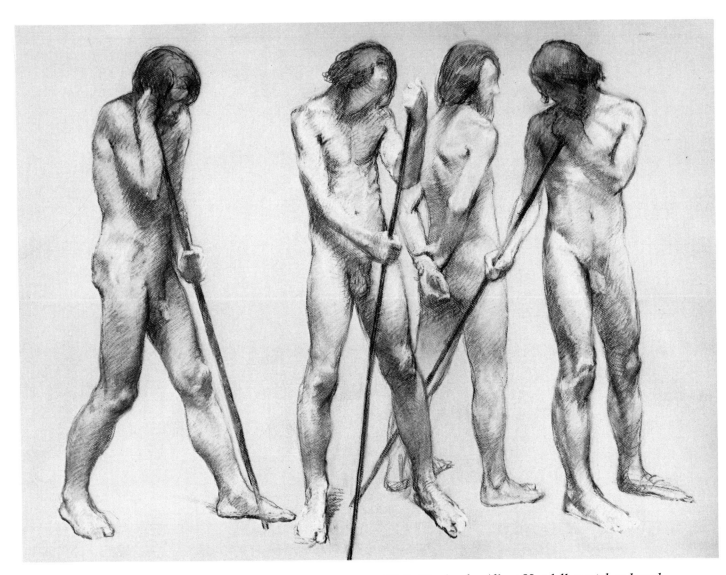

Male Nudes by *Albert Handell, pastel on board. Handell took advantage of the model's presence to paint him in a series of poses. Here's where pastel shines again; I can't see anyone doing this in a purely painting medium. The pole serves to emphasize the balance, a point that I harp on so repeatedly. Leaning upon it throws the body into a series of actions in which the muscles, ligaments, and tendons alternately tense or relax to accommodate the pressures (or lack of them) placed upon them by the function of the pole. Thus the figure switches from a positive to a negative action with each new situation. The artist must be acutely aware of these subtle changes.*

ferent kind of background. It can be extensive or brief, vague or distinct, dark or light, flat or broken in color or tone, etc. When to use which is again a problem only you can resolve. The main consideration is that it be appropriate to the particular painting. In other words it must complement, not resist, the subject. It can be contrasting in mood, tone, color, etc., but it mustn't be antagonistic.

Up until the time of the Impressionists, the tendency was to use dark, somber backgrounds. Following the Impressionists, backgrounds lighter than the subject came into vogue. Neither is more preferable, neither is correct—they're merely two different approaches based largely on personal preference and inclination. Some artists will show every aspect of the room where the figure is posing in clear detail, others will merely surround the figure with vague tones. Handle this in any way you choose, but don't *ignore* it or leave it to chance. Think about your backgrounds with the same intensity you devote to your main subject matter. They are vital to the success of your painting when they perform their function, which is to effectively set off the figure in your painting.

Using Props

Props are those seemingly unobtrusive objects that support, complement, and adorn the main subject matter, which here is the figure. The intelligent use of props dictates discretion and restraint. In the seventeenth and eighteenth centuries, artists were forced to bedeck their subjects with yards of lace, wigs, beauty spots, sashes, swords, and fans. Today's artist has been totally emancipated so that props can be used at his or her own discretion, although artists belabor the point by loading all kinds of unrelated items onto their models. So unless you're consciously attempting to jolt your viewers out of their shoes (which is okay with me), I suggest you exercise considerable selectivity in your use of props with the figure. Whenever you include a chair, cane, umbrella, or whip, ask yourself: Does it add or take anything away from the figure? Does it advance or retard the effect I'm seeking? Am I putting it in to help the composition or just to make people stop dead in front of my picture?

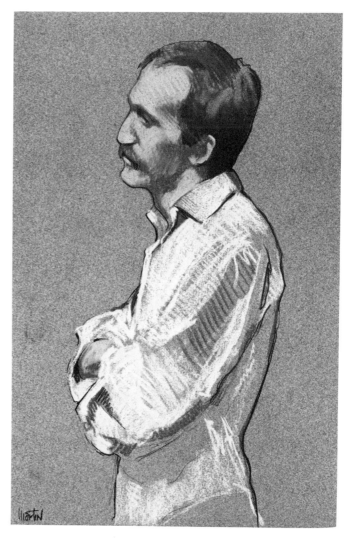

Patrick *by David Martin, pastel on paper, 14" × 9-1/2" (Courtesy Desmond/Weiss Galleries). The artist uses line to define the proportions before him. Contrary to accepted practice, he saves his lightest lights for the shirt and throws the face into halftone. But his aim here is to accentuate the action of the pose, not to depict the character of the model. This kind of painting is designed essentially to express the rhythms and masses of the human figure; the individuality of the model is subordinated to the accurate interpretation of the form.*

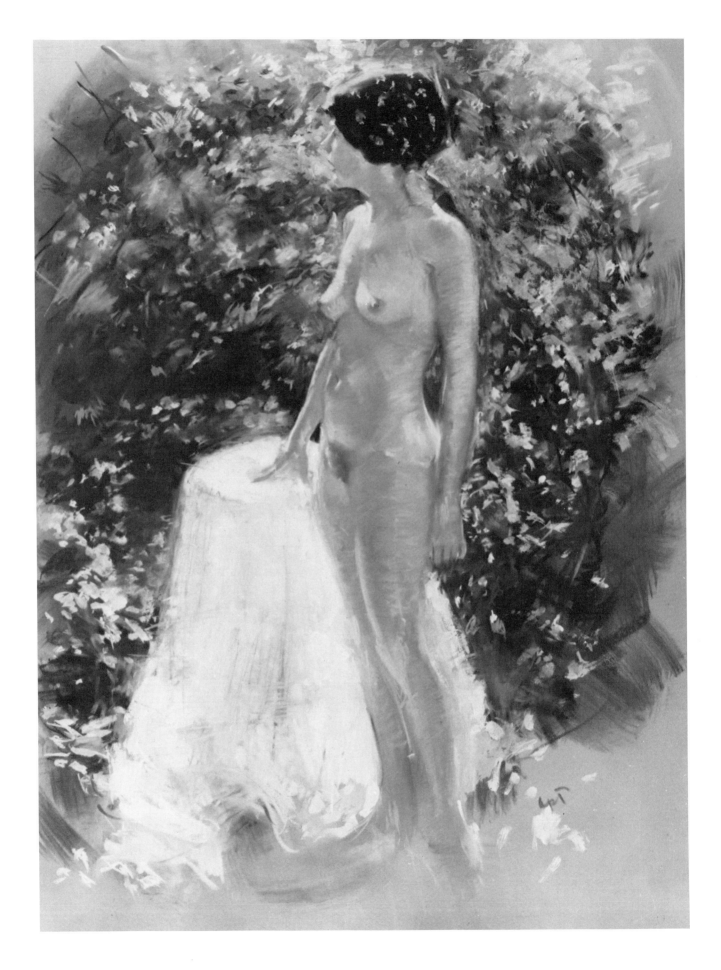

The Nude Figure

The nude has always dominated figure painting, and to most people—artists and nonartists alike—these are synonymous terms. In *Painting the Human Figure* the late Moses Soyer gives a brief but most useful history of the nude in art. Mr. Soyer tells us that through the ages the popularity of the nude has waxed and waned due to historical, social, and other concurrent events. During the Golden Age of the Greeks the nude reigned supreme as the prime subject for artists and sculptors. The nude suffered a stunning decline with the onset of Christian religious art in the fourth century and languished thus for a thousand years. It enjoyed a revival in the fifteenth century and went through a series of changes in which the human body was idealized, stylized, elongated, stretched every which way, and otherwise rearranged.

It took the Impressionists to bring the nude down to earth with a rude bang and a crash, and it's never been the same since. Today arms, legs, and other accoutrements grow out of the most unlikely sites, and heads are allowed to float astrally. The nude is no longer sacred, and artists feel free to do with it whatever they choose.

The Female Nude

The classic nude is the female nude—a subject that has probably been painted more often than all other subjects combined. Hardly a painter of note has failed to represent this subject in his or her oeuvre. The reasons for the popularity of the female nude throughout art history are probably complex and most interesting. However, whatever they may be, the fact remains that most artists have and will continue to paint this subject as long as easel painting endures. But to an artist interested in painting the human body, the factor of gender should not be of primary concern to the concept of *figure* painting

Nude in Sunlight by *Charles Apt, pastel on bristol board, 40" × 30" (Courtesy Far Gallery). Apt prepared his ground by spraying tempera over the kid-finish bristol with an airbrush before proceeding with the soft pastels. Note how light the shadows on the fair skin emerge in the bright outdoor setting. There are pointillist effects here, particularly in the scarf and shrubbery. The skin tones are masterfully rendered with cool blue areas alternating with pinks, pale tans, and touches of very light ochre along the shoulders and buttocks where the figure picks up original and reflected light. The entire painting seems to shout: outdoors!*

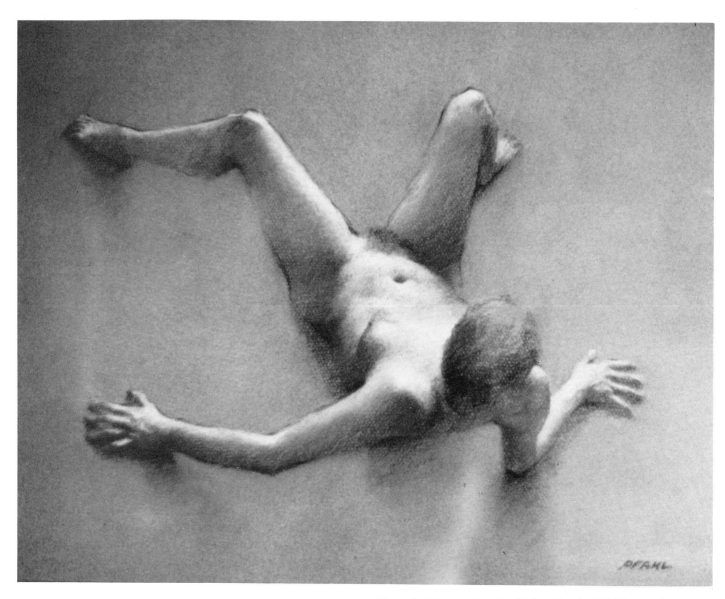

Female Figure Study #1 *by Charles Pfahl, pastel on paper. Only someone as sure of his skills as Pfahl would dare tackle such a difficult pose. The angle of view recalls some of the offbeat efforts of Degas, who constantly sought to transcend the banal "mug-shot" approach. Note the perfect balance of the reclining figure, an illusion further enhanced by the artfully placed shadows beneath the hands, arm, and torso. Placing the highest lights in the breast and gradually darkening them as they travel down the body gives us an indication of where the light is coming from, a most useful device for depicting the roundness of the form. The skin tones couldn't be truer to life, yet there's not even a trace of so-called pink "flesh" color.*

The Male Nude

This is a subject that has long festered under a smokescreen of hypocrisy, fear, and misunderstanding. In many societies it was simply unthinkable to paint a nude man. Male artists feared the stigma of suspicion, and female artists social disapproval, for daring to paint the male nude at all. American artists particularly, with the notable exception of Thomas Eakins who laughed at such bourgeois notions, barred the male nude from their studios—victims of the Puritan ethic.

So except for Pan, or other mythological figures, men kept their drawers on when posing for artists. I still remember the shocked reactions of schoolchildren at New York's Metropolitan Museum, who having been herded past acres of female nudes without so much as a snicker, stopped dead in front of Gericault's very naked gentleman tugging a rope. Today most of that is over and artists of all persuasions feel free to paint the nude in its splendid variety—female and male, old and young, white and black—without fear of slander, gossip, or innuendo.

Painting the Head and Neck

All figures begin in heads, which are, at least in most cases, an integral part of the whole human being. However, a most important factor enters into this aspect of figure painting, and it's one I've never read about or heard being touched on by teachers or writers. I'm speaking of the degree of attention the head and facial features receive in a figure painting as compared to a portrait, where the face is the prime consideration. To me, figure painting exemplifies the body—it accentuates the pose, the thrust, and the action—while portrait painting stresses the personality, the inner presence, and the emotional character of the subject. To put it into the most simplistic terms—portrait painting is spiritual and figure painting corporal.

Some of Degas' most successful figure studies have no faces at all—only mere smudges to indicate light and shadow. In his wisdom, he knew when to subdue the partial and to stress the whole. However, this does not mean that you should paint the heads and faces of your figures with blank expressions or with little care. Just remember not to paint faces with such deliberate emphasis that they become the focal point of the picture.

In painting the figure, the individuality of the model must emerge through posture, carriage, gait, flexibility—not through the face. If you think the figure has no personality of its own, think again. You can recognize someone you know and love blocks away, long before you're able to distinguish his or her features.

The head is a marvelously constructed mechanism full of fascinating bones, ligaments, and muscles designed to permit us to express hundreds of moods and emotions; but in painting the figure, reduce it to a cube resting on a cylinder and show it in simple, basic terms of shadow, halftone, and light. Treat the head and neck as two large and distinct masses—the former supported by the latter but able to swivel upon it so that it almost thrusts in direct opposition to it.

Painting the Trunk

The trunk, or torso, is considered the area that commences at the bottom of the neck and ends at the pelvis. It includes the shoulders, spine, thorax, and buttocks. The most important thing to remember about the trunk is that it bends forward, backward, and sideways at the waist.

The trunk is by far the bulkiest part of the body and contains all its vital parts except for the brain. It should be remembered that the trunk is packed with bone down to the bottom of the ribcage where it suddenly becomes a wispy bit of nothing that is connected to the pelvis by merely a few sections of spine in back. The spine that keeps it all glued together is a marvelously instrumented chain that most of us abuse with our poor posture and lack of exercise. The lowest sections of this spine are fused to the pelvis, but the upper are flexible, permitting us to stoop or dance. The buttocks envelop powerful muscles that allow us to sit, get up, walk, jump, climb, etc.

For artistic purposes, the trunk should be considered a kind of solid snake able to twist, bend, turn, and generally disport itself—unlike the head, which can only turn if the neck cooperates. Some of the most dramatic poses are struck with the head facing one way, the trunk another, and the legs either in the same direction as the head or opposite from it. The trunk can be painted with equal fascination from front or back. The frontal view is more interesting for its outer appendages, such as breasts, and the back for its inner struc-

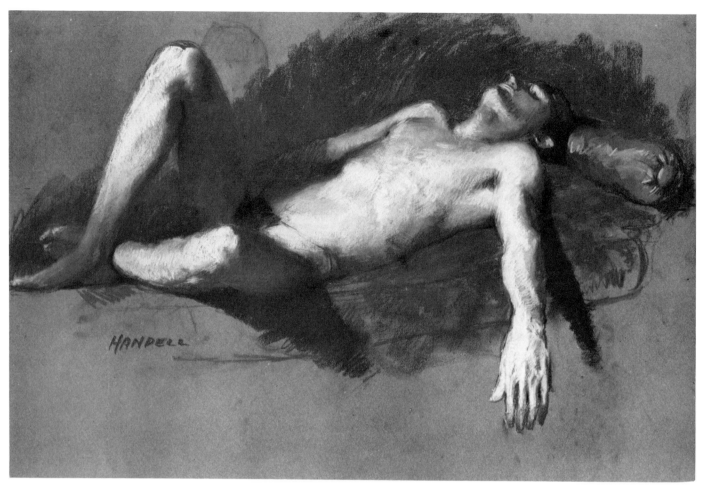

Male Nude (*Above*) *by Albert Handell, pastel on board (Collection Bernard Ungerleider). This most difficult pose is rendered effective through the ingenious use of darks and lights, which serve to draw the eye to areas closest to us and thus promote the illusion of receding and advancing planes. Note the dark passage beneath the left thigh and the shadow behind the left arm. They tell us that the light is coming strongly from the direction of the model's feet and that both the leg and arm are extending outward from the divan. Using light to define the form is an old, but valuable, painting trick.*

Female Model Sitting (*Right*) *by John Foote, pastel, 20" × 16" (Collection Philip Parnes). Painting the figure in cool variations of gray and lavender against a rich brown background has produced here a striking study in contrast. The artist lit the figure with a strong side light which enhanced the contrast of flesh and background even further. Foote uses his pastel in a powerful, distinct style, working the strokes around the form to show their shape and roundness. He makes no effort to smooth the pastel, leaving his strokes just as he puts them down, which lends vigor and force to the painting. Note the extremely broken treatment of edges, particularly at the left ankle and shin.*

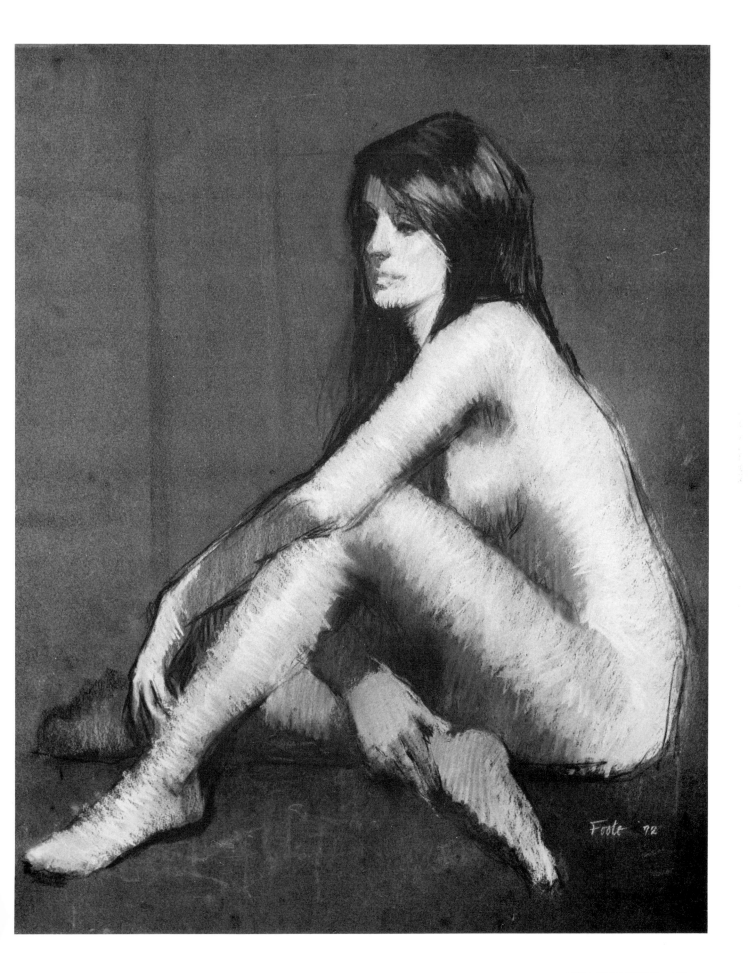

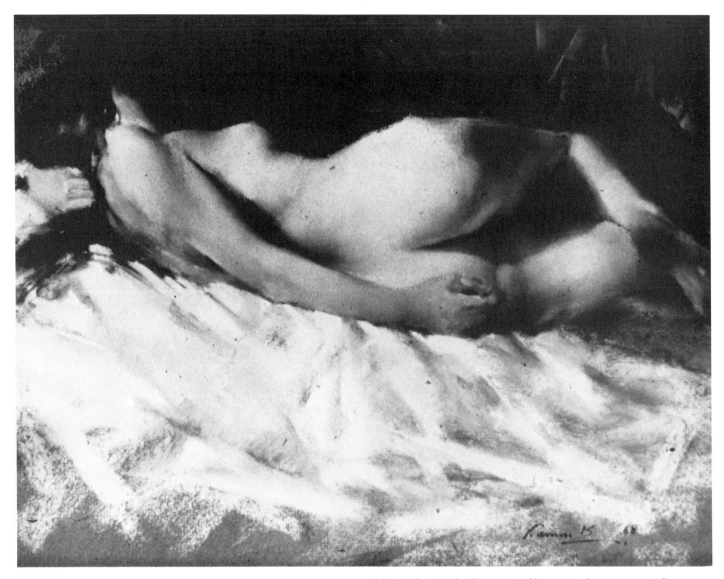

Nude Study *by Ramon Kelley, pastel on paper, 12" ×
16" (Collection Dr. and Mrs. Stephen Scott). Kelley
literally paints with pastel. If I didn't know, I might say
this was a watercolor or acrylic study. The smooth
transition of tones within the figure works particularly
well against the dark background. Note the skillful use
of the rectangle of shadow in the buttocks and inner
thighs. The touch of reflected light on the right rump
merely adds versimilitude to the roundness of the curv-
ing plane. The left hand gripping the hair is a deft, but
somewhat amusing, touch. There's nothing in the
rulebook that says a figure painting can't contain ele-
ments of humor.*

tural workings that graphically demonstrate the major thrusts of the spine, hips, and shoulders. The lightest tones of the flesh are *usually* located within the trunk, with the exception of Negro skin, which is lightest on the palms and soles.

Painting Arms and Hands

Certain factors should be considered when painting arms and hands. Notice that arms rarely hang perfectly straight but are usually bent at the elbow and the wrist. The biceps (which you can see when you flex your muscles) brings the forearm up, the triceps straighten it again. The bones of the forearm allow you to twist your lower arm and the muscles therein let you clench your fists. The hand dangles in a half-closed position, as it does in the other primates such as apes and monkeys. Since blood runs downward to the extremities, the skin on the hands is usually redder, particularly around the knuckles. Also, hands tend to be exposed more than the rest of the body and consequently bear the brunt of the sun and wind. Fingers can prove devilish to paint since few of us become expert at this task. This is the only part of the body I would advise you to draw and paint separately as exercises, for you can never learn enough about hands.

As you are reading this, glance down at your hands and note their complex but ingenious configuration. If you take the time to observe how the four fingers work in conjunction with the thumb, you'll realize what an engineering miracle the human hand is. Imagine how helpless we would be if the thumb bent in the *same* direction as the other fingers. Merely understanding the basic mechanism of the hand and its main function, which is to grip, should begin to allay the fear and awe of painting hands, a trepidation with which I have complete sympathy. Leaving hands out of the picture or hiding them artfully behind an object is not the solution to this problem. Studying how the hand works and drawing it repeatedly is much more productive.

Painting Legs and Feet

Legs and feet play an important role in painting the figure in that they provide the balance so vital in representing the human body. Since man rose up and began to walk on two legs, we have had to learn to balance ourselves in this precarious stance. Each new infant has to learn this skill, and I've watched with fascination as one after the other of my children stood proudly for the first time on his or her stumpy little legs. So we can see that balance is also the prime requisite in effective figure painting. Unless you aim to imitate Marc Chagall and float fiddlers over roofs, your figure will have to stand, sit, squat, kneel, and even lie in perfect balance.

The key to balance in the standing position is the legs. The body is constantly undergoing thousands of tiny adjustments in order to maintain balance. When we plant our feet in such a manner as to distribute the weight evenly, the spine then takes over and leans and bends this way or that to counteract any tendencies to tilt the bulk too much to one side. The legs bend forward and backward from the hips, but only backward at the knee. Legs come in various shapes—straight, bowed, knock-kneed, etc. The hardest part of the leg to paint is the knee, which runs from dimpled to knobby and is full of all kinds of puckish little bumps and pads.

As in the case of hands, feet tend to be redder than the rest of the leg. They are similar to hands in that they have prominent veins that may create interesting bluish accents. Note that feet move in a rotary manner at the ankle. Some people walk with toes pointing out in the duck position, and some are pigeon-toed. The four little toes point out slightly away from the big toe, which is a vestigial feature from the day we used our feet to grip in the manner of apes. Another such feature that reminds us of our ape ancestors is the webbing between our second and third toes. Check this out for yourself—if you don't believe me.

Feet are terribly important in the daily scheme of things, but they're usually a rather ugly item, so don't spend too much time fussing over them. They're comparatively easy to paint unless you feel the compulsion to show each and every toe, in which case you're borrowing unnecessary trouble.

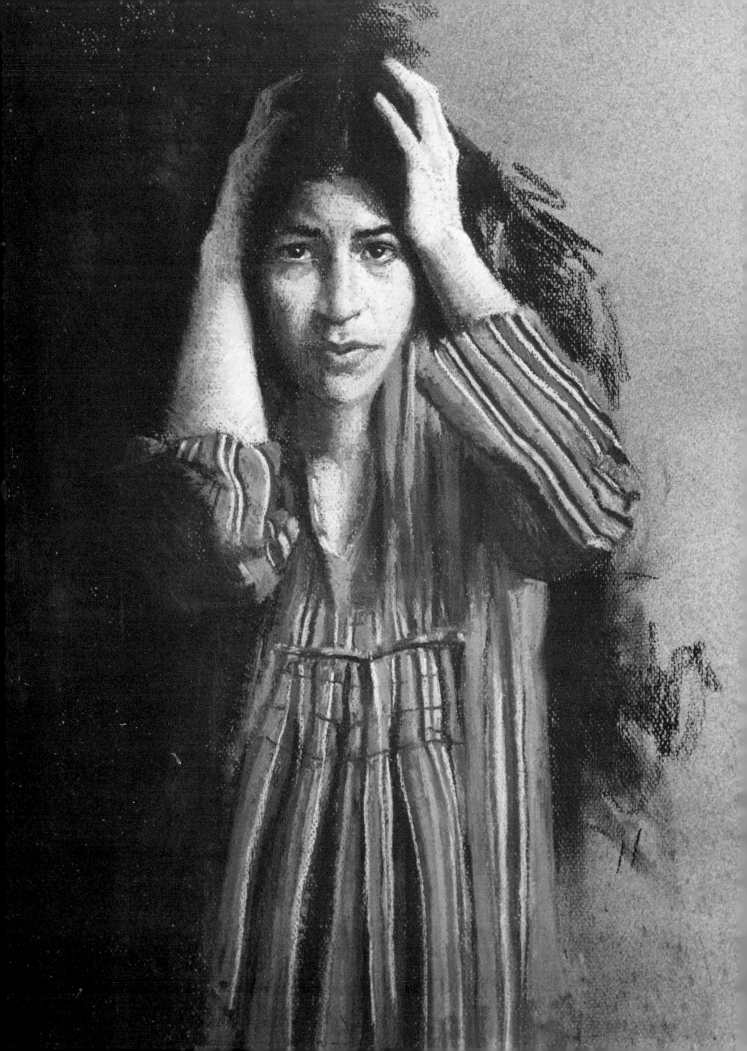

CHAPTER TWELVE

Skin and Hair Tones

In this chapter we'll discuss how to paint the varying shades of skin, reflected light on skin, and the effects of shadow on skin. Also, we'll review how to handle hair—natural or artificial —in a painting.

Light Skin

In separating light and dark skin, I'll use as my yardstick the degree of value each type presents rather than racial origin. In my scheme of categorization, light skin has six variations:

1. *Fair.* This is skin that's light in value and tends toward the pinkish side. The color combination it calls for from our palette is white and flesh ochre.

2. *Florid.* Somewhat darker than fair, this type is more toward the reddish side. It calls for a combination of white, cadmium red light, and burnt umber.

3. *Sallow.* This type is light in value and tends toward the yellow side. It takes white and raw umber.

4. *Olive.* Darker in value than the others, olive skin has a greenish cast. It might require a combination of white, yellow ochre, and a touch of viridian.

5. *Ivory.* Ivory skin is light in value, but definitely toward the cool, grayish side. It requires a combination of white, raw umber, and gray blue.

6. *White.* This is the lightest human complexion that's almost milky white—neither warm nor cool—and is almost albinolike in its lack of pigmentation. It's often found with flaxen or light reddish hair. This interesting skin color is different from ivory in its lack of grayish undertones. For white skin, combine white with light touches of raw umber.

Introspect *by Sharon Sprung, pastel on paper, 21" × 16". There's deep inner turmoil here, but it's the hands not the face that best proclaim this. Cover the hands and you merely have a slight frown. This is in the true figure painting tradition in that elements other than facial features create the mood. The use of the dark background on one side is likewise a contributing factor to the emotional statement the artist chose to make. All parts of our body express our inner feelings and the skilled painter knows and takes advantage of this factor. In this case, the straight-ahead gaze is used to most telling effect.*

These are the *general* kinds of light complexion and only suggested combinations for painting overall local flesh color. Of course you would use many other shades and hues to indicate the various shadows, lights, accents, and reflected lights that modify general skin color.

Dark Skin

Dark skin runs a much wider gamut of value, hue, and color temperature than light skin—it runs from warm copper to purplish black to various shades of brown, yellow, and tan. It would be presumptuous to offer even perfunctory color combinations due to this enormous range of possibilities. I can therefore only offer some general advice concerning the painting of dark skin.

The first is to lay aside all preconceptions and really study the model before you. An American Indian is no more red than an Oriental is yellow or a Negro is black. Dark skin transcends presumed racial categories, as we can see in the black races of Africa that have dozens of ethnological roots and tribal divisions. They are short, tall, lean, fat; of brown, yellow, black, gray, and tan complexion. They have thin and thick lips; straight and curly hair; and narrow and wide features. Here are some general hints for painting dark skin:

1. One must rely on observation alone. Don't use black to show even *apparently* black skin, but arrive at a dark tone through combinations of burnt umber, ultramarine, caput mortuum, cobalt blue, viridian, olive green, raw umber, and burnt sienna—or whatever the case may be.

2. Be very careful not to overstate highlights on dark skin. Observe their true value by isolating them and judging their value independently, not in contrast to the darks around them.

3. Avoid painting dark skin too hot; rely on greens and blues to keep it under control.

4. See to it that you don't paint dark skin too dark (an error most artists tend to fall into), but look for modifying halftones lest you end up with a dull, matte effect.

5. Look for interesting areas of lighter pigmentation that can be shown as arresting contrasts of hue, value, and temperature.

6. Keep the whites of the eye low in value! In

many dark-skinned people, they are dark red or dark gray.

7. Try to break up general skin tone areas with strokes of complementary colors. No one is consistently one shade of *anything*!

8. Note how often the lights on dark skin tend strongly toward the blue order of the spectrum.

To sum up—paint dark skin as the living, breathing, viable organ it is, not as some postery, flat black area.

Reflected Light on Light Skin

Reflected light is a bugaboo whose dangers I've already enumerated. Still it's a phenomenon that exists and is worth briefly looking into. Reflected light is a thing unto itself possessing a life and a will of its own. It's not regulated by considerations of local color, and rather than *being* modified, *it* modifies. Its value, hue, and temperature are products of the source from which it issues, whether this be an electric bulb, a window, or a mirror. What reflected light does is bring up the value of the area it falls upon or change its hue or temperature. Thus, a neck tone can be rendered degrees lighter by the white collar bouncing light back into it, or considerably warmed by a fiery red material.

Reflected light vitiates the true lights of light skin and throws the whole tonal relationship out of kilter. It forces the artist to go up in his lights so that the reflected light doesn't gain the upper hand—or even worse, makes him go lower in his shadows to show that delicious contrast of reflected light and shadow that titillates the unknowing. Reflected light only works well in high-key impressionistic paintings of figures in outdoor settings, where the reflections of water, greenery, or other natural phenomena seem proper and correct. In studio painting it's a factor best avoided, or at least strongly subdued.

Reflected Light on Dark Skin

Due to its lower overall tonality and warmer character, dark skin accepts reflected light much better than light skin does, but only if this reflected light is cool in character. If the subject is really dark, a striking greenish or bluish reflected light can work wonders to pep it up. Again, it's a matter of taste and discretion on the part of the

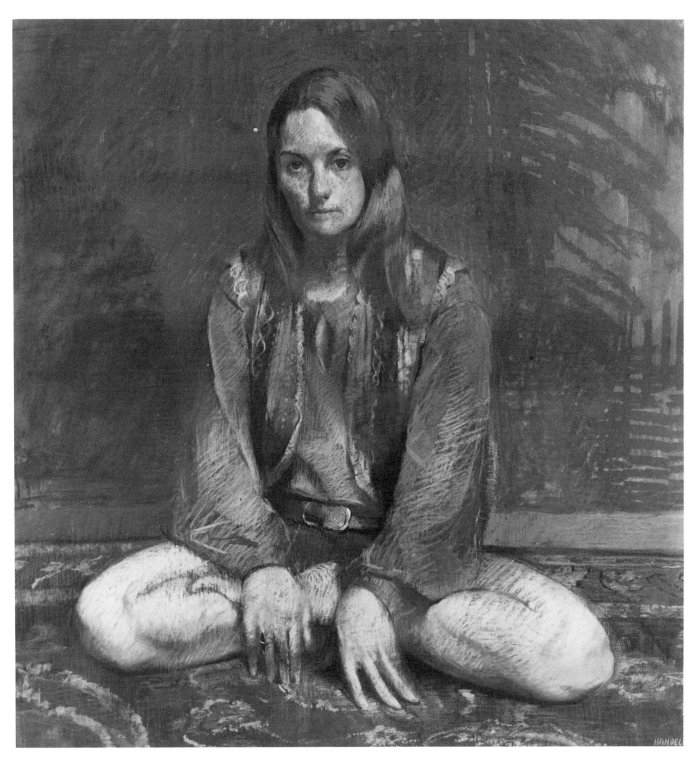

Betty *by Albert Handell, pastel on board (Courtesy The Capricorn Gallery). The model has assumed the classic Yoga position, and sits presumably absorbed in mystical contemplation. In painting the figure, it's vital to consider the sitter's inner feelings if the pose is as deeply affected by them as this one obviously is. Since Yoga is designed to put you in a placid, contemplative mood, it would have defeated the purpose of the painting to give the woman a tense, charged, expression.*

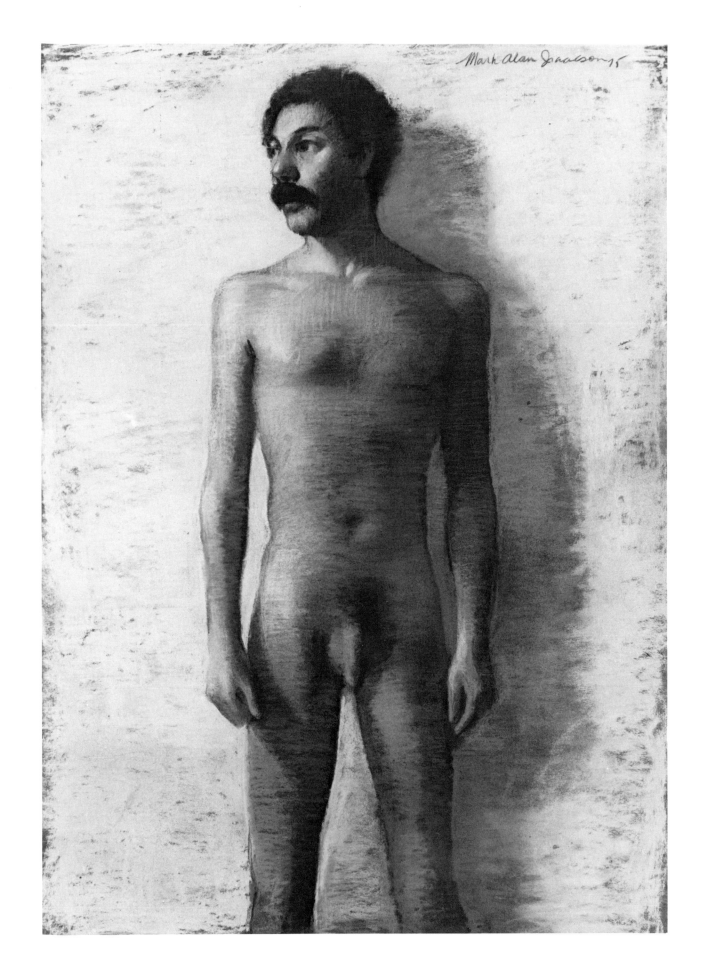

painter, but he has more latitude here and can indulge himself a bit more freely. Since lights on a dark skin may run very low in value, the figure can be painted almost totally in shadow and halftone with a few propitious *cool* highlights and reflected lights that may almost serve the same function as the lights in a light skin painting. But again I must warn you not to let yourself go too much and to exercise considerable restraint in mixing and placing reflected lights. Keep them to an absolute minimum, don't make them too light, and above all—don't let them get hot or even warm.

Effects of Shadow on Light Skin

Shadow on light skin is rarely as dark as it's commonly painted. Shadow on light skin should be considered a filmy veil draped over the flesh, never an opaque, heavy material that blocks out the tones underneath. Skin shadow must always be kept thin, almost like a glaze. While it can be *deep,* it can never be *dense,* like a body of water that is deep yet translucent. I also think of shadow on light skin as a pane of darker glass that alters much of the hue of the object viewed through it but retains the feeling of form, value, and possibly color.

I can't think of any situation in which the value or hue of shadow on light skin should fall much lower than the darkest shade of raw umber, except for an accent or two. I know that many artists paint it a deep, rich dark burnt umber, but I take strong exception to this practice. Possibly one can go lower in skin shadows in oils, but not in pastel.

It's simply too harsh and ugly. I lean toward greenish shadows for light skin mixed from combinations of olive green, raw umber, flesh ochre, blue violet, yellow ochre, or mouse gray.

Effects of Shadow on Dark Skin

Here's where shadows can go really deep. In dark complexions they lend verve and vivacity to the figure. As I've already stated, very dark skin can be painted in halftone and shadow with a few highlights thrown in. This is your chance to bring out your ultramarines, burnt umbers, blue violets, caput mortuums, and even black and really go to town on deep, dark rich shadow.

Painting the Hair

Hair plays a lesser part in figure painting than in portraits—at least it should. I advise you to handle it as one overall mass of light, halftone, or shadow with several accents, if so indicated. Diddling with hair, which is unadvisable under any circumstances, is particularly deadly in figure painting, whose main purpose is to show the action and thrust of the *total* body.

Hair offers a splendid opportunity to paint a light or dark mass flowing together with the areas of the face to shape the unified form that is the head. Once you show the sharp divisions between the hair and the skin tones of the head or body, you're skipping over into commercial illustration and abandoning serious figure painting. As for painting body hair, all I can say is forget it!

Blaise *by Mark Alan Isaacson, pastel on sanded paper 28" × 22". Lighting the figure from the side is here abetted by running the strokes of the pastel in the same direction. Through the subtle use of light, middle, and dark tones, the artist has modeled the form with skill, intelligence, and precision. Edges are generally hard around the outer contours but the planes within the figure are handled with extreme delicacy. The pose is daring in that the man merely stands there in a somewhat tense attitude, but the artist has handled the painting intelligently, giving us a direct, honest character study of a highly individual human being.*

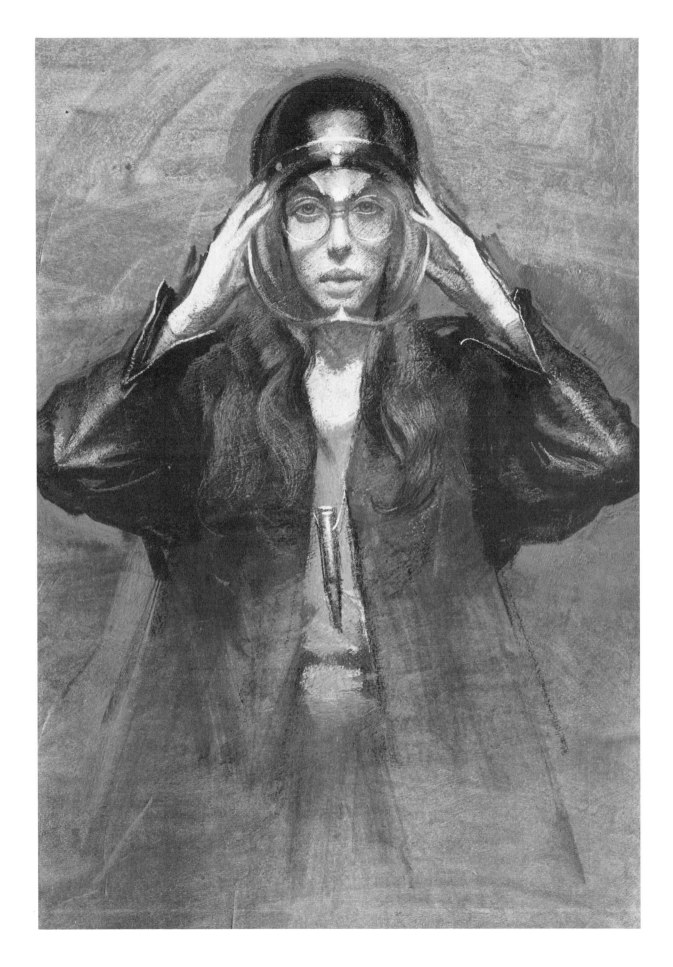

CHAPTER THIRTEEN

The Clothed Figure

Figure painting also involves painting the clothed figure, an aspect barely touched on in instructional and historical books on the subject. The reason for this is perhaps that figure painting is so closely associated with the nude that few bother to consider the alternatives. Let's briefly try to rectify this omission.

Folds and Wrinkles

Depending upon the degree of verisimilitude in your painting method, folds and wrinkles will certainly play an important part in painting the clothed figure. The more you know of their nature and action, the more likely your chances of achieving success. Two factors are of significance regarding folds (wrinkles are merely their younger siblings), the first being that only the main folds are important to the painter. Secondly, these main folds behave consistently under the same prescribed circumstances, so that once you learn their behavior you can apply this knowledge in all subsequent work. You can learn about the action of folds in these ways:

1. By reading passages in anatomy books dealing with the subject.

2. By studying in museums or in reproductions the ways in which such artists as Ingres, Sargent, Rembrandt, Ter Borch, Vermeer, Rubens, and the classical sculptors handled the problem.

3. By studying photographs of people in various poses.

4. By observation.

5. By memory drawing without a model and afterwards checking the accuracy of folds against life.

6. By studying yourself in the mirror.

Young Woman with Helmet by *Harvey Dinnerstein, pastel, 28" × 19-1/2. Dinnerstein uses the reflected light of an ordinary motorcycle helmet's faceguard to create a bizarre, almost outer-space-like figure. Reflected light when used with such purpose is a perfectly legitimate tool. However, when overdone for pure effect it becomes a cheap, gratuitous attention-grabber. Look at the portraits or figure studies you admire most at the museum. How many (if any) show any great measure of reflected light? This is a most dangerous device and one to be avoided like the plague.*

Folds are not that mysterious or capricious. They behave strictly according to the laws of gravity, stress, and tension, and react in a perfectly logical fashion to the factors that catalyze them. In order to understand their behavior you must observe and commit to memory the results of your research so that you don't falter when confronted with the situation.

If you do intend to paint with such exactitude that every tiny wrinkle is represented, follow the same pattern as in all painting. Get the big forms down first—the major lights, shadows, planes, and angles—then begin to refine by adding the detail that cloth stretched over solid flesh and bone produces. If need be, take a photograph of the subject and work from that. Or, if you and your model have the patience, paint these particulars from life.

However, my advice is to follow in the path of Degas and include only those folds that define the action of the pose, and ignore the rest. This, in my opinion, will not only strengthen the painting but make it seem even more realistic, since hundreds of tiny wrinkles serve merely to vitiate the impact that a few *telling* folds create. For the fact in painting is that an impression of reality is more indicative of life than the attempt to slavishly mimic life itself.

Material Textures

Silk is different from wool which is different from fur which is different from cotton. These differences are usually a matter of texture and some effort should be made to indicate the characteristic of the fabric worn by the clothed figure. When painting shiny, smooth fabrics such as silk and satin, notice that they are reflective and therefore contain more definite and apparent lights and highlights than such rough materials as wool, which tend to absorb light. To paint shiny fabric, you might do a good amount of blending or rubbing in the pastel in the darker parts, and spot in some bright highlights. Areas showing fur can also be blended and rubbed, then spotted with a few strokes here and there to show the character of the hair. Silk would generally present sharp folds, and fur, very soft, indistinct ones.

Rough fabrics, such as wool, can be painted in an almost flat, matte fashion in which there are no sharp, dramatic changes of color. Cotton tends to be thinner and will therefore have more folds and breaks in the cloth. Velvet and plush are soft and extremely pliable and can be painted quite heavily by repeated fixing and overpainting to gain the appearance of a sinuous, slinky material. Brocade and taffeta are stiff and call for strong, impressionistic strokes applied with a degree of boldness.

My concept is that "man makes the clothes" not the other way around, and I therefore resist fussing with garments to any great extent. I do think, however, that textural characteristics are of some importance and that you should employ all the potentiality of pastel technique including fixing, laying-on, rubbing, blending, dipping, juxtaposing, scumbling, and crosshatching to capture the *essence* of the fabric worn by your model. Obviously I cannot tell you how to handle every kind of material you might encounter. I can, however, advise you to study the costume you are about to paint, and to get down its essential shape, form, tonality, and major folds. Then, simply indicate in a few strategic places its inherent color and degree of weight, thickness, roughness, and flexbbility.

One, two, or all of the three major pastel techniques can be employed in this process, depending upon the circumstance. We will be discussing these three techniques in the upcoming chapters at which time you can refer back to this section and decide which technique best serves to paint a particular texture.

Patterned Clothing

Paint patterned clothing very, very sparingly— and don't try to reproduce every dot in a polkadot dress unless you want to ruin your eyes. The key to this challenge is simply to *suggest*. Pick a significant area and paint in a half-dozen dots just to show what it's all about—then let the viewer's imagination take over and complete the job.

Study Rembrandt's costumes and notice how he handled such detail as armor, ribbons, sashes, and patterns. Ninety percent is lost in shadow and only a few dramatic details are painted with a degree of clarity (even there the edges are never hard). Yet ask the casual observer and he or she will probably swear that Rembrandt paints with hard-edged photographic fidelity.

In a similar vein, avoid such traps as ruffles, lace, jewelry, lapel pins, ribbons, buttons, medals, belt buckles, and other frippery. Relegate this

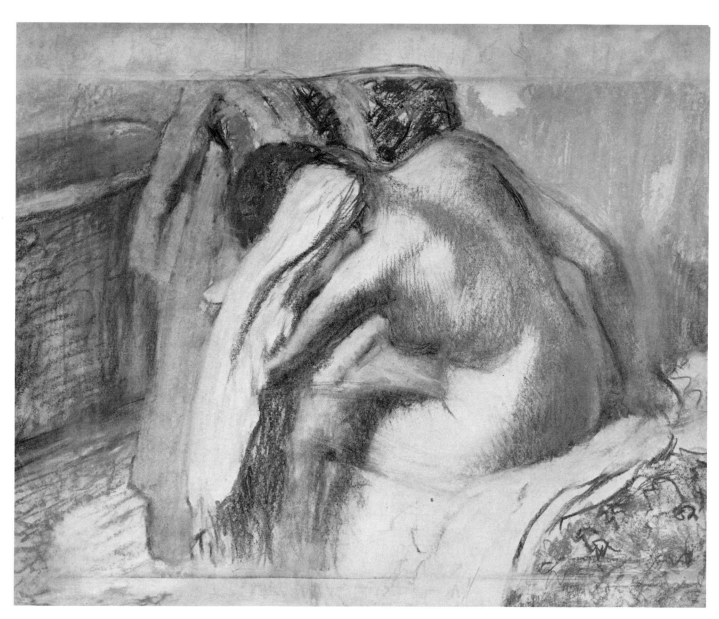

Drying Her Hair After The Bath *by Edgar Degas, pastel (Courtesy The Brooklyn Museum). For Degas, the subject of a woman drying her hair was merely an excuse to create an intriguing design. Hair wasn't a substance worthy of any particular concern or admiration but merely an object he employed to create an interesting pattern or mass. If you worry excessively about the exact shade, color, and texture of hair, become a hairdresser. To an artist, hair should merely mark the top of an object that happens to be the human body. Paint it correctly, but don't get too involved with it.*

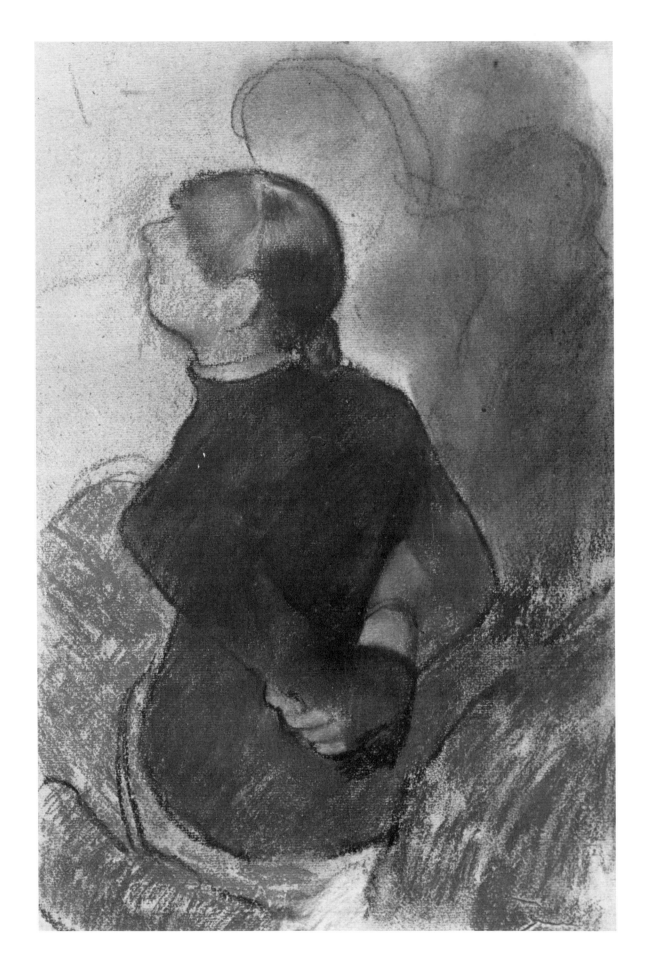

junk to the scrap heap of trivia and leave it to others to waste their time on. Whatever doesn't advance the action of the figure doesn't belong in your painting.

Light on Clothing

When light falls on clothes worn by the model, the clothing does one of several things. If the fabric is smooth and shiny it reflects much of the light back; if it's rough, it absorbs most of the light. In either case the clothing displays local color in the light areas and it's this local color that has to be represented somehow by the artist in the painting.

If this local color is harsh and garish, its effect is to cancel out some of the vitality of the figure itself and to draw undue attention to the attire. This works well if one is painting a clown, or a witchdoctor, but it's detrimental if the effort is to paint the figure *per se*. One solution is simply not to pose the figure in such outlandish costume (unless for some specific purpose). Another solution is to tone down the local color sufficiently so that it won't dominate the painting. By using strokes of broken color in hues contrasting to the overall tone, you can minimize the stridency of overly aggressive clothing. Or, try scumbling over the general tone with grays, tans, or browns or spraying with fixative to lower the tone. By stroking some black into the painting or rubbing it down with your thumb, you can also minimize the effect of harsh local color. Roughing the texture by applying pressure on a soft pastel to create an impasto will also tend to hold down the effect of an area of gaudy color. Or you can thumb your nose at reality and simply paint a robin's-egg-blue jacket a mousy brown and solve the problem that way. Whatever path you take,

Young Women in Blue by Edgar Degas, pastel on paper. Here is another example of Degas' eternal experimentation with color, line, tone, and design. Degas was fascinated by repeated angles—such as the sharp shoulder line that echoes the thrust of the jutting nose—in the context of the human figure. His was a mind that had gone beyond the strictly literal into the areas of abstraction long before abstraction had become fashionable. He was the true precursor of the movements (Fauvism, Cubism, Dada, etc.) that led to Abstract Expressionism and the modern concepts of seeing and painting.

do guard the light areas of your model's garments to keep them from taking over the painting.

Shadow on Clothing

Shadow on clothing is an excellent means of modeling the form in the figure. My concept of shadow is to paint it as one continuous mass, running—if so indicated—from hair to toes without a break or division. I'm not saying that it shouldn't contain a variety of colors and tones, but I am saying that you shouldn't cut off the shadow at the neck with a sharp line, then recommence it in, let's say, a blue shirt as an entirely different element. What I advise is that you let the shadow slop over from area to area, allowing it all to swim and flow together. Spot it here and there with a mere touch of local color and let it hang together simply as shadow. A shadow on a black suit is certainly blacker than that on a fair skin, but it's not all that different. The main difference lies in the degree of tonality, not in the degree of local color.

Shadow is an elusive thing compared to solid, opaque light. I differentiate between shadow and background, which may run counter to popular notion. A background is a dense, deep abyss with infinitely receding dimensional planes. A shadow is a filmy veil draped over form, bathing it in soft mystery.

Don't make the shadow on clothing too dark, too sharp, too rigid, or too inanimate. Keep it loose, porous, ephemeral, but never weak. Don't automatically use rubbing or blending to create shadow, but instead use a succession of lightly laid on layers of pastel as you would glaze in oils. Shadow is a veil, not a curtain.

What to Leave Out

The problem of what to leave out in painting the clothes on a figure is simple. Drape your figure in just enough clothing to keep from straying from your main course, which is to paint the figure in a certain pose, not to create fashion advertisements. After you've decided on the absolute barest minimum of clothing that will be included, *halve* this estimate and you'll come out just about right. Paint clothing as a simple extension of the figure, a kind of loose second skin that follows the main thrusts of the trunk and limbs.

Indoor and Outdoor Painting

I've already spoken to some degree about lighting the figure. However, I'll now take time to discuss the different effects achieved by posing the figure indoors under natural or artificial light, and outdoors where light is natural.

Indoor Lighting

Lighting in the studio can be either natural or artificial. The main difference lies in the *temperature* of the light—daylight is generally cooler or bluer, and artificial light is yellower and warmer. However, fluorescent lighting equalizes some or all of this variability and often closely mimics the cool aspect of natural light.

Be that as it may, there are other subtle variations to differentiate these two kinds of illumination. Daylight tends to be softer and more atmospheric than artificial light. It fuses the values in a more cohesive fashion and precludes the harsh divisions of light and shadow created by artificial lighting. The effect of *sfumato,* or the misty appearance of outlines, colors, and shades, is eminently more possible under natural light indoors. Artificial light tends to bathe the human form in a ghastly (or ghostly) aura that either grays colors or yellows them, robbing them of those delicate tints that many figure artists eagerly look for in the nude. Also, edges tend to grow harder under artificial light and subtle halftones disappear altogether.

All in all, given the choice, I would select natural light in the studio over artificial without any hesitation. If nothing else, artificial light also affects one's estimate of his or her colors, and I find myself spending less time looking for just the right stick and settling for a close approximation when working under Mr. Edison's invention.

Vicki in the Kitchen *by Mary Beth McKenzie, pastel on sanded paper, 14" × 11". McKenzie took a direct approach, using her pastel in a rough, smeary, painterly manner to attain her effects. Note the very simple manner of painting the model's clothing in a basic division of darks and lights. Fussing with garments was a habit in the nineteenth century when artists were compelled to execute exquisite renditions of the fashions then prevalent. Isn't it much more effective to see them handled as easily and naturally as this?*

Lighting Direction

The most desirable light source in the studio is that which comes from above. This is because overhead lighting most closely simulates the natural effect of the sky. The next best lighting is side lighting, although this sometimes slips into looking like a contrived arrangement. The least favorable is lighting that comes from below the subject, which is clearly tricky and unnatural.

Thus, a skylight offers the best solution for natural light indoors, and if you're lucky enough to have one in your studio, you're that much ahead of the game. Most of us are not so fortunate and we have to make do with side lighting. Windows that are high off the floor are adequate, or you can install shades that roll up from the bottom and keep them halfway up so that the light enters from only the top part of the window.

If working with artificial light, it's better to install these lights overhead in order to achieve a high source of illumination. Working with light issuing from below creates the Frankenstein-like effects you achieved as a child holding a flashlight under your face, or those produced by stage footlights.

Direct and Diffused Light

Direct light is that which strikes the subject without any intervening screen, glass, or other obstruction. Diffused light, on the other hand, passes through some modifying agent that spreads or diffuses this light so that it achieves a broken, patterned quality and falls more softly upon the subject. Light shining through a closed window is already partially diffused and if this window is dirty to boot, the diffusion increases. If the glass is translucent rather than transparent, there is even more diffusion. Natural sunlight is diffused by clouds and other atmospheric factors as fog, mist, smog, smoke, and steam. Artificial light is diffused by the glass of the bulb and by a shade. Devices such as screens of wire, glass, plastic, cloth, paper, or other material can be arranged to scatter or diffuse both natural and artificial light.

So we can see that the difference between direct and diffused light depends upon the number of obstacles placed between the light source and the subject, which in turn affects the degree of sharpness or softness of the light. Naturally, the sharper the light the stronger the tonality the subject will display.

Color Indoors and Outdoors

During daylight hours—barring dawn and dusk when the earth doesn't receive the direct light of the sun—no studio illumination can hope to match the brilliance of natural light outdoors. The local color of any object is directly affected by the amount of illumination it receives. It therefore follows that, under most circumstances, a figure posed outdoors will be *lighter* (but not necessarily brighter) than a figure posed indoors. The subject posed in bright sunlight is, of course, bathed by direct lighting. But with some notable exceptions such as Homer, Sorolla, and Renoir, most painters have preferred posing the figure in the shade.

The factor of reflected light is also much more in evidence outdoors. Grass and water tend to throw lots of reflected light and considerably enliven shadow areas. This is one of the most obvious elements in the *plein-air* painting practiced by the Impressionists. Here you see the strong green, blue, and violet areas in the shadows that were actually present in the clear, pure air of the French countryside.

Shadows outdoors can appear so high in value that they nearly fall into the *light* category. Of course, the lights go proportionately higher too, but not in the same ratio. Outdoor shadows (and I'm speaking of the subject in the shade) differ from the other areas in the degree of *hue* that they lack, not in the degree of *value* as they would indoors.

The matter of climate and zone plays an enormous difference in the effect of outdoor light on color. The flat countryside and big sky of Holland with its cool, clear light doesn't produce the bright, airy, atmospheric light of southern France

Inca Market by Ramon Kelley, pastel on sanded board, 16" ×12 (Courtesy Big Sky Gallery of Arizona). Here, costume is used deliberately to establish the locale and character of the picture. The Indian women wear garments that to us seem colorful and bizarre (as our Hawaiian shirts and Bermuda shorts must certainly appear to them). Painting on location in exotic places adds another dimension to figure painting. Look for every opportunity to do so. If you can't bring your pastels on vacation, at least take a sketchpad or camera so you can accumulate material for future paintings.

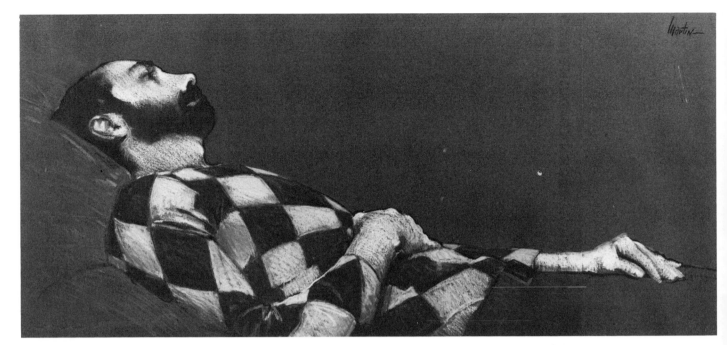

Harlequin (*Above*) *by David Martin, pastel, on paper, 10 1/2" × 23" (Courtesy Desmond/Weiss Galleries).* One way to paint patterned clothing is to stress rather than underplay the pattern. Naturally, this will draw attention from the figure, but if introduced deliberately the pattern will become a new and fascinating element of the painting. In this painting, the way the artist handles the face, beard, and hands casts them most naturally into the overall scheme of the picture: they too form a black-white pattern that echoes the diamond shapes of the shirt. Anything goes in painting if it's done on purpose and carefully thought out beforehand.

White Coat (*Right*) *by David Martin, mixed media on paper, 19" × 13" (Courtesy Desmond/Weiss Galleries).* Here, the garment plays the major part in establishing the character of the painting. Our attention is immediately drawn to the white of the coat which, set against the dark background, becomes almost an exercise in painting folds and wrinkles. Had the artist gone on to elaborate every single such break in the material, he would have ended up with a fashion drawing. As it is, it's a powerful study in darks and whites and it remains in the fold (pun intended) of serious figure painting.

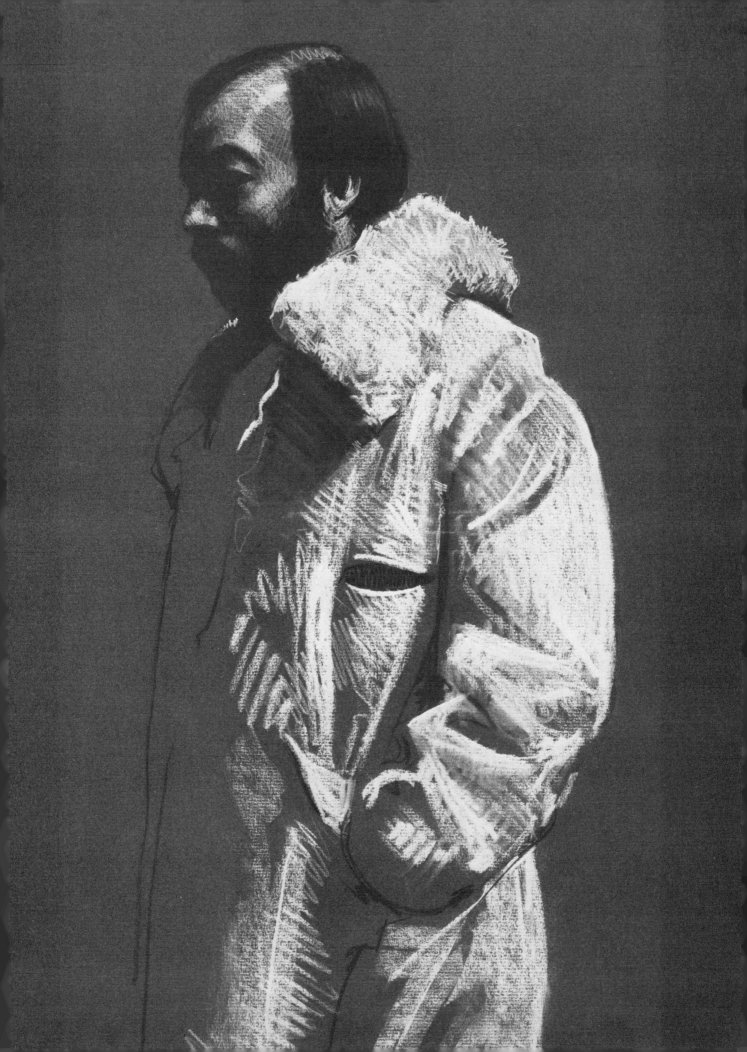

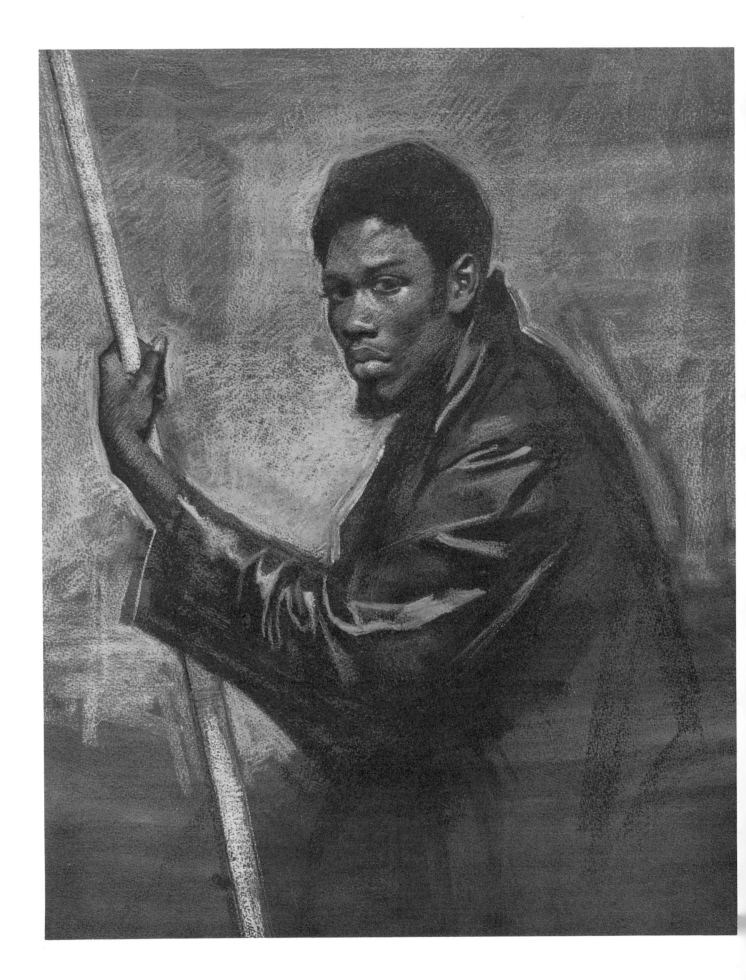

or the brooding cloud formations of Spain or the generally placid skies of Kansas.

Wherever you happen to be and whatever the season, look intently for the effects outdoor light produces on form and note how it alters the color of skin and fabric when you step in and out of the house. By simply putting your hand out the window you can see not only how much lighter its overall tonality becomes, but depending upon the weather, the time, and the season, you'll see an actual color change.

Sunlight or Shade

Painting the figure in sunlight can prove a most tricky business and takes quite a bit of skill. Contrary to general opinion, a very bright sun tends to deaden rather than enliven color, acting like a powerful spotlight. This phenomenon is rarely mentioned in treatises on light and color but it's a factor known and exploited by experienced outdoor painters.

Another problem encountered when painting in direct sunlight is whether pastels and paper should be placed in the same powerful light bathing the subject or under a tree or umbrella. Although students are often advised to work under the same light that illuminates the subject, does this recommendation apply to the above situation?

I myself don't like to paint in direct sunlight. But there are obviously those who follow the practice without any difficulties whatsoever. I do find that when both the model and the artist are in the shade, working is much easier, more comfortable, and less complicated. There are no problems of waiting for the sun to emerge from behind clouds, there is less pressure to hurry as the sun glides to the west, and there seems to be less trouble selecting colors away from the glare of direct sunlight. If you do choose to pose your figure in direct sunlight, place yourself in the shade and see how this arrangement works out. I'm encouraged in this advice after seeing photos of Sargent, Monet, and Pissaro working under large umbrellas outdoors.

Backgrounds Outdoors

The one factor that changes radically from indoor to outdoor painting is backgrounds. To paint the figure outdoors with an indistinct background seems counterproductive to the inherent character of the effort. The job and challenge of outdoor figure painting is to show how the figure responds to natural surroundings. Removing that element from the painting means robbing it of its *raison d'être*. If you're not going to bother with a background, why paint outdoors? Outdoor backgrounds should include at least the color of the setting, if not the form. This adds sparkle to the figure and lends a special vitality. To briefly sum up the best way to paint the outdoor background, I say keep it light, keep it colorful, keep it lively, paint it edge-to-edge, and give it shape and substance.

Terry by Harvey Dinnerstein, pastel on paper, 24" × 18". Leather is skin borrowed from our fellow animals. Therefore this, too, can be considered a study in skin tones. Dinnerstein understands the character of leather's texture and accordingly painted the breaks in this material in sharp, distinct highlights. Because of the model's dark skin and relatively similar strong highlights, a pattern of cohesiveness is achieved that wouldn't have worked as effectively with a light-skinned subject. Having shown what he intended on the sleeve, Dinnerstein wisely ignored the bottom of the jacket, which serves no appreciable purpose. Knowing what to leave out is the mark of the experienced artist.

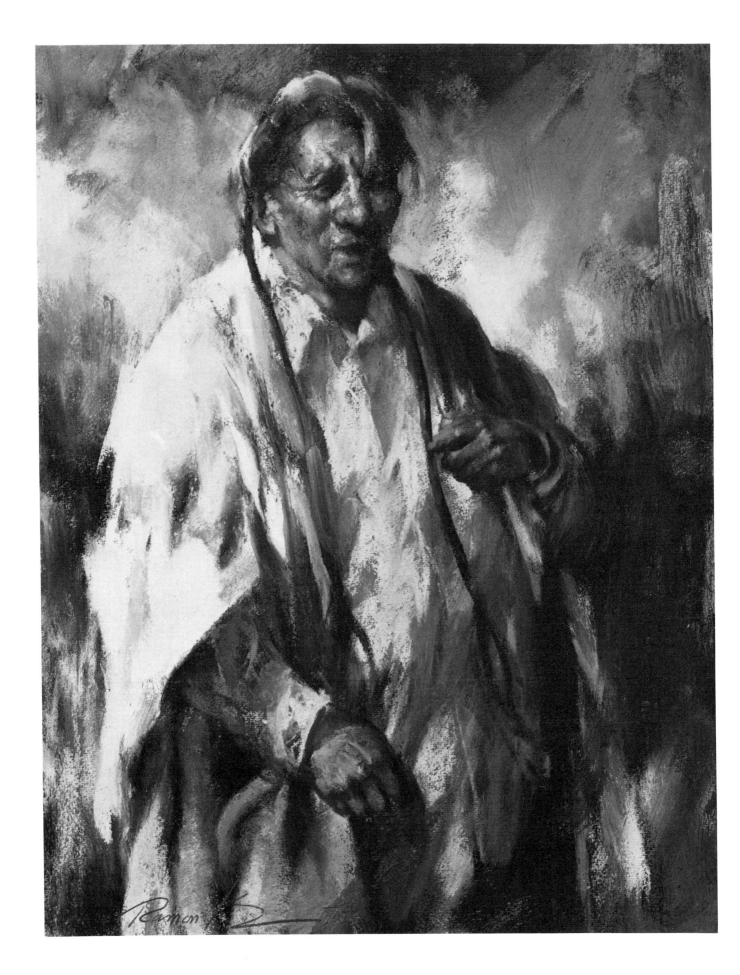

The Pointillist Technique

Taos Dancer *by Ramon Kelley, pastel on charcoal paper, 16" × 12" (Private Collection). Compare this Indian dancer with the one painted by Bettina Steinke in the color section. Kelley's dancer is an older person, and the artist elected to show him at rest rather than performing. To the Indian, the dance is a deeply solemn, religious occasion which unfortunately has deteriorated into a commercial tourist attraction. This loss and degradation of privacy, dignity, and racial pride has served to depress and humiliate our Indian brothers, and some of this anguish seems evident in the old man's stance and expression.*

In these next three chapters, I'll be discussing the three major pastel techniques—painterly, rubbing in, and in this chapter, pointillist. Each has been successfully used by experienced painters and each is equally valuable in the hands of the adept pastelist.

The most striking characteristic of the pointillist technique is the division of strokes, which may vary from dots—as exemplified in the true pointillism of Seurat and Signac—to *linear* strokes—as seen in the paintings of van Gogh. In the pointillist method, no effort is made to blend the patches of color on the painted surface. This task is left strictly to the viewer, whose eye fuses the strokes of color together to create forms that are familiar. Since we know what the human figure looks like, we all join in this subconscious effort to tie together seemingly unrelated elements into a shape with which we feel comfortable. The clever pointillist who knows and exploits this factor emerges with a painting that's lifelike yet loose, free, and highly imaginative.

Pointillism was conceived by Seurat and Signac as a scientifically predictable process based on laws governing color, atmosphere, and visual perception. Happily, it blossomed from this didactic theory into a freewheeling artistic technique that ignores science and concentrates on the purely emotional aspects of painting. Of all people, painters are the least likely to accept dictums of how, what, when, and where to work, and it's therefore always puzzling when artists fall victim to ideologies that subscribe to restrictive measures.

Be that as it may, pointillism is an excellent technique for pastel since it makes most productive use of the surface areas lying between dots or strokes of painted color. The tone of the prepared or readymade surface takes on particular signifi-

cance in the pointillist painting, and taking advantage of this factor is one of the delights of the technique.

The Surface

Since the surface does play such a significant role in this technique, it bears some contemplation before beginning the painting. Pointillism can be compared to a mosaic in which patches of bright color glow and scintillate to create a throbbing, vibrating, deeply animated effect. Thus, try using a rough surface that fosters this broken, patchy, gemlike sensation. Keep in mind that board usually has a rougher tooth than paper.

Pointillism, which also stresses bright color, seems to demand a *toned* surface that will serve as an integral part of the painting. The color of this tone can be either bright or dull, but its value, in my opinion, should lie toward the slightly darker side of the tonal range in keeping with the vivid, strong-keyed effect desired here. As for the hue and temperature of this tone, there are two choices. Use either a dull, cool tone that serves as a modifying halftone between the bright spots of applied pastel, or use a bright, warm tone around which cooler, grayer strokes are then applied.

The Palette

The pointillist method clearly advocates color—and rich color at that—and therefore calls for a palette of strong colors and a minimum of subtle, grayish shades. Here is where you might forget actual or realistic color and go a bit daring in painting flesh—green, blue, yellow, or violet. Shadows in pointillism are also much lighter and brighter and are often generously sprinkled with pure, bright shades.

Therefore, cast off all restrictions and inhibitions when choosing your colors for this technique, and grab all those bright sticks you've been holding back on because of the author's solemn warnings not to go too hot, too gaudy, or too fanciful. Pointillism allows such deprecations (to a point) and this is your chance to wallow in color.

Lighting and Pose

The lighting for the pointillist figure painting should be fairly bright and high—the outdoor setting is best for this technique. Here you can include all those gorgeous reflected lights of greenery as it strikes back into the figure. None of the brown veils of the studio are wanted here for the shadows—they should be free, open, and pervaded with patches of color. Pointillism clearly calls for the *plein-air* of Impressionist painting—think of Renoir's rosy milkmaids or Bonnard's blue-green shopgirls when you turn to this method.

As for pose—I would think a casual pose in a bright summer setting or a recreational activity such as boating, bathing, or picnicing would be most appropriate. It's difficult to imagine a brooding winter scene or a gloomy studio setting for a pointillist painting. To me, pointillism means air, sun, light, summer, beach, flowers, water. Perhaps to you it seems something else—just follow your own inclinations and urges.

The Outline

The outline for the pointillist painting is probably more important than for the other two techniques, which freely utilize line (particularly outline) and in which you can black in the whole figure and the shadows without fear of its affecting the subsequent painting.

Pointillism, therefore, requires a fairly complete blueprint into which to place the little mosaics of colors. This outline must of necessity be fragile enough so that it completely disappears as its inner areas are filled in. Here soft charcoal serves well since it vanishes at the merest blow. I would advise you to draw in a complete outline, but not to darken the areas where the shadows fall as you would in the other techniques. The accuracy of such an outline is important since pointillism is based on the theory of putting a patch of color down and letting it stay there. This technique is—in one aspect at least—less flexible than the others in that while it's entirely free and emotional, it also allows for less physical moving about of color. So draw your outline in carefully, remove all but its outer contours, and start filling in as you would tile a wall (but, hopefully, with more inspiration).

Painting the Figure

Let's say for the sake of example that you're about to paint a fair-skinned blond nude in a forest clearing. Patches of sunlight are bursting through

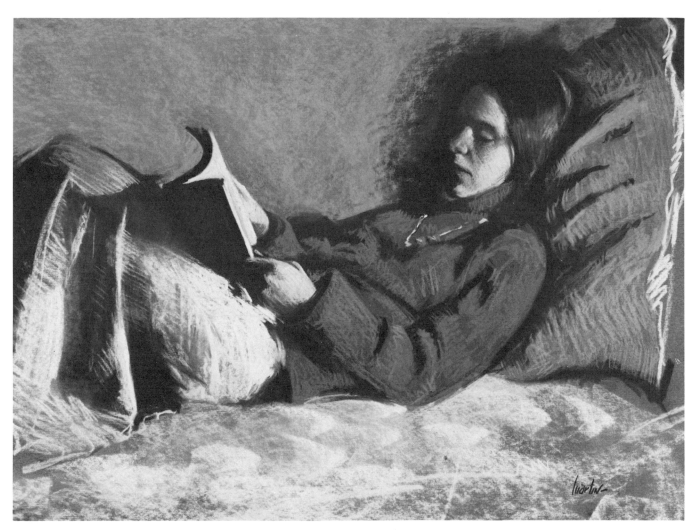

Liz Reading *by David Martin, pastel on sanded paper, 15" × 21-1/2" (Courtesy Desmond/Weiss Galleries). The harshness and sharp division of darks and lights indicate that this was painted under artificial light. Some artists prefer this wide range of tonality, which allows for dramatic, positive exposition. Seldom would you find such dark shadows outdoors, unless under streetlights at night. Natural and artificial light lends an entirely different character to a painting. The finest example of this is van Gogh's tortured scene of the billious billiard table and drunken sots in his brilliant* The Night Cafe.

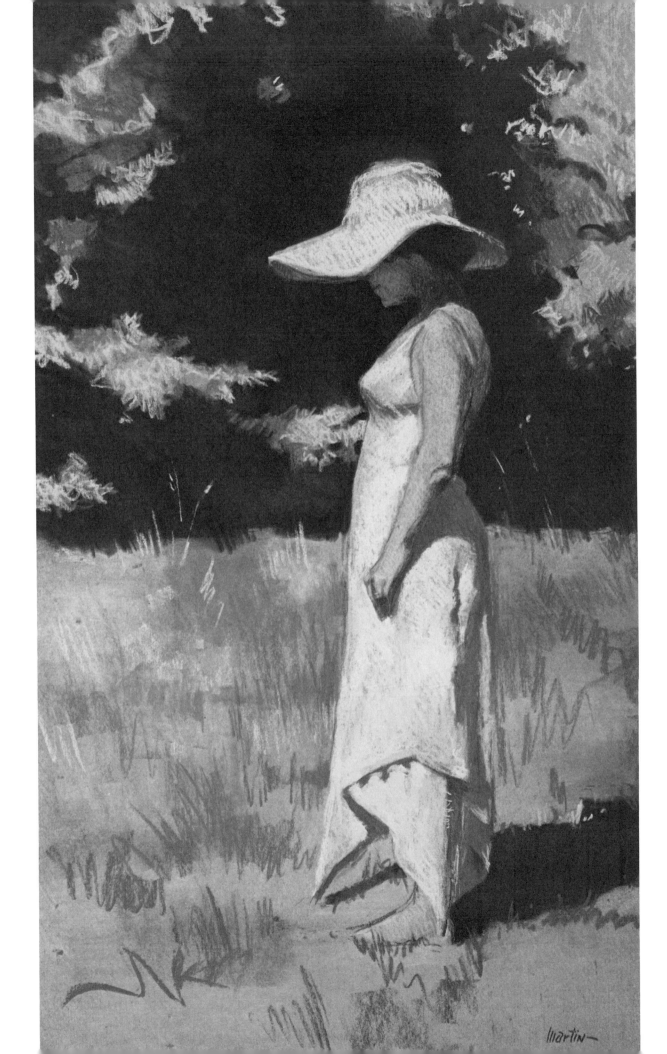

the leafy ceiling here and there. Begin with the shadows in the figure. Out in the open where the air is so clear (if such a condition still exists) the shadows are light; much lighter than you would have expected. Using dots of flesh ochre, yellow ochre, cobalt blue, and viridian, stroke in all the shadow areas of the figure, letting the tone of the board, which is olive, show through between the strokes. You'll find that the hard and semihard pastel sticks are very useful in this technique, so you'll vary them with dots of the soft pastel sticks. Working on the theory of thick lights and thin shadows, use the greens and blues in the hard pastels and the ochres and pinks in the soft pastels.

For the moment, disregard the yellows and greens that the plants and grasses are throwing back into the figure's shadows, but dot in your colors loosely so that the shadow areas remain open and free. Vary the shadows with an occasional blue violet, ultramarine, cadmium red light, or cadmium yellow for additional sparkle. Don't be afraid if a color seems too obtrusive—it will, hopefully, all calm down when the painting is more fully developed.

Having covered all the shadow areas, turn your attention to the halftones. Here is where the tone of the surface can play a major role. The olive of the board provides an ideal middletone and all it requires is a few selected dots of either red or blue to warm or cool it. Remember that pointillism is not a technique in which colors are laid *over* one another but one in which they lie *next* to each other. It therefore takes a bit of planning before placing a stroke so that no excessive build-up accumulates to spoil the elusive charm of the pointillistic painting.

Having livened up the halftones with dashes of

Cecilia in Summer Hat *by David Martin, pastel on paper, 21" × 12" (Collection Dr. Octavio Aguilar). Much of what I've said about painting outdoors is personified here. The brilliant sun makes a glaring white of the woman's hat and dress; the bottom of her face catches the strong reflected light of the dress; the greenery pops out in pointillistic patches of color; the very air breathes sun, wind, flowers, and grass. Painting outdoors is a most rewarding experience that I recommend to every figure painter. I take every opportunity to grab my pastels when I go to the beach, to the country, or even to a ballgame.*

red, blue, violet, or yellow, we now turn our attention to the lights. Here's where the full beauty of the pointillist technique can be exploited. Dots of pale lemon yellow, cadmium yellow, cadmium red, flesh ochre, and white are interplayed against light blue, moss green, blue-violet, and viridian to provide a sparkling, vibrating flesh area that's high in key but cool in overall color. The effect should be airy, gay, and breezy. Little concern should be paid to features and much to the sweep and action of the pose. Look for those milk-white, cool areas of flesh such as in the breasts, hips, and neck. Find those good pinks or violets in the blood areas such as knees, fingers, knuckles, elbows, and cheeks. Run some of these flesh tones into the yellow of the hair so that it swims together in slightly amorphous fashion, but don't go so far as to lose all form. The hair can include touches of olive, blue, yellow, ochre, and white with perhaps a dash of green or orange to spice it. Now turn your attention to the background. Here you can let the colors run riot for awhile. Dot and stroke in all those gorgeous greens, yellows, blues, and tans. Sprinkle in a scattering of cool violets and liven up areas with touches of pure lemon yellow. Be sure that no part of the background or the figure receives any stroke darker than a middletone in value. Let the juxtaposition of several of the darker colors provide the illusion of darkness. Don't hesitate to place a bright green against a bright red.

Nowhere in the painting must even a trace of outline remain. All edges are broken and rough, but not necessarily soft. The eyes, nose, and mouth can be mere dots. If you try for precision drawing in pointillism, you court disaster.

Proceed at this stage to strike colors from one area into another. Show those reflected lights in the figure with strong and vivid blues and greens. Run the reds, violets, and yellows of the "flesh" into the background. This scrambling of color throughout the painting serves to both unify and enliven it. All forms will drift into the other areas of the painting and you'll end up with a picture truer to life than one in which the shapes are meticulously drawn, bordered, and isolated.

The Painterly Technique

One of the three major techniques in pastel painting, the painterly is the most commonly used. In it, the artist builds layers of pastel one over the other until a completed painting is achieved. The manipulations involved may include such techniques as crosshatching, juxtaposing, scumbling, etc., but the end result is a sculptured, painterly effect one encounters in a realistic oil painting.

The painterly method allows for a significant amount of change and correction. For fumblers and painters who love to work spontaneously and with a minimum of intellectual planning, it's the ideal technique. By regaining the surface tooth, you can technically keep painting in this method forever. Over the years it has evolved into the traditional way in which to work in pastel. It's probably closest to oil painting in technique and allows for a natural progression from outline to underpainting to finish.

The chief advantage of the painterly technique is that it makes bold and vigorous work possible for those who may be overwhelmed by pastel. It also helps put the lie to the hard-to-destroy notion that pastel is a timid, fleeting, rather wishy-washy medium.

The Surface

The painterly technique works equally well on a smooth or rough ground, therefore any surface —board, paper, or canvas—will do. Since the pastel generally covers the surface fairly completely, the underlying tone of the surface is less important here than in the pointillist technique, where the ground is so much in evidence. This leaves the field pretty much open and you can use a surface of middle tone and of medium tooth, or whatever you prefer. When choosing the surface, also consider the fact that the heavier your pastel is to be applied, the greater the tooth

Nude Study *by Robert Brackman, pastel on paper. Only a few artists can get away with outlining a figure as consistently as this; Brackman is one of them. The reason for this is his superb handling of value relationships. Note how the shadows flow softly into the lights. Nowhere is there a sharp break or transition. If your values are right, your picture will be right. Note also the perfect balance of the figure. Had her left foot been placed a touch farther to the right, she would have ended up floating in space. Squint down and study the figure. Even though it's only reproduced in black and white, its color seems to appear.*

you'll want to grip and hold these coats.

As to surface color and value, the only time to consider this is if you're planning a vignetted study and are seeking a background of a specific tone and hue. Otherwise, any decent pastel surface will serve for the painterly technique.

The Palette

Both soft and hard pastels are used in the painterly method, although the number of actual pastels can be quite limited. The painterly method relies less upon broken color and leans more toward flat areas of color, so that seven or eight hues in their range of shades can be more than enough. I've executed large pastels in this method with as few as twelve sticks. Your selection should include a good mix of gray and brown halftones, several pure hues (for local color), and two or three darks and lights. This is a method that, to me, stresses value rather than color so that the subdued, gray shades are the most important in the palette you select for it.

Although it can be adapted to any kind of painting, the painterly method does *not* seem the ideal course if you're planning extremely delicate or subtle coloration. For such airy, gossamer subjects, the pointillist or rubbing-in methods seem more appropriate.

Lighting and Pose

In the lighting and pose aspect, too, the painterly method best serves the average pastelist since it leaves so much room for alteration and choice. You can use it to paint any subject in an indoor or outdoor setting, under natural or artificial light, in high or low key, in bright or dull color—anything goes in this technique.

Making the Outline

An outline for the painterly method picture needs far less work than the outline for the pointillist painting. In this case, a kind of rough map marking the shadow areas of the form, a few notes indicating the general placement of shapes, and possibly several keynotes defining proportions, angles, and strategic points within the figure should suffice. Certainly the closed contour study indicated for the pointillist painting is unnecessary here unless you deem it helpful to make such a precise preliminary drawing. How-

ever, in this technique I generally advise against such involved preparation, which tends to hamper one's freedom. The outline will be obliterated in the subsequent stages of painting anyway and it should be used only as an initial guidepost.

Instead, try to draw and paint simultaneously, encompassing value, color, placement, composition, and proportion in every stroke rather than consigning them each to a different aspect of your approach. Keep the painterly outline loose but informative, rough but meaningful, open but expedient. Put into it just enough information to help you achieve your goal. There'll be plenty of time to polish and primp later.

Painting the Figure

All right, let's say we've posed a burly, dark-skinned longshoreman stripped to the waist and flinging a sack of coffee onto a truck. It's nearly dusk and the waning daylight is blended with garish electric lights and truck headlights. The man's skin is gleaming with sweat that makes strong highlights, and the shadows on his figure are correspondingly dark under the harsh lights.

Having briefly sketched in the action of the pose and indicated the darks of the figure, the truck, the dock, and the pile of sacks, we now turn to dark burnt umber and stroke it in fairly thickly over all the shadow areas in the picture. We then pick up a stick of pure raw umber and fill in completely all the halftones. Leaving the lights alone for now, we note that the shadow mass still seems too light and go over it again with the side of darkest cobalt blue. With black, we spot in a few of the darkest accents in the man's pants, the truck, and the dark side of the sacks. Now only the lights should be blank, with the rest covered

Male Figure Study by *Charles Pfahl, pastel on paper. This is a highly sophisticated study executed in deceptively simple style. Pfahl shows himself a master of pastel with his selective use of rough and smooth passages and soft treatment of so many areas of the figure. The face appears a blend of a few smears and smudges, yet its form is as powerful as anything painted in a dozen deep coats. I particularly like the way he loses edges—a factor that has always intrigued me. Painting hard edges is a tendency I must constantly resist and don't always succeed in doing.*

PFAHL.

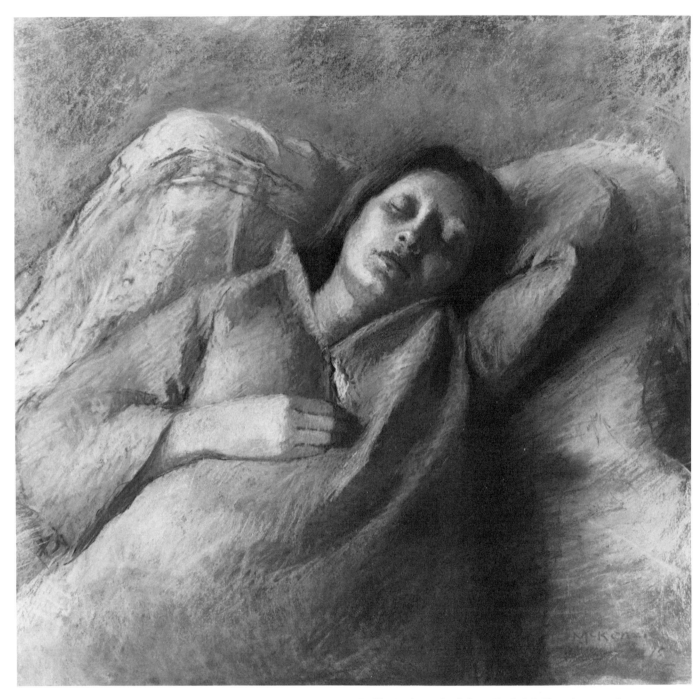

Julie Asleep *by Mary Beth McKenzie, pastel on prepared board, 20" × 21". The artist used pastel in basically painterly fashion to express the planes, with selected linear strokes to delineate the shapes of the folds, features, and shadows. The tonality here is fairly wide in range with deep darks, distinct halftones ,and strong lights. The treatment of edges is also essentially hard. This works well if the painting tends to be finished fairly extensively rather than left sketchy or in vignette form. Pastel allows you to achieve such a degree of finish and leaves room for almost every kind of technical approach.*

by a fairly dense layer of pastel. Now we'll pick up a tone darker than the actual light, perhaps darkest flesh ochre, and fill in all the lights. Don't worry about overlapping actual areas—precision isn't the goal.

So, with all the areas of the painting containing at least one layer of pastel with no (or little) surface color showing through, we begin building up. The man's skin is cooler than we've painted it so with an olive green stick we go over the entire figure working our strokes alternatively with and against the form to create a variety of lively, interesting patterns. If the background seems too cool, use a cadmium red orange to go over it all lightly, leaving the strokes open and spread apart so that the underlying tone shows through.

Unlike the mosaiclike effect of the pointillist method, the painterly technique gives a wet, juicy appearance—as if a liquid medium were being flowed onto the surface for a sculptured, plastic effect. The pastel is put on thickly in selected areas and built up and up until a strong three-dimensional effect is achieved. When the entire painting is adequately covered, a few thick impasto lights are placed here and there in soft, pure pastel. This is the finishing touch, like whipped cream on a sundae. Now, we go back to check our shadows and drawing and put in a line of black here or there to strengthen an action or emphasize a shape. A few bold, direct darks will do the job. Fixative will be used most constructively in the painterly method to darken a particular area and to provide tooth for subsequent layers of pastel. When painting in this method, think of your pastels as blobs of oil paint and your hands as brushes.

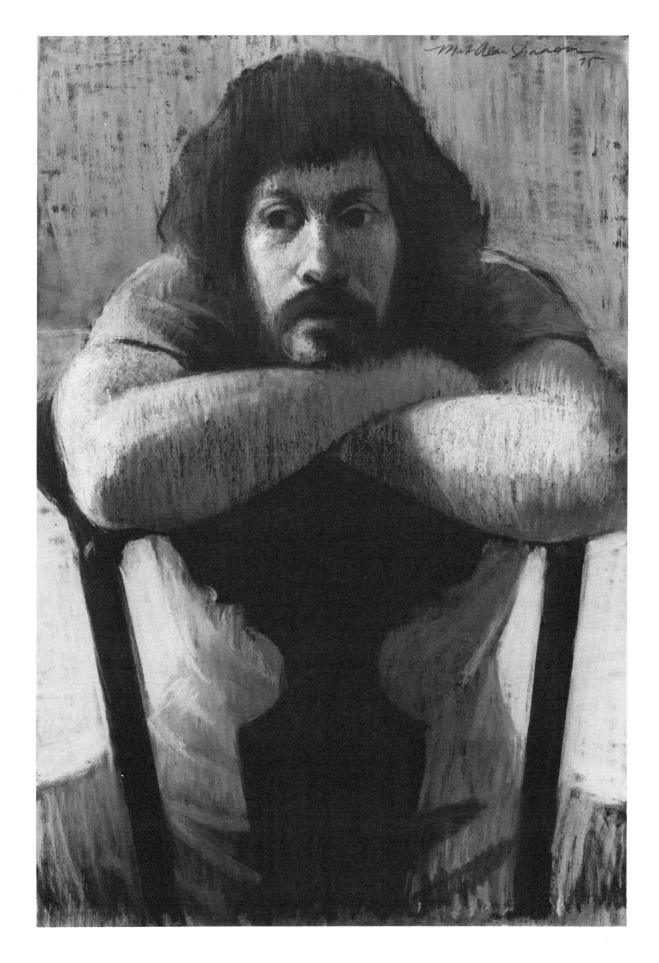

CHAPTER SEVENTEEN

Rubbing-In

The last of the three major pastel techniques is the rubbing-in, which eliminates all appearance of strokes and achieves a rather thin, smooth, blended, highly fused effect. This was the way the French pastelists of the eighteenth century worked to execute their smooth, silken portraits, and it inadvertently gave pastel its bad name.

The French ladies and gentlemen of the day demanded flawless complexions in their portraits and also insisted that their wigs, ribbons, laces, and magnificent costumes be not only reproduced but enhanced beyond fidelity. So the poor artist complied, joined his contemporaries in music, literature, and the theater, and earned his bread the best way he could.

Still, some of the early pastelists were blessed with such talent that it transcended the banality of these portraits and resulted in some magnificent character studies. However, most artists so thoroughly rubbed pastel that they ended up with paintings whose tints were robbed of their natural vigor. This damned the medium as incapable of producing powerful tones and hues. In time, pastel in general fell into disfavor as an effete medium unfit for the burgeoning militant proletariat, and the rubbing-in method lay quiescent until a number of modernday artists revived it as ideal for painting children's portraits. To this day people use the term "pastel tone" to indicate a pale, weak, flimsy color.

If I sound at all snide about this technique I don't mean to, for it's a perfectly legitimate and acceptable method of using pastel. Although it's currently out of favor, there's no reason it can't be pursued by those to whom it comes easily and naturally. I myself used pastel this way for years until I discovered that it was not the *only* way.

Generally speaking, the rubbing-in method involves putting down a stroke or several strokes of pastel and using a finger or other instrument to

Mark L *by Mark Alan Isaacson, pastel on sandpaper, 18" × 12". Letting the surface show through and laying the color on rather thickly in other areas lends interest to the overall concept. Varying the character of the techniques and manipulations in different parts of a single painting is another aspect which is almost exclusive to pastel. The beauty of the medium is that it allows such variation with no apparent loss of unity or cohesiveness. The wise pastelist takes advantage of such latitude to milk pastel of all its marvelous variety and diversity.*

rub and spread this stroke over an area, or to blend it into an adjoining area. Beautifully subtle tones can be achieved this way and everybody probably does *some* of this blending no matter what technique they use. But what we're speaking of here is, of course, rubbing in all or most of the painting—not the sporadic, selective rubbing in of a few passages. All in all, it's a rather pleasant, refined, studiously charming manner of painting and if it fits in naturally with your personality and style, don't hesitate to pursue it.

The Surface

The rubbing-in method is best accomplished on a smooth surface. A rough tooth negates the very effect you're after, which is a subtle gradation of colors and values. On a rough surface the granules tend to clump and adhere in patches and you'd have to pack in plenty of pastel to even out the lumps and crevices. And this is quite contrary to the rubbing-in method, which calls for a thin layer of "paint." Since scant pressure is to be applied, you can even use a thin charcoal paper, which is less expensive and less adaptable to vigorous stroking and manipulation.

A lighter tone is indicated for the surface since the rubbing-in method generally produces higher-key paintings and it's easier to paint in high key on a lighter-toned surface. A pale gray, blue, tan, or pink paper would probably be fine.

The Palette

The palette for the rubbing-in method can be quite restricted. Since the finger does so much combining here, much of the halftones are almost automatically eliminated. The finger creates mixtures of colors and blends complements into pleasing grays, thus avoiding the need for sticks one would normally need for these intermediary areas.

The palette should be keyed to the pure shades and should play down the tans, grays, and neutral shades that emerge from the blending itself. The range of tonality is also lower as the keynote of this method is color, not value.

So a selection of perhaps eight to nine pure colors in their various tints should suffice. The hard and semihard pastels are of almost no use here—what's needed are the soft, friable pastels that will rub out smoothly into a pleasing, even tone.

Lighting and Pose

For this gentler type of painting, gentler lighting is indicated. You wouldn't want a harsh, severe lighting setup with its deep, dramatic shadows for a painting executed in the rubbing-in method. Soft frontal or side lighting with comparatively bland shadows is more appropriate. As for the pose, it too should remain in character with the rather formal, placid nature of the technique. I wouldn't, for instance, paint something as violent as my boxers (see the color plates) in this method. Young nudes work particularly well in the rubbing-in technique, which seems just right for the silken, silvery sheen of tender, unwrinkled skin.

The Outline

The outline for a painting in the rubbing-in technique should be more complete than the one for the painterly method, but less so than that for the pointillist. The reason for this is that the layer of pastel is kept thin in this method, so that less room is left for overpainting, changing, building up, etc. In other words, while the painterly method allows you endless opportunity to solve the problems of drawing as you're painting, the rubbing-in method is more *alla prima*—completed in one shot, so to say. Therefore the problems of drawing should be fairly well resolved from the beginning.

Also, the outline should be kept fairly clean and loose in the shadow areas. It shouldn't be blocked in heavily and should be kept more linear in character. Rubbing-in is best achieved over a clean surface—rubbing color into darks will only muddy the tones. A loose, sketchy outline with open shadow areas is most desirable here.

Henry Fonda *by Rodolfo de Luca, pastel on paper (Courtesy Portraits, Inc.). The deliberate elongation of this figure has been practiced by artists with such diverse styles as El Greco, Rubens, and Modigliani. The purpose is usually to lend a certain majesty and distinction to the human animal, and when properly executed, such mannerism often results in a most compelling and arresting picture. De Luca has developed his own highly individual style in which he reduces the body to a minimum of several distinct and indistinct contours, and concentrates color in the head and hands. Only pastel, which so aptly expresses line, tone, and color could serve this type of painting.*

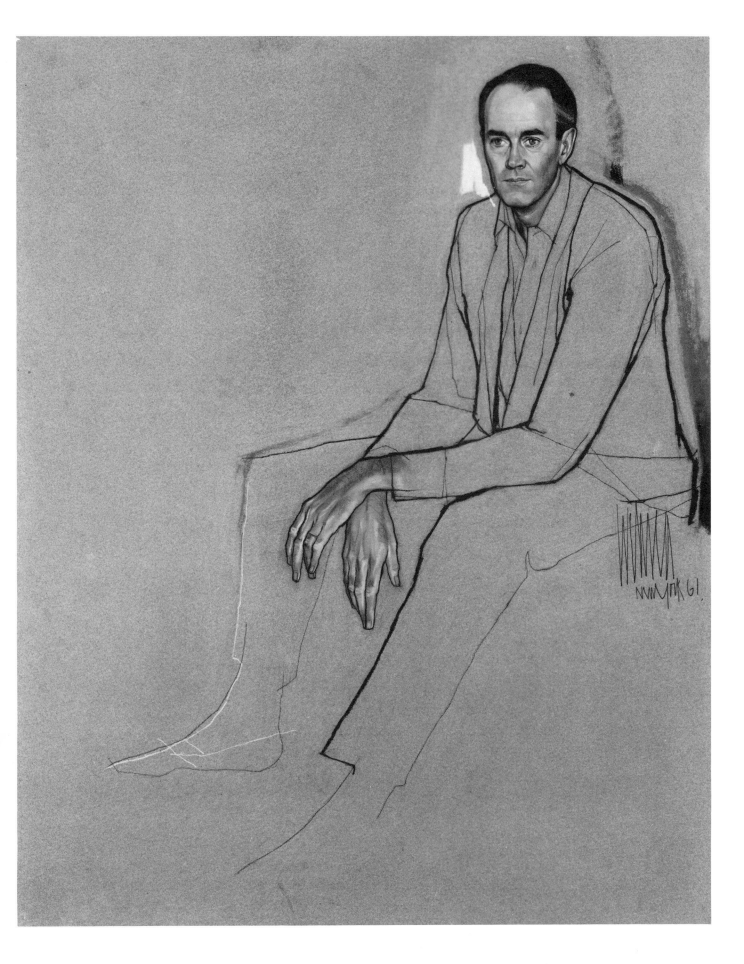

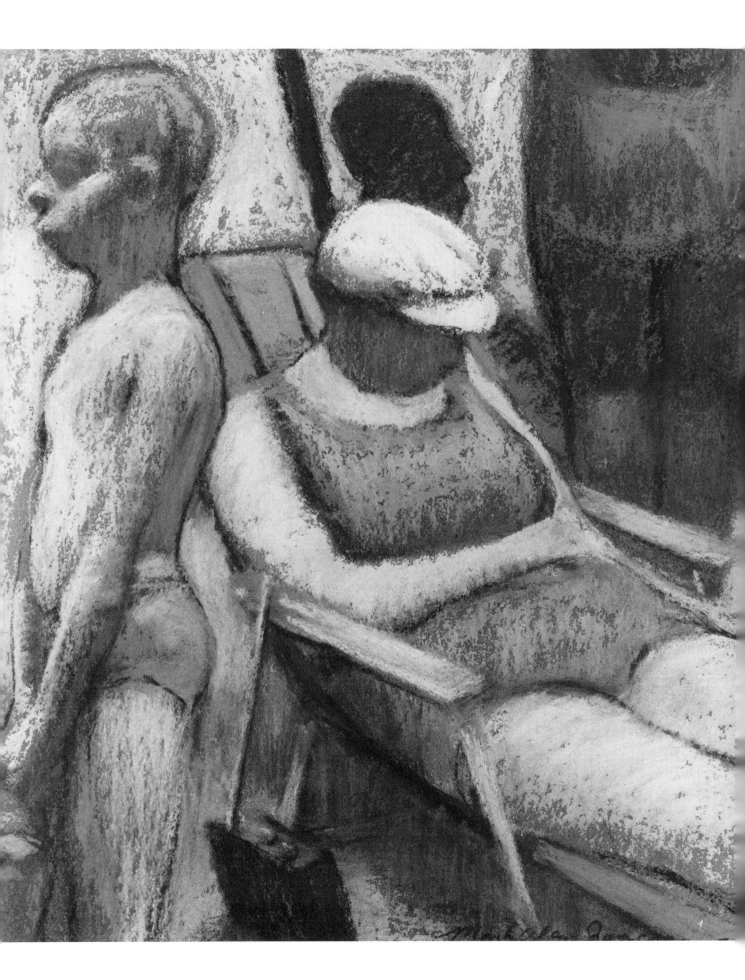

Painting the Figure

This time, let's use for our imaginary model a young lady curled up in a chair reading a book on a winter Saturday afternoon. The light filtering through the window is even and cool and just a bit of reflected light is bounced back into the sitter's shadow side. The key is medium and the overall tonality is fairly narrow. She is brunette and on the sallow side, dressed in a rust-colored blouse and black slacks. The armchair is a dull gold color. The rest of the room is fairly cool—a blend of blues, whites, and cool yellows.

A thick stroke of darkest raw umber is placed on the shadow side of her face and a stroke of lightest cadmium yellow deep for the light side. Now, blend the tones to fill in the appropriate areas in the face and run them together at the juncture where light turns into shadow. If the resulting transitionary tone is too cool, use a drop of cadmium red in the halftone area and blend some more. If it's now too hot, rub some more of the umber over it.

And so it goes. The fingertip (or stump if you prefer) washes the pastel over the areas that need to be filled in, fuses the colors, cools or warms them by combining them to their neighbors, and creates grays for the halftone areas. One thing it cannot do is *brighten* the colors. It merely works as a blender brush does in oil painting, swimming tones into one another and keeping them soft and unobtrusive. If you need more color or a different color, you simply add a stroke of what's needed and blend into what's already been put down.

Now use strokes of burnt sienna over the blouse and then blend to the edges. Too hot? Run a stroke of raw umber into the center of the blouse and rub. Continue on with a few strokes of burnt umber for the darks and a few of flesh ochre for the lights. For the darks, use an underlying coat of raw umber (black goes on very poorly over a plain surface), spread, add a few dashes of black —and blend to the edges. This is the way the rubbing-in method works—stroke, spread, stroke, rub. Naturally, a few linear strokes are left unblended to define the form, to establish shapes, to sharpen (some) edges, and generally to lend substance to the painting. Those few crisp, striking accents give sparkle and tang to what might otherwise turn out to be a ball of cotton candy. However, if too many accents are put in, the painting may turn out magnificent but it would no longer be executed in a rubbing-in technique.

Combining the Three Techniques

Since no one stands over you telling you that you *must* stick rigidly to a particular method, the wise pastelist usually uses aspects of all three techniques in his work. He might pointillize the background, be painterly in the figure, and rub in other areas. Or he may use two or three techniques in every area of the picture. Or he may do one painting in one method, a second painting in another method, and so on. The possibilities are endless, and that's as it should be. No artist should impose unnecessary rigors upon himself for reasons of self-discipline or character building. Painting is not transcendental meditation, yoga, or any other psychological exercise. Painting should be the most direct expression of one's artistic urges and feeling, and it mustn't be dictated by rules, limitations, or compulsions, except those imposed by natural circumstances.

The person who gets the most out of any effort is the one who puts the most into it. By all means learn to paint in each of the three techniques. By all means paint a picture exclusively in any one. But once you've proven to yourself that you understand how each technique works and what each is capable of, don't limit yourself to any particular one. Dot, rub, stroke, blend, crosshatch, fix, and scumble—use any method that best helps express what you want to say.

The Fourth of July by Mark Alan Isaacson, pastel on sandpaper, 9-3/4" × 8-3/4". Almost expressionistic in style, this is a highly sophisticated little pastel which shows how much can be expressed with extreme economy of line, tone, and composition. The forms are roughly articulated, the design is almost abstract, yet the visual impact is clear, direct, and unhampered by a single superfluous stroke. Although the artist submitted this painting at a very late date, I'm delighted he did so, since I consider it by far his best effort. Isaacson shows great promise in this very ingenious painting.

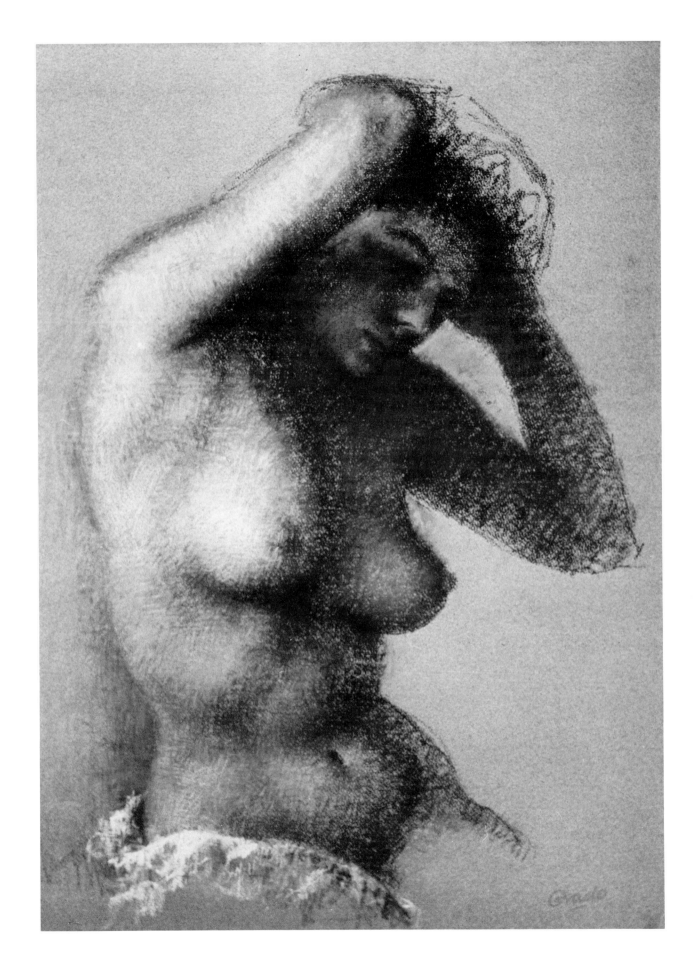

CHAPTER EIGHTEEN

The Final Stages

After the completion of the actual painting, the final stages—matting, fixing, and selecting the frame and glass—can be crucial to the outcome of your hard work. Also, you should keep in mind the importance of handling, storing, and transporting the finished painting in the proper manner so that it won't be damaged.

Matting

A question that often puzzles beginning pastelists is whether or not to mat the finished pastel before framing. Almost every expert advises that matting is necessary for the protection of the painting, and I must go along with this overwhelming weight of opinion. The purposes of the mat are to keep the pastel surface from rubbing against the glass, and to enhance the beauty of the picture by serving as a complementary transcending plane between frame and painting.

Mats these days come in a bewildering array of materials ranging from straw, fabric, cork, paper, wood products, and plastic, etc., and run the full gamut of color from daffodil to pussy willow. There are mats with round, oval, square, and rectangular openings. There are readycut mats and mats sold in sheet or board form so you can do it yourself. I don't like to prepare my own mats since I inevitably mess up the edge and usually cut myself. However, it's an excellent practice to learn for both economical and esthetic reasons. For those who do elect to mat and frame their own pastels, there are ingeniously constructed matcutters to help facilitate the task safely and accurately.

A prime requisite for a mat is that it be thick enough to keep the pastel surface and glass far enough apart to prevent contact. A second requisite is that its color and value complement rather than overwhelm the painting. For this reason I advise you to choose a mat that's at least

Sylvia by Angelo John Grado, pastel on paper, 22-1/2" × 16-1/2" (Collection Mr. and Mrs. Joseph Grado). The broken, scratchy technique evident here is one that works well if the concept of form isn't totally sacrificed. The model's left arm is barely worked out, but in context of the entire painting it holds up quite well. Contrast this to the technique used in the model's right side, where a smoother, more painterly method was employed. Most pastelists don't stay with any one way of working but utilize elements of all techniques in each painting. The approach is: anything that will help promote the effort is perfectly proper and acceptable.

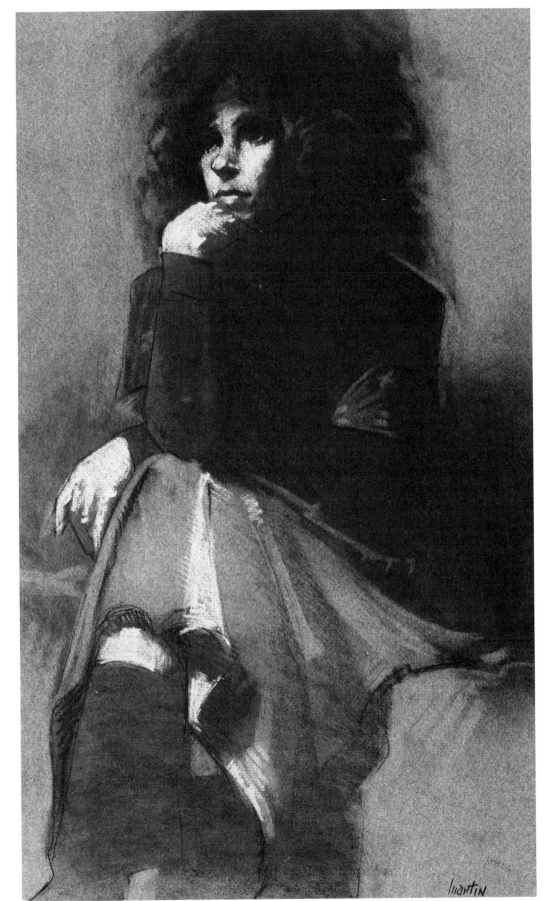

Alice by David Martin, mixed media on paper, 17" × 11" (Courtesy Desmond/Weiss Galleries). In some instances it becomes necessary to paint shadows darker on light skin. Under a very strong light the range of tonality stretches and the artist may choose to stress this factor by reaching into either extreme of value. Note how loosely Martin has painted the model's bushy hair. It drifts into the background as merely another shadow area and as such serves as a contrast to the light sections of the face. Hair, for the artist's purposes, is merely a value consideration. Under certain conditions, however, it can predominate because of its color.

¼" thick, at least 4" at its broadest point, and of some middle tone, value, and subdued color such as gray, tan, olive, or dull gold.

I prefer to use a mat with a wide border since this helps enhance the painting and lends it an aura of importance. The mat guides the viewer's eye into the picture, and when it's wide enough and of a pleasing neutral shade it heightens the impact as the eye finally comes to rest on the magnificent (we hope) colors therein. If the mat is strident and garish, the eye will stop and linger there, thus vitiating the excitement of the painting. A plain paper mat, in my opinion, is preferable to some of the exotic materials now being used for mats.

Preserving the Pastel

Since I'm not an advocate of final fixing, the only method of preserving the finished pastel, in my opinion, is to get it under glass and into the frame as quickly as possible. Dust, moisture (and accompanying mold), excessive heat, direct sunlight, and rubbing or other unnatural contact are the greatest enemies of the finished pastel. Even an unframed pastel will stand a minimum amount of contact but if any *lateral* pressure is applied, the pastel granules will smear and fall away from the surface.

If you're unable to frame the pastel immediately, carefully lay a sheet of waxed paper over it and store it lying face up in some dry, dustless area. If you do decide to give the painting a final fixing, be gentle about it—don't drown the picture with fixative or you'll end up with a gooey mess. If you use a mouth atomizer, don't let any drops of fixative fall on the surface or they will remain there as dark smears.

Another hint from experienced pastelists is to attach pieces of cork to each corner at the back of the frame so that it doesn't rest directly against the wall when it's hung. This helps guard against possible moisture in the walls. A rigid backing in the frame will help seal out dust and guard the painting from knocks and bruises.

Using a mat made of superior paper (these are usually called museum mounts) will help prevent the painting from catching a harmful disease from its neighbor. Pastel paints are in some instances subject to ailments caused by mildew, but should this occur the best thing is to rush the

"patient" to a restorer—who will try to cure the affliction.

The Proper Glass

A pastel painting must be framed under glass, and sometimes the choice of glass is recklessly made. You can buy so-called glareproof or non-reflective glass, or plastic, which lends the pastel a pleasing appearance. Experts, however, warn against the plastic since it may draw the pastel granules from the surface through some kind of magnetic process. Glareproof glass is perfectly acceptable for pastels, but I still use the old-fashioned glass—glare, fragility, and all. To avoid glare I simply hang it where the light won't produce an adverse reflection.

Selecting the Frame

The problem of selecting the proper frame for the pastel painting can be resolved by simple logic and good taste. Who's to say what frame is or isn't proper for a particular painting? No one but yourself. If you like simplicity choose an unadorned frame, or if your taste tends toward the other direction choose an elaborate frame. Nothing indicates that you can't get an ornate, foot-wide, gold-carved frame for a 3" x 4" pastel. I've seen such combinations and they go together as nicely as coffee and doughnuts. Then again, I've seen spartan, mouse-brown frames encompassing 40" x 60" pastel extravaganzas, and they, too, were appropriate. So, just remember this when choosing a frame for your pastel painting: if it looks good, it *is* good.

There are, however, some practical considerations. A chief one is weight. When you combine the weight of a huge frame and wide mat with glass and backing, you might easily end up with a ponderous monster once the sandwich is fully assembled. This is fine if the painting hasn't far to go, but suppose you plan to ship it to an exhibition 3,000 miles away? The cost of shipping is prohibitive in any case, and a huge, heavy frame makes it exorbitant.

Personally, I love heavy, elaborate gold frames and would frame all my paintings this way if I could. Above all, don't let anyone persuade you that pastel automatically dictates a thin or plain frame based on the modest character of the medium. Again, let your eye be the judge.

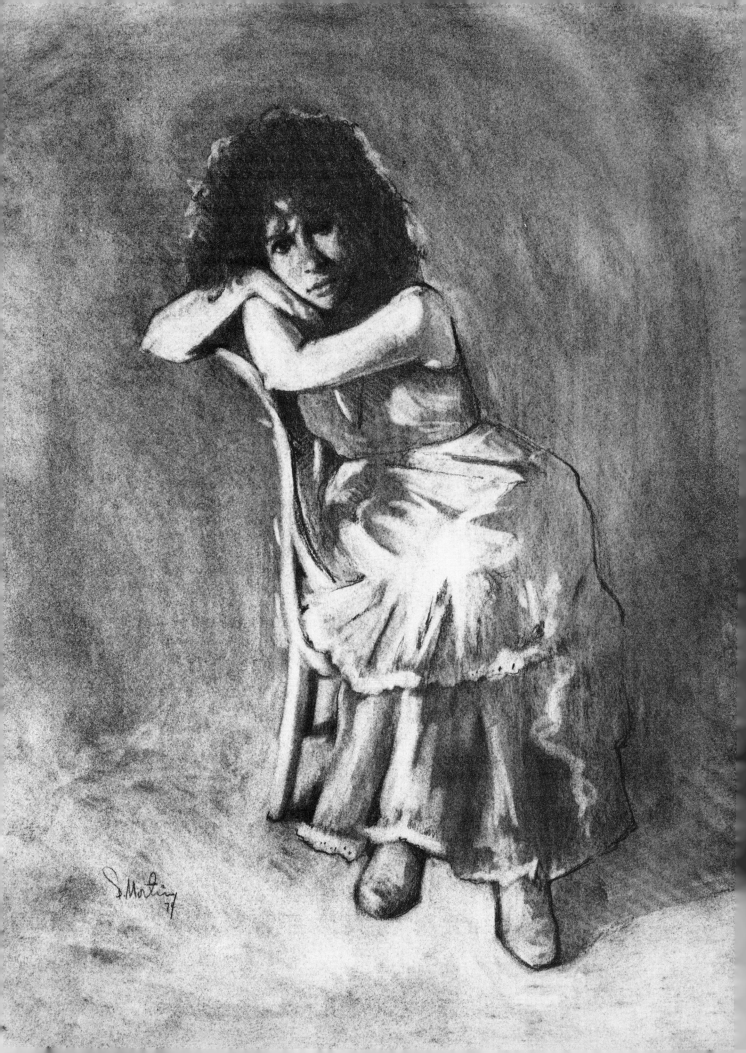

Framing the Pastel

If you're going to frame your painting yourself, here's one method of doing it:

1. Have all your materials—frame, painting, mat, tape, backing, glue, etc.—at hand.

2. Place your frame face down on a clean, dustfree surface.

3. Glue a few wedges of cork inside the rabbet so that they'll keep the mat from touching the glass yet not show up from the front.

4. Place the glass inside the rabbet of the frame.

5. Using ammonia or window cleaner, wash and dry the *inside* of the glass.

6. Drop the mat in on top of the glass.

7. Check the glass once more for dust and clean again if necessary.

8. Flick the back of the painting so that all loose particles of pastel are dislodged.

9. Using library tape, affix the top of the painting only to the back of the mat and place it gently down over it inside the frame.

10. Place a precut piece of cardboard or other rigid board over the back of the frame and nail or tape it all around so that it seals in the sandwich. Some experts advise that you do this only in places to avoid moisture that will otherwise collect there.

11. (Optional) Glue or tape a piece of brown wrapping paper over the backing. After attaching hooks and wire, the picture is ready to hang.

There's an additional method of framing called *passe-partout*, in which the glass, painting, and

Alice by David Martin, mixed media on paper, 18" × 14" (Courtesy Desmond/Weiss Galleries). Here is another painting of Alice (see page 160), but this time in a thin, sketchy treatment, with the tone of the paper showing through and heavy use of line to indicate the forms. Actually, except for the hair and neck, the whole study is a matter of lights picked out of the halftone of the paper with hardly a touch of shadow. The lightest lights are used to bring the knee forward. The artist might have done away with contour line altogether and let the figure fade into the background. A study of this type relies more on value relationships than color.

backing are all the same size, laid flush one against another and sealed along the edges with tape for a concise, self-contained package.

Handling the Finished Painting

The time you'll commence to curse pastel is when an exhibition draws near. Frankly, pastel paintings are a terrible nuisance to ship. The collective weight of frame and glass is considerable, the glass is always susceptible to breakage, and rough handling is deadly to pastel. Extreme care must be taken to protect the painting while in transit.

I take the coward's way and leave it all to professional art movers who are expert at this delicate task. However, many artists I know bravely build crates themselves and manage to send their pastel paintings all around the country without any problems. A crate carrying a framed, glassed pastel must be strong enough to resist the mistreatment of baggage handlers, firm enough to keep the painting from shifting about inside it, and so cleverly constructed that it will be light enough to lift and maneuver at the same time. Never having built such a crate I can only suggest you consult a carpenter or anyone generally familiar with tools. Shipping companies and movers can also make valuable suggestions.

As for transporting unframed pastels, I strongly advise against it. Find a framer with a shop close to your studio and get the painting to him as fast as you can. If you must carry it some distance, clip the painting to a support board, cover its front with another sheet of pastel paper, and at all cost avoid *lateral* movement that might smear or rub the painting. Always remember that it's the lateral, side-to-side movement, more than up-and-down contact, that causes the pastel to smear. Also, make sure it isn't raining when you leave the house since water can wreak havoc with the picture.

If you plan to store unframed paintings for any length of time, cover each one well and make sure no one lays anything against or upon it. Of course, if there's minimal smearing you can always correct it before framing, although, generally speaking, once a pastel is finished it's best not to touch it. If you do anticipate a long stretch between the completion of the picture and its framing, do your work on boards, which withstand abuse somewhat better than paper.

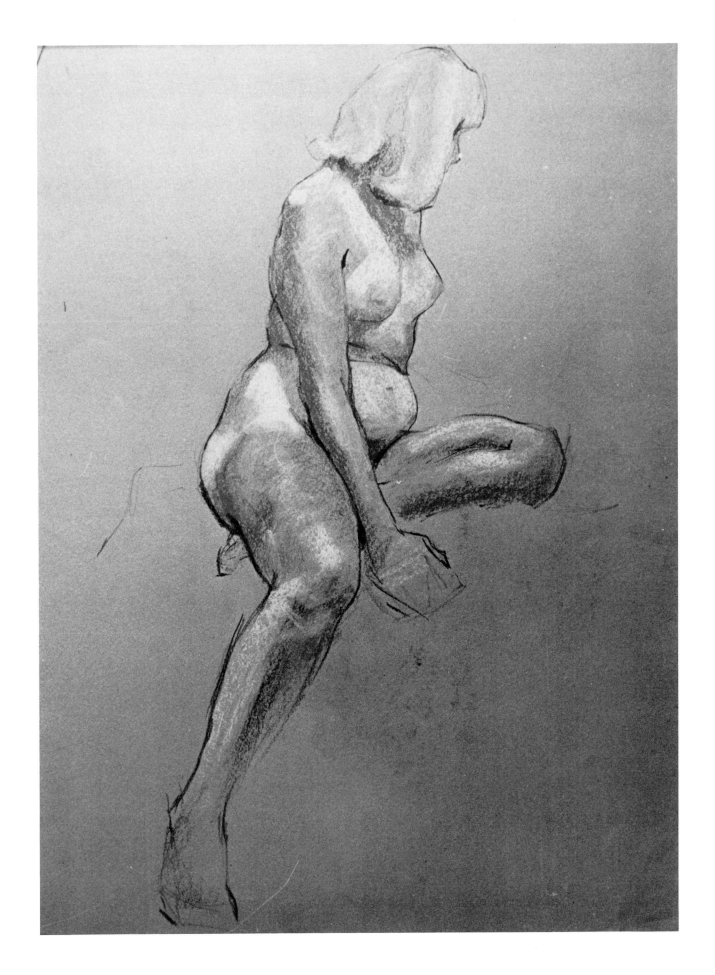

Bibliography

Doerner, Max. *The Materials of the Artist and Their Use in Painting, with Notes on the Techniques of the Masters*. New York: Harcourt Brace Jovanovich, 1949.

Gerdts, William H. *The Great American Nude*. New York: Praeger, 1975.

Hiler, Hilaire. *Notes on the Technique of Painting*. New York: Watson-Guptill, 1969.

Hiler, Hilaire. *The Painter's Pocket Book of Methods and Materials*. New York: Watson-Guptill, 1970.

Hogarth, Burne. *Dynamic Figure Drawing*. New York: Watson-Guptill, 1970, and London: Pitman, 1973.

Massey, Robert. *Formulas for Painters*. New York: Watson-Guptill, 1967.

Mayer, Ralph. *The Artist's Handbook of Materials and Techniques*. New York: Viking, 1970.

Mayer, Ralph. *The Painter's Craft*. New York: Van Nostrand Reinhold, 1966.

Muybridge, Eadweard. *The Human Figure in Motion*. New York: Dover, 1955.

Reinhardt, Ed, and Rogers, Hal. *How to Make Your Own Picture Frames*. New York: Watson-Guptill, 1964.

Richer, Paul. *Artistic Anatomy*. New York: Watson-Guptill, and London: Pitman, 1971, 1973.

Richmond, Leonard, and Littlejohns, J. *Fundamentals of Pastel Painting*. New York: Watson-Guptill, 1970.

Sears, Elinor Lathrop. *Pastel Painting Step-by-Step*. New York: Watson-Guptill, 1968.

Singer, Joe. *How to Paint Portraits in Pastel*. New York: Watson-Guptill, and London: Pitman, 1972.

Soyer, Moses. *Painting the Human Figure*. New York: Watson-Guptill, 1964.

Watrous, James. *The Craft of Old Master Drawings*. Madison: University of Wisconsin Press, 1957.

Werner, Alfred. *Degas Pastels*. New York: Watson-Guptill, 1969.

Nude Study *by Dennis W. Frost, pastel on paper, 22" × 18". It took Frost just forty-five minutes to complete this study. The foreshortening is emphasized, but not enough to create undue distortion. Pastel is ideal for such quick exercises. A few telling lines, some swiftly placed tones, a highlight here and there, and a shadow or two—and you have it, assuming you know where everything goes and know enough when to stop. Overworking a pastel is one of the bugaboos that continue to haunt the beginner. Inevitably he goes on too long and often spoils all the fine effects he has achieved. When to stop, however, can only be learned from experience.*

Index

Edited by Joan Fisher and Bonnie Silverstein
Designed by James Craig
Set in 11 point Palatino by Gerard Associates/Graphic Arts, Inc.
Printed and bound by Halliday Lithograph Corp.
Color printed by Toppan Printing Company (U.S.A.) Ltd.